The American Institute of Graphic Arts is the national non-profit organization which promotes excellence in graphic design. Founded in 1914, the AIGA advances graphic design through competitions, exhibitions, publications, professional seminars, educational activities, and projects in the public interest.

Members of the Institute are involved in the design and production of books, magazines, and periodicals as well as corporate, environmental, and promotional graphics. Their contributions of specialized skills and expertise provide the foundation for the Institute's program. Through the Institute, members form an effective, informal network of professional assistance that is a resource to the profession and to the public.

The AIGA network continues to grow throughout the country, with seven new chapters in the last year alone. Separately incorporated, AIGA chapters enable designers to represent their profession collectively on a local level. Drawing upon the resources of the national organization, chapters sponsor a wide variety of programs dealing with all areas of graphic design.

By being a part of a national network, bringing in speakers and exhibitions from other parts of the country and abroad, focusing on new ideas and technical advances, and discussing business practice issues, the chapters place the profession of graphic design in an integrated and national content.

The competitive exhibition schedule at the Institute's gallery includes the annual Book Show and Communication Graphics. Other exhibitions include Illustration, Photography, Covers (book jackets, record albums, magazines, and periodicals), Posters, Signage, and Packaging. The exhibitions travel nationally and are reproduced in *Graphic Design USA*. Acquisitions have been made from AIGA exhibitions by the Popular and Applied Arts Division of the Library of Congress. Each year the Book Show is donated to the Rare Book and Manuscript Library of Columbia University, which houses the AIGA collection of award-winning books dating back to the 1920's. For the past seven years, the Book Show has also been exhibited at the Frankfurt Book Fair.

The AIGA sponsors a biennial national conference covering topics including professional practice, education, technology, the creative process, and design history. The 1989 conference was held in San Antonio, Texas.

The AIGA also sponsors an active and extensive publications program. Publications include *Graphic Design USA*, the annual of the Institute; the *Journal of Graphic Design*, published quarterly; the AIGA Salary Survey; Graphic Design Education Statement; a voluntary *Code of Ethics and Professional Conduct* for AIGA members; Standard Form of Agreement for Graphic Design Services; *Symbol Signs Repro Art*, a portfolio containing 50 passenger/pedestrian symbols originally designed for the U.S. Department of Transportation and guidelines for their use; and a *Membership Directory*.

Caroline Hightower, *Director*
Irene Bareis, *Associate Director for Administration*
Chris Jenkins, *Associate Director for Membership and Chapters*
Allen Payne, *Director of Programs*
Greg Hendren, *Development Director*
Nathan Gluck, *Competition Coordinator/Archivist*
Ruth Toda, *Publications Coordinator*
Pam Roetzer, *Business Manager*
Kay Bergl, *Public Relations/Traveling Show Coordinator*
Levern Coger, *Office Coordinator*
Gigi Cooper, *Membership/Chapters Assistant*
Leah Weston, *Programs Assistant*
Michelle Kalvert, *Assistant to the Director*
Tracy Turner, *Receptionist*
Charles Alves, *Facilities Assistant*

BOARD OF DIRECTORS 1989–90

Nancye Green, *President*
Caroline Hightower, *Director*
Robert B. Ott, Jr., *Secretary/Treasurer*

Vice-Presidents
Michael Mabry
Douglas Wadden
Anthony Russell
Richard Saul Wurman
Cheryl Heller
Leslie Smolan
Judi Skalsky

Directors
Janet Blank
Ivan Chermayeff
Pat Hansen
Timothy Larsen
Sheila Levrant de Bretteville
Harry Marks
Miho
Clement Mok
Meg Reville
Gordon Salchow
A. Gregory Samata
Douglass Scott
Dugald Stermer
Jack Summerford
Lloyd Ziff

CONTRIBUTORS

Advancing excellence in graphic design is a collaborative effort. For their generous support of the Institute during the past year we would like to thank:

Adobe Systems Incorporated
Agfa Compugraphic Corporation
Neale Albert
Aldus Corporation
Eva Anderson
Gail Anderson
Apple Computer, Inc.
Kim Aquino
Art Center College of Design
AR Lithographers
Jan Borowicz
Brian Boyd
The Bradley Printing Company
Broderbund Software, Inc.
California College of Arts and Crafts
Ken Carbone
Champion International Corporation
Chiles & Chiles Graphic Services
Claris Corporation
Susan Cole
Colorcurve Systems Inc.
Computer Image Systems
Cooper Union
Cross Pointe Paper Corporation
Drake Printing Company
Fox River Paper Company
French Paper Company
George Rice & Sons, Inc.
Gilbert Paper
Milton Glaser
Gotham Graphics, Inc.
Graphic Technology Inc.
Graphis U.S., Inc.
Great Northern Design Printing Co.
R/Greenberg Associates
Grover Printing Company
The Hennegan Company
Heritage Press
Jerry Herring
Mike Hicks
DK Holland
Hopper Paper Company
IPP LithoColor
James River Corporation
Eric Johansen
Tibor Kalman
Jim Kaltwasser
Kansas City Art Institute
Geof Kern
Janis Koy
Letraset USA Inc.
Dennis Ortiz-Lopez
Lowell Williams Design, Inc.
MacWeek

Eric Marquard
McChesney Design
Hobart McIntosh
Mead Paper
Mohawk Paper Mills, Inc.
Clement Mok
Monadnock Paper Mills, Inc.
Monarch Press
Neenah Paper Company
Vida Ogorelec
One Works
Pantone Inc.
The Pennsylvania State University
Pentagram Design Inc.
Brian Peterson & Company
Pratt Institute
Radius, Inc.
Hansford Ray
Chris Raymond
Rhode Island School of Design
Richards Brock Miller Mitchell and Associates
Ricoh Corporation
Rochester Institute of Technology
Pat and Greg Samata
School of Visual Arts
Sendor Bindery
S.D. Warren Company
Silicon Beach Software, Inc.
Simpson Paper Company
Nancy Skolos
Southwestern Typographics
Sterling–Roman Press, Inc.
Strathmore Paper Company
Dan Sullivan
Jack Summerford
Bob Tolchin
Richard Turtletaub
Tyler School of Art
Typecrafters, Inc.
Typographic Resource Limited
Unitron Graphics, Inc.
U.S. Lithograph, typographers
Williamson Printing Corporation
Fred Woodward
Yale University

AIGA CHAPTERS AND CHAPTER PRESIDENTS AS OF JUNE 1, 1990

Anchorage—Harriet Drummond
Atlanta—Debbie McKinney
Baltimore—Anthony Rutka
Birmingham—Susan Williams Levine
Boston—Judy Richland
Chicago—Bart Crosby
Cincinnati—Dan Bittman
Cleveland—Nancy Petro
Denver—Mark Hanger
Detroit—Jim Houff
Honolulu—Oren Schlieman
Jacksonville—Diane Hunt
Kansas City—John Muller
Knoxville—Mary Workman
Los Angeles—Josh Freeman
Minnesota—Jo Davison Strand
New York—Richard Poulin
Philadelphia—Russ Gazzara
Phoenix—Greg Fisher
Pittsburgh—Frank Garrity
Raleigh—Deborah Rives
Richmond—Mary Mayer
Rochester—Trish Corcoran
St. Louis—Doug Wolfe
Salt Lake City—Rebecca Jacoby
San Diego—Esther Coit
San Francisco—Michael Patrick Cronan
Seattle—Anne Traver
South Florida—Cynthia Hanegraaf
Texas—Eric Johansen
Washington DC—David J. Franek
Wichita—Susan Mikulecky

The Annual of the American Institute of Graphic Arts

Written by Steven Heller, Chuck Byrne,
and Philip B. Meggs; Designed by Anthony Russell;
Barbara Nieminen, Associate Designer;
Brian Stanlake, Production Coordinator

insides outsides

ISBN 0-8230-6032-2
Printed in Japan by Dai Nippon Printing Co., Ltd.
Type set by U.S. Lithograph, typographers, New York, N.Y.
First printing, 1990
Distributed outside the U.S.A. and Canada by RotoVision S.A.
10 rue de l'Arquebuse, case postal 434, CH-1211 Geneva 11,
Switzerland.

A I G A
B O O K
S H O W
1 9 8 9

CONTENTS

MMUNICATION GRAPHICS 88/89

PEOPLE
&
PLACES
THINGS

The cakes on the following pages were part of a nationwide graphic hurrah in celebration of our 75th birthday year. From elegant to offbeat, they demonstrate the vitality of the chapters that created them, and they generated a variety of local and national media coverage about the AIGA and graphic design. Coincidentally, the Walker Art Center's "Graphic Design in America: A Visual Language History," opened in Minneapolis and in New York and was seen by over 157,900 people (who, if they had not been before, have now been introduced to graphic design). The exhibition then traveled to Phoenix and London. It provided a lightning rod for comment, criticism, and attention and provided a foundation for continuing coverage of a field that is just now establishing a public identity. The AIGA held a large press party in celebration of both our 75th Anniversary and the Walker opening at the IBM Gallery, which proved to be an effective first.

Dangerous Ideas, our third national conference, was also a catalyst for critical comment and a general sense that it's okay to voice opinions. Eleven hundred people had a lively time in San Antonio prompted by a lineup of over 55 provocative speakers. The conference focused on a number of issues relating to graphic design in the broader society. We published an ÊCO (ecology) Newsletter which was distributed in San Antonio and to our national membership; graphic design as garbage was also the subject of a conference presentation. We produced a round-table program on ethics in graphic design for the conference at large which has been produced as a videotape and will be available to schools and chapters.

Well aware that membership dues and earned-income can no longer support a growing organization, we have brought a development director on staff whose efforts on the associated trades reception at the conference made it possible for us to extend the program and maintain the conference fee at the level it had been two years earlier. Our 75th anniversary also provided the impetus to put in place a Patrons Program which will help to underwrite our efforts in new programming.

Thirty-two chapters held over 200 programs nationwide including international exhibitions from Czechoslovakia (Raleigh chapter) and Russia (San Diego chapter) which created more positive press and television coverage and are now traveling around the United States. Other programs were as varied as a 2-day regional computer graphics conference in Pittsburgh and the weekend Design Camp in the wilds of Minnesota.

Issues of social awareness relating to graphic design were the subject of our latest chapter/board retreat in Atlanta which focused on potential chapter/national programs related to education, environment, minorities, and pro-bono design services for local communities.

The AIGA continues its efforts to advance excellence in graphic design as a discipline, profession, and cultural force. We have grown to a point where we can collectively address issues that concern our members which it would be difficult for them to address alone.

The strength of the AIGA remains its membership. The largest committee of our membership, the board of directors, and its executive committee under the intelligent leadership of our president, Nancye Green, has served us well. This has been a productive year.

I would like to thank the AIGA staff which continues to bring order out of chaos as we encouraged and coped with the chance and growth of 1989. We are also indebted to Tony Russell, who designed this annual and guided it to publication; to Paula Scher for her offbeat, on target jacket (no, we don't have to take ourselves so seriously…except, perhaps, on the issue of Helvetica); and Steve Heller, who has kept the AIGA Journal lively and provocative. In all, a happy birthday, indeed!

Caroline Hightower
Director

Overleaf:

1 **Atlanta**
Dawn Fogler, Designer
Chuck Young, Photographer

2 **Baltimore**
Stephanie Coustenis, Designer
Mike Ciesielski, Photographer

3 **Birmingham**
Karen Schmoll, Matt Dorning, Designers
Mark Gooch, Photographer

4 **Boston**
Nancy Skolos, Designer
Tom Wedell, Photographer

5 **Chicago**
Bart Crosby, Joseph Essex, Steve Liska, Ann Tyler,
Karen Robinson, Designers
Dave Jordano, Photographer

6 **Cincinnati**
John Emery, Designer
Kim Simmons, Photographer

7 **Cleveland**
Dyane Hronek Hanslik, Francis Topping,
Arno Bohme, Gary Cirino, Beckett Daniel,
Cathryn H. Kapp, Robert Porter, Designers
Don Snyder, Photographer

8 **Denver**
Elizabeth Stout, Designer
Sidney Brock, Photographer

9 **Jacksonville**
Mike Boynes, Suzanne Hendrix, Diane Hunt,
Deborah Levine, Vanessa Quan, Barry Parker,
Tom Schifanella, David Smith, George Strumlauf,
Erik Williams, Suzanne Cavallero, Design Committee
Garry McElwee, Photographer

10 **Knoxville**
Sherry Blankenship, Designer
Keith Poveda, Photographer

11 **Los Angeles**
John Clark, Designer
Terri Gilman, Photographer

12 **Minnesota**
Brent Bentrott, Designer
Ben Saltzman, Photographer

13 **New York**
Michael Bierut, Designer
Elliott Kaufman, Photographer

14 **Philadelphia**
Stacy Lewis, Designer
Bel-Hop Studio, Photographer

15 **Pittsburgh**
Richard M. Seman, Designer
Tom Barr, Photographer

16 **Raleigh**
Student Chapter, Designer
Peter Hutson, Photographer

17 **Richmond**
Manuel V. Timbreza, Natalie Jeffers, Scott Fields,
Neil Quimby, Jeffrey B. Burt, Bob Littlehales,
Diana Plasberg, Designers
Mike Jones, Photographer

18 **St. Louis**
Gary Karpinski, Linda Solovic, Designers
Bob Bishop, Photographer

19 **Salt Lake City**
Tracy O'Very-Covey, Designer
Michael Covey, Photographer

20 **San Francisco**
Gerald Reis, Designer
John Clayton, Photographer

21 **Seattle**
Katy Homans, Nancy Gellos, Anne Traver, Designers
Kevin Latona, Photographer

22 **South Florida**
Patrick J. Hamilton, Designer
Christian Verlent, Photographer

23 **Texas**
David MacKenzie, Jim Ammenheuser, Designers
David MacKenzie, Photographer

24 **Washington**
Marianne Michalakis, Kimberly Doebler,
Christine Pittman, Designers
Taran Z, Photographer

25 **Wichita**
Bill Gardner, Mike Kline, Susan Mikulecky,
Jana Snyder, Todd Whipple, Designers
Paul Chauncey, Photographer

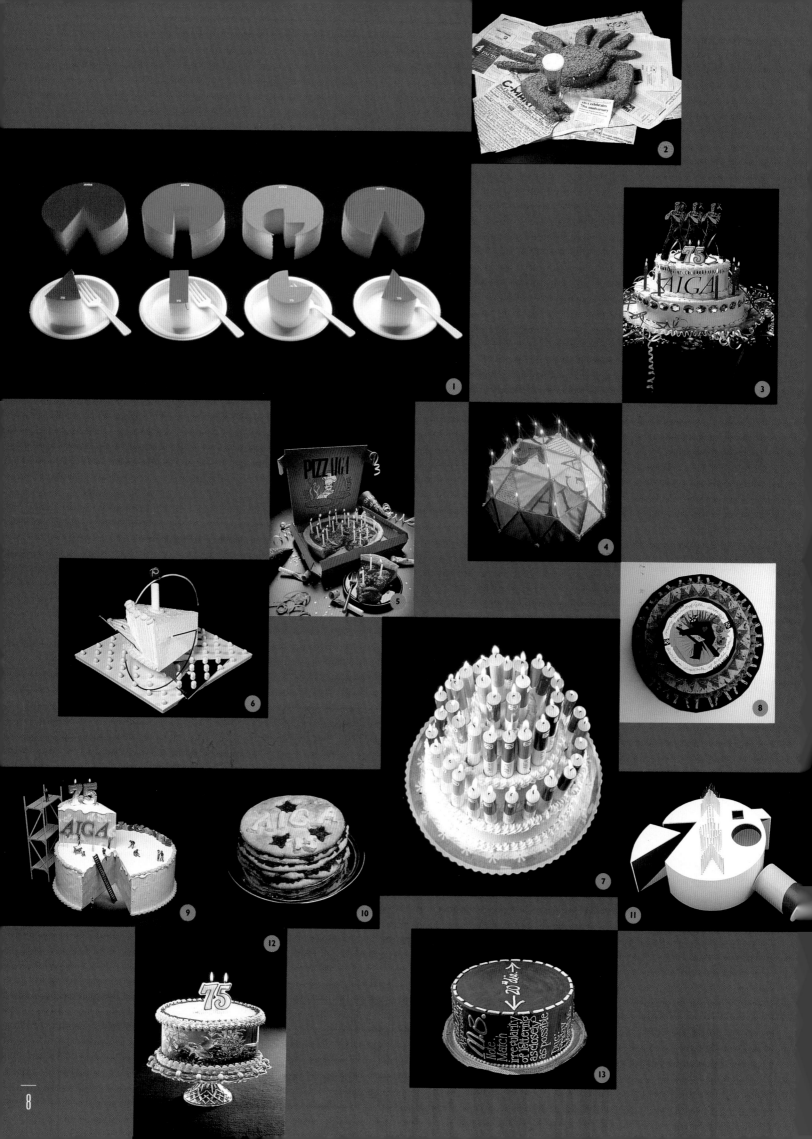

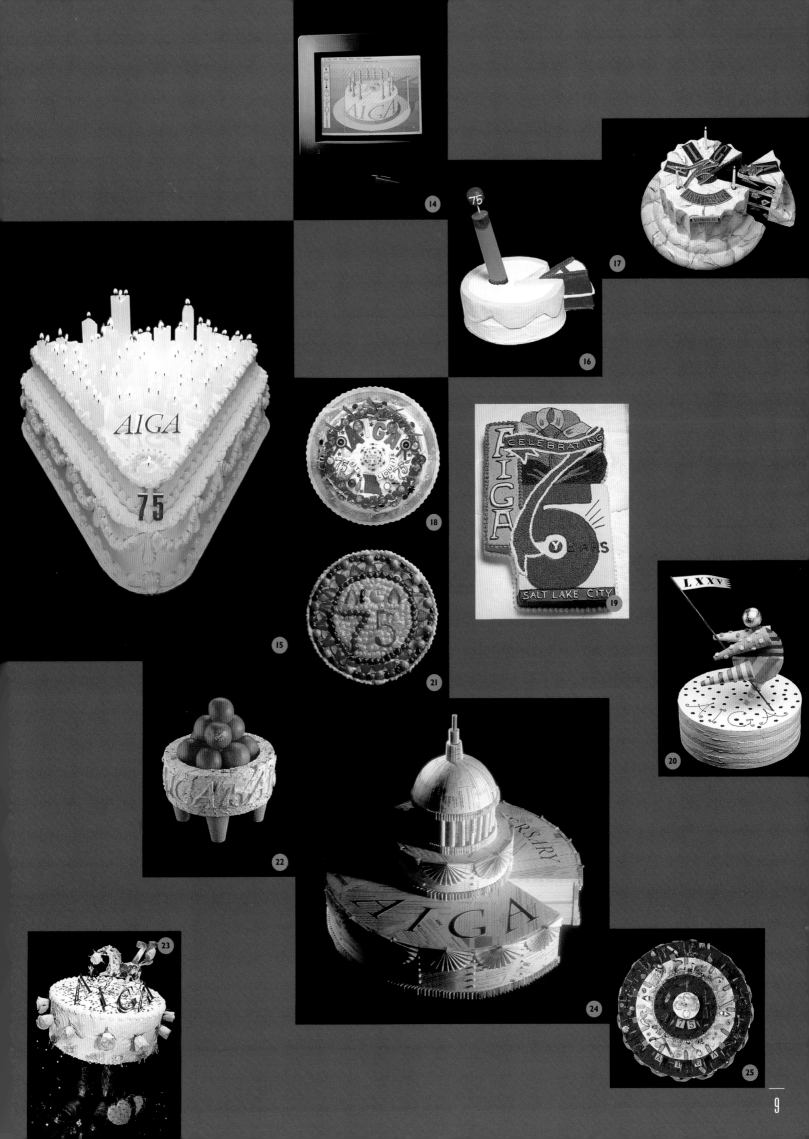

For 70 years, the medal of the AIGA has been awarded to individuals in recognition of their distinguished achievements, services, or other contributions within the field of the graphic arts. Medalists are chosen by a committee, subject to approval by the Board of Directors.

1989 AWARDS COMMITTEE

Chairman, Jerry Herring
President, Herring Design

Steve Heller
Art Director, *The New York Times Book Review*

Marty Fox
Editor-in-Chief, *PRINT* Magazine

PAST RECIPIENTS

Norman T.A. Munder, 1920
Daniel Berkeley Updike, 1922
John C. Agar, 1924
Stephen H. Horgan, 1924
Bruce Rogers, 1925
Burton Emmett, 1926
Timothy Cole, 1927
Frederic W. Goudy, 1927
William A. Dwiggins, 1929
Henry Watson Kent, 1930
Dard Hunter, 1931
Porter Garnett, 1932
Henry Lewis Bullen, 1934
J. Thompson Willing, 1935
Rudolph Ruzicka, 1936
William A. Kittredge, 1939
Thomas M. Cleland, 1940
Carl Purington Rollins, 1941
Edwin and Robert Grabhorn, 1942
Edward Epstean, 1944
Frederic G. Melcher, 1945
Stanley Morison, 1946
Elmer Adler, 1947
Lawrence C. Wroth, 1948
Earnest Elmo Calkins, 1950
Alfred A. Knopf, 1950
Harry L. Gage, 1951
Joseph Blumenthal, 1952
George Macy, 1953
Will Bradley, 1954
Jan Tschichold, 1954
P.J. Conkwright, 1955
Ray Nash, 1956
Dr. M.F. Agha, 1957
Ben Shahn, 1958
Mary Massee, 1959
Walter Paepcke, 1960
Paul A. Bennett, 1961
Willem Sandberg, 1963
Saul Steinberg, 1963
Josef Albers, 1964
Leonard Baskin, 1965
Paul Rand, 1966
Romana Javitz, 1967
Dr. Giovanni Mardersteig, 1968
Dr. Robert L. Leslie, 1969
Herbert Bayer, 1970
Will Burtin, 1971
Milton Glaser, 1972
Richard Avedon, 1973
Allen Hurlburt, 1973
Philip Johnson, 1973
Robert Rauschenberg, 1974
Bradbury Thompson, 1975

Henry Wolf, 1976
Jerome Snyder, 1976
Charles and Ray Eames, 1977
Lou Dorfsman, 1978
Ivan Chermayeff and Thomas Geismar, 1979
Herb Lubalin, 1980
Saul Bass, 1981
Massimo and Lella Vignelli, 1982
Herbert Matter, 1983
Leo Lionni, 1984
Seymour Chwast, 1985
Walter Herdeg, 1986
Alexy Brodovitch, 1987
Gene Federico, 1987
William Golden, 1988
George Tscherny, 1988

Bea Feitler.

BY PHILIP B. MEGGS

Bea Feitler: The Vitality of Risk

A vivacious young woman from Rio de Janeiro moves to New York to study design and is later appointed co-art director of the world-renowned *Harper's Bazaar* magazine at age twenty-five. After ten years at *Bazaar*, she becomes the first art director of *Ms.*, the magazine of the women's liberation movement. Other accomplishments include designing award-winning books, working for *Rolling Stone*, and being chosen to art direct the revival of the 1930s classic, *Vanity Fair*. She is at the zenith of her career and celebrated for her work when cancer takes her life at age forty-four.

This chronicle is not fiction. It is the story of Bea Feitler, described by friends and admirers as a "risk-taker," a "whirlwind persona," and "an unstoppable creative force."

Feitler's parents provided a European education offering broad learning and stressing excellence. She showed talent and enthusiasm for art in her teens. Her parents encouraged Feitler's interest, made a global search for the right art school, and chose Parson's School of Design in Manhattan. Her uncle, Edward Newman, lived in the New York area and provided her with a transitional home.

Feitler was exotic and full of nervous energy. She thrived on the life of the city and her design-school experiences. Music, literature, and the ballet fascinated her. She would wait in line for hours to get standing room at the Met. Her initial interest in illustration yielded to a growing fascination with design. The fashion magazines, especially *Harper's Bazaar*—art directed by the legendary Alexey Brodovitch until his retirement in 1958, the year before her gradua-

March 1967. Pages 192-197. Art Directors: Ruth Ansel, Bea Feitler; Designer: Bea Feitler; Photographs by Bill Silano. Copyright © 1967. The Hearst Corporation. Courtesy of *Harper's Bazaar*.

October 1967. Art Directors: Ruth Ansel, Bea Feitler; Designer: Bea Feitler; Photograph by Bill Silano. Copyright © 1967. The Hearst Corporation. Courtesy of *Harper's Bazaar*, opposite.

OCT. 1967

HARPER'S

BAZAAR

**THE
NEW
FASHION
LIFE:**
A TASTE
FOR
SPLENDOR

**THE
NEXT
TEN
YEARS:**
AVORA
OVE
PROPHESIES

**CHOOSING
THE RIGHT
PLASTIC
SURGEON:**
A PERSONAL
HISTORY

tion from Parson's—held a special fascination for her. After graduation she made the rounds in New York, including a visit to *Bazaar*, where she was told to come back after she had more experience. She decided to return to Brazil and launch her career there. In partnership with two other graphic designers, she started Estudio G specializing in poster, record album, and book design. She also collaborated on the design of the Brazilian magazine *Senhor*, which was revolutionary among Brazilian cultural and political magazines in its commitment to graphic concepts and progressive design. *Senhor* provided a wonderful opportunity for Feitler to experiment, to innovate, to succeed, and to fail.

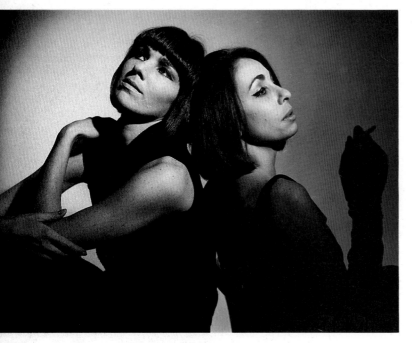

Henry Wolf followed Brodovitch as art director of *Bazaar* in 1958. When Wolf left to become art director of *Show* in 1961, Marvin Israel, one of Feitler's teachers from Parson's, became art director of *Bazaar*. Two issues later the names Beatriz Feitler and Ruth Ansel appeared on *Bazaar*'s masthead as art assistants. Israel had contacted Feitler in Rio de Janeiro and invited her to return to Manhattan and join him at *Bazaar*. It was a fabulous opportunity for the 23-year-old designer.

From their first meeting in the offices of *Bazaar*, Feitler and Ansel proved to be kindred spirits. The Brodovitch heritage still illuminated *Bazaar* for Israel had been his student. Feitler and Ansel felt the mandate of Brodovitch's legacy and hoped to meet him. Though the opportunity never came, they absorbed his influence from Marvin Israel until he left *Bazaar* in 1963. In a move that received national press comment and surprised the media world, *Bazaar* promoted Feitler and Ansel, then in their mid-twenties, from art assistants to co-art directors. Pundits in the press who expressed open skepticism about their ability to manage the graphic destiny of one of the world's most sophisticated publications soon ate crow for the synergy and energy of Feitler and Ansel occurred at a time when high fashion was colliding with pop fashion from the streets, rock music and experimental film were extending sensory experience, women and minorities were taking to the streets, and the new art movements, notably Pop and Op, were changing the face of aesthetic experience. Moon rockets, assassinations, and the Vietnam War stunned the

national psyche. Feitler and Ansel remained true to the best Brodovitch tradition of designing magazines as a harmonious and cinematic whole, while responding to events in the streets of the time, in a collaboration that was organic and mutually supportive. They were open to accidents, material around the studio, and events surrounding them. In their office an inspirational wall collage would grow and change, providing an unending source for invention. Feitler once summed up her editorial design philosophy: "A magazine should flow. It should have rhythm. You can't look at one page alone, you have to visualize what comes before and after. Good editorial design is all about creating a harmonic flow."

Friends remember Feitler's energy as inexhaustible, and her zest for life as exuberant and extravagant. A stunning contradiction was at the center of her being. She was a traditionalist with a deep devotion to her family and a sense of her cultural history. Yet she was filled with the spirit of the sixties. Close associates recall that she handled the dichotomy well. Her present was undaunted by any struggle between her past and future.

In a 1968 *Graphis* article, photographer Richard Avedon recalled working with Feitler and Ansel on the April 1965 *Bazaar* cover. The deadline was past, it was after 11 p.m., and the photographs of Jean Shrimpton in a "space helmet" designed by one of New York's most famous milliners did not work.

"Ruth started to explain that we could cut the shape of the space helmet out of Day-Glo paper," Avedon wrote, "but she never finished because Bea was already cutting the shape. Rubber cement, color swatches. An eighth of an inch between the pink helmet and the grey background. No, a sixteenth. I was in the room and I don't know how it happened. And, it all happened in minutes... the moment was absolute magic, to watch Bea, the classicist, and Ruth, the modern, work as if they were one person."

The final cover with Avedon's photograph of Jean Shrimpton—now peering from behind a bright pink Day-Glo space helmet with the logo vibrating against it in acid green—won the New York Art Director's Club medal and has been often reproduced as an emblem of the sixties.

Bazaar of the 1960's was a dynamic statement of its time.

BAZAAR

OCT. 1961 HARPER'S

Magic
Moments in
BEAUTY
and
FASHION

GLORIA
GUINNESS:
The Chip
on the
Shoulder

THE
FLIRTING
GAME

WHAT'S AHEAD IN BEAUTY

YEAR 2067

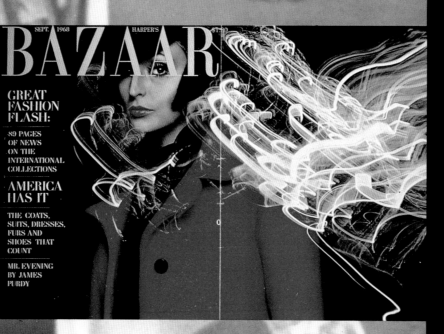

Bea's "inspirational wall" at *Harper's Bazaar*.

Insets/August 1966. Pages 124-125. Art Directors: Ruth Ansel, Bea Feitler; Designer: Bea Feitler; Photograph by Hiro; Illustrator: Denziger, Copyright © 1966. The Hearst Corporation. Courtesy of *Harper's Bazaar*, top, left./March 1969. Pages 194-195. Art Directors: Ruth Ansel, Bea Feitler; Designer: Bea Feitler; Photograph by Alberto Rizzo. Copyright © 1969. The Hearst Corporation. Courtesy of *Harper's Bazaar*, bottom, left./March 1969. Pages 198-199. Art Directors: Ruth Ansel, Bea Feitler; Designer: Bea Feitler; Photographs by Alberto Rizzo. Copyright © 1969. The Hearst Corporation. Courtesy of *Harper's Bazaar*, center./September 1968. Art Directors: Ruth Ansel, Bea Feitler; Designer: Bea Feitler; Photograph by Hiro. Copyright © 1968. The Hearst Corporation. Courtesy of *Harper's Bazaar*, top, right./April 1969. Art Directors: Ruth Ansel, Bea Feitler; Designer: Bea Feitler; Photograph by Hiro. Copyright © 1969. The Hearst Corporation. Courtesy of *Harper's Bazaar*, bottom, right.

Rollicking sequence photography, cinematic pacing, incredible scale changes, Pop art, and Op art often filled its uninhibited pages. It walked away with award after award in major design exhibitions. Breaking precedent in 1965, Avedon, Feitler, and Ansel fought for and won the right to use a black model in the pages of a major fashion magazine. The reaction—subscriptions cancelled and advertisers withdrawing their advertising—was unexpected and frightened management, which did not use black models again for a long time.

Feitler worked well with photographers, who trusted her judgment and ability to select and design effectively with their images. In addition to close collaboration with photographers having long-standing relationships with *Bazaar*, such as Avedon and Hiro, Feitler and Ansel brought Bill Silano, Duane Michals, Bill King, and Bob Richardson to the pages of *Bazaar*. While working on a shoe portfolio with Silano, Feitler took him to see the French film *A Man and A Woman* six times. The lyrical romanticism and elegant cinematography from this landmark movie found its graphic equal in the pages of *Bazaar*.

Today a two-year tenure by an art director at a major consumer magazine is considered lengthy: the Feitler/Ansel ten-year occupancy of the office made famous by Brodovitch seems remarkable in retrospect. In the early 1970's, a new editor arrived and seemed somewhat unnerved upon inheriting two dynamic young art directors who carried considerable clout. It became apparent that the situation was not feasible. Feitler's final issue was May 1972. She left to join Gloria Steinem in launching the new *Ms.* magazine. Ansel art directed *Bazaar* solo for five months, then departed after the October 1972 issue.

"In one sense, Feitler was always the original feminist," recalls her longtime associate Carl Barile, who worked with her at *Bazaar*, *Ms.*, *Rolling Stone*, and on the premiere issue of *Vanity Fair*, "but her decision to go to *Ms.* was made because she saw it as an opportunity to be creative and do innovative work." Her feminism was of the "treat everyone equally" school rather than the militant. And innovate, she did, with editorial designs as startling for the time as the articles appearing in *Ms.* Feitler used Day-Glo inks, established unique signature formats for various sections of *Ms.*, and mixed photography with illustration. Her typography could be expressionistic and uninhibited. She was willing to cross the line separating the tried and true from the risky and unproved. Many art directors are unwilling to cross this line until fad and fashion certify its acceptability, but Bea Feitler would reach across and return with a novelty face, a decorated letter, or a hopelessly eccentric form which happened to be just right for the message at hand. Conventional wisdom decrees that all-type magazine covers are newsstand disasters, but Feitler rattled marketing and outraged some with revisionist scripture on the all-type *Ms.* cover declaring "Peace on earth, good will to people" in pink and green Day-Glo. It sold out on the newsstands in December 1972. *Ms.* followed up with a neon-sign version in December 1973.

Her South American heritage influenced her design sensibility about color. She told assistants, "Trust me, listen to me, I know," while replacing their color selections with vibrant contrasting hues.

At *Ms.* Feitler made an indelible mark upon the face of American graphic design. Her deep interest in all of the arts was catalytic in expanding the magazine's scope to include cultural coverage. Perhaps she sensed that she was making history by graphically defining a movement and a cultural revolution. But she did not see *Ms.* and her graphics as the parochial product of strident feminism, she saw them as an all-people movement. Not disenfranchising males who traditionally dominated the culture, but enfranchising those who had been left out. Not only did she commission art and photography from image makers of reputation and renown, she also commissioned art from fine artists, housewives from Brooklyn who made art or crafts and took the subway over to show her their work, and yes from men. She made time for those who showed her their work, and pondered whether their unique and even modest gifts might somehow make a point or provide a counterpoint.

Feitler's assistants were inspired but never governed by her approach to design. She was generous in allowing them to design their assignments and develop their own approaches. She had good judgment and intuition about people. Once a photographer or assistant gained her trust, she would let them fly, helping them to recognize their great potential. Many young designers who worked with her went on to become prominent art directors in their own right, including: Carl Barile at *Avenue*; Charles Churchward at *Vanity Fair*;

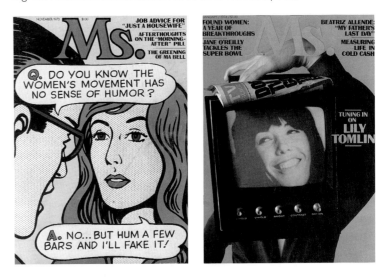

Paula Grief at *Mademoiselle*; and Barbara Richer at *Ms.* Her charming personality touched everyone who knew her, but she could also be very demanding. Her standards of design excellence were not negotiable.

Even while art directing major magazines, Feitler had book jacket, album cover, and book design projects under way. In 1974 Feitler left *Ms.* and worked on a variety of projects; Alvin Ailey's City Center dance posters and even costumes; record jackets including *Black and Blue* for The Rolling Stones; books; magazine designs and redesigns; and ad campaigns for Christian Dior, Diane von Furstenberg, Bill Haire, and Calvin Klein. Her book designs are superb examples of the genre, including *The Beatles, Cole, Diaghilev and the Ballets Russe, Lartigue's Diary of a Century, Vogue Book of Fashion Photography 1919–1979,* and Helmut Newton's *White Women.* In this area of design notorious for its flat-as-a-pancake fees, Bea Feitler asked for and received cover credit with the author and/or photographer and negotiated a royalty from the books she designed. The book designer, she reasoned,

Opposite/November 1973. Art Director: Bea Feitler; Illustration by Marie Severin. Copyright © 1973. Courtesy of *Ms.* Magazine, left./January 1974. Art Director: Bea Feitler; Photograph by Annie Leibovitz. Copyright © 1974. Courtesy of *Ms.* Magazine, right.

Counter-clockwise from below/March 1973. Art Director: Bea Feitler; Designer: Carl Barile. Copyright © 1973. Courtesy of *Ms.* Magazine. June 1973. Pages 46-47. Art Director: Bea Feitler. Copyright © 1973. Courtesy of *Ms.* Magazine. April 1973. Pages 78-79. Art Director: Bea Feitler. Copyright © 1973. Courtesy of *Ms.* Magazine. December 1972. Art Director: Bea Feitler. Copyright © 1972. Courtesy of *Ms.* Magazine.

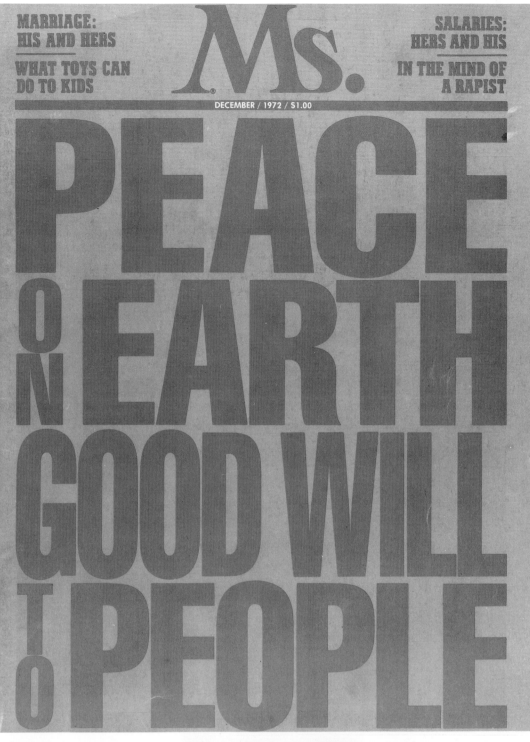

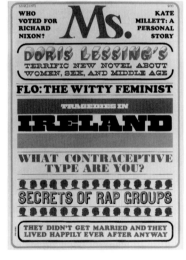

WINDOWS
MICHAEL EMORY

I GOT RHYTHM

THE GERSHWINS

PORGY AND BESS

RHAPSODY IN BLUE

helmut newton • white women

VOGUE
BOOK OF FASHION
PHOTOGRAPHY
1919-1979

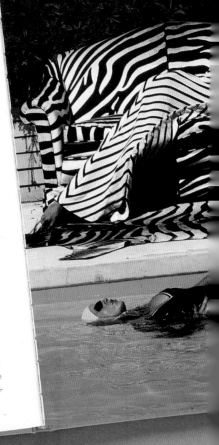

There's something very formal and contained about a pool—it's like photographing a landscape, a private lake, especially beautiful at night. In Europe, at least, a pool is a thing of luxury around which a lot of things happen. It's a place of mystery and meeting.…When I was young I was a champion swimmer and I return often to water in my photographs. I have always loved water and it's only when a girl is above water that one can make her appear to fly through the air or suspend her freely—in a lit pool at night or during the day in the bright sun. Most photographers don't like to shoot at midday because of the heavy shadows created by the sun overhead. But I love the midday sun, even in the desert, with the nose and eyelash shadows on the cheeks delineated by the hard noon light.

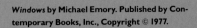

$5.95

Cheap CHIC

Hundreds of money saving hints to create your own great look
by Caterine Milinaire and Carol Troy

DIARY OF A CENTURY JACQUES

THE BEATLES

INTRODUCTION BY LEONARD BERNSTEIN/WITH JACKET ARTWORK BY ANDY WARHOL

Windows by Michael Emory. Published by Contemporary Books, Inc., Copyright © 1977.

The Gershwins by Robert Kimball and Alfred Simon. Published by Atheneum Publishers, Copyright © 1973.

Cole by Robert Kimball and John F. Wharton. Published by Holt, Rhinehart & Winston, Copyright © 1971.

Diary of A Century: Jacques Henri Lartigue. Translation by Carla van Splunteren. Published by The Viking Press, Inc., Copyright © 1970.

Cheap Chic by Caterine Milinaire and Carol Troy. Published by Crown Publishers Inc., Copyright © 1975.

The Beatles by Geoffery Stokes, "A Rolling Stone Press Book." Published by Times Books, Copyright © 1980.

White Women by Helmut Newton. Published by the Stonehill Publishing Company, Copyright © 1976.

Vogue: Book of Fashion Photography 1919-1979 by Polly Devlin. Published by the Condé Nast Publications, Ltd., Copyright © 1979.

Elvis by Dave Marsh, "A Rolling Stone Press Book." Published by Times Books, Copyright © 1982.

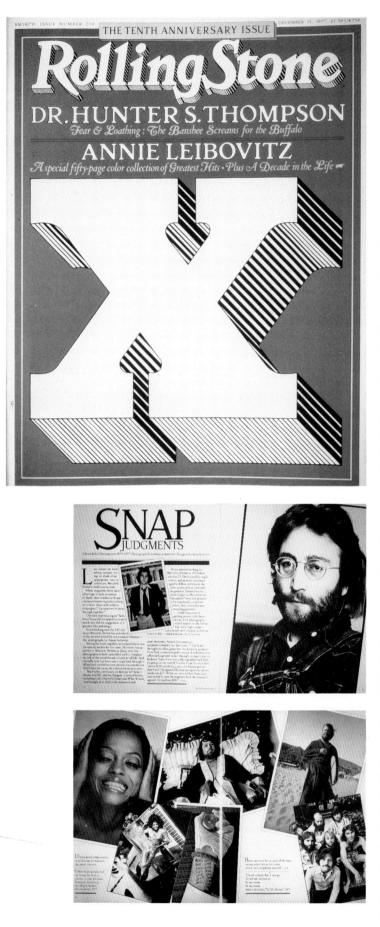

gives life and joy and form as surely as the author or picture-maker does and should share in the rewards if the book attracted readers. She believed, "Modern books should be 50–50 in terms of visuals and words. People have to be hit over the head and drawn into the book. There is so much visual material in today's world that people can't judge what is good and what is bad. It's up to the graphic designer to set standards."

From 1974 until 1980, Feitler taught advanced students at the School of Visual Arts where program head Richard Wilde remembers her as "one of the very best" teachers. Students fought to get into her class and she rarely denied entry, once commenting in an interview,"…what really turns me on is the 55 students in my Editorial Design course at the School of Visual Arts." After declining to teach one semester due to an overwhelming workload, she called Wilde and asked if she could be assigned a class for the next term. He asked if her workload had lightened. She replied that on the contrary, it had increased, but she needed the inspiration and contact with students which only teaching could provide. As an instructor she was uninhibited, and nothing rattled her. Her interest was in encouraging each student's personal direction. As one example, Wilde recalls that student Keith Haring's graffiti-inspired work had detractors, but Feitler was enthusiastic about its vigor and potential. She encouraged him to further develop his direction. She was a wonderful role model for female students studying design.

A six-year association with *Rolling Stone* began in 1975. Feitler redesigned its format twice: in 1977 for its tenth-anniversary issue featuring the stunning photographs of Annie Leibovitz; and again in 1981 when it shifted from a tabloid to the current magazine format. In 1978, Feitler signed on as a consulting art director for Condé Nast Publications and created the graphic image for a new publication, *Self*. Editor-in-Chief Phyllis Wilson credited much of *Self*'s distinctiveness to Feitler's experimental design approach and perceptive ability to work with photographs, "…seeing them and cropping them and moving them (until) you got something that would suddenly turn exciting…"

Her final project was the premiere issue of the revived *Vanity Fair*, which appeared after her death in 1982. She underwent surgery twice for a rare form of cancer. Her spirits were undaunted and many close associates at Condé Nast did not know she had been undergoing chemotherapy for several months. They thought her stylish turbans were a fashion statement. An associate took the mechanicals for the premiere issue of *Vanity Fair* to her apartment for her approval. After completing the issue, she went home to Brazil and did not live to see it published.

Bea Feitler only lived 44 years, but filled them with energy, enthusiasm, and a passion for life and design. Hundreds of people attended her memorial service, and as a living tribute her friends and family established the Bea Feitler Foundation which funds a full one-year scholarship for a junior graphic-design student at the School of Visual Arts. She believed a graphic designer's work matters because the culture is expanded and enriched by those who shape and form information. She is missed for the vision, passion, and vitality she brought to each day's life and work and remembered for her profound contribution.

December 15, 1977. Art Director: Bea Feitler. From *Rolling Stone* Magazine. Copyright © Straight Arrow Publishers, 1977./December 15, 1977. Pages 62-63. Art Director: Bea Feitler. Photographs by Annie Leibovitz. From *Rolling Stone* Magazine. Copyright © Straight Arrow Publishers, 1977./December 15, 1977. Pages 64-65. Art Director: Bea Feitler. Photographs by Annie Leibovitz. From *Rolling Stone* Magazine. Copyright © Straight Arrow Publishers, 1977.

December 1979. Art Director: Bea Feitler; Photograph by Bill King. Courtesy *Self*. Copyright © 1979 by the Condé Nast Publications Inc. July 1979. Pages 96-97. Art Director: Bea Feitler; Designer: Paula Grief; Photograph by Michael Geiger. Courtesy *Self*. Copyright © 1979 by the Condé Nast Publications Inc., right.

1982. Prototype for *Vanity Fair*. Art Director: Bea Feitler; Photograph by Duane Michals; Collage: Carl Barile. Courtesy *Vanity Fair*. Copyright © 1982 by the Condé Nast Publications Inc., below.

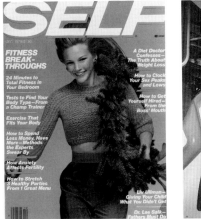

1982 $3.00

VANITY FAIR

Television

BY TONI TVCRITIC

Pbs: A British Empire

Khat more has the Manager of the rmance to say? To acknowledge the hess with which it has been received l the principal towns of England igh which the Show has passed, and e it has been most favourably noby the respected conductors of the public Press, and by the Nobility and Gentry. He is proud to think that his Puppets have given satisfaction to the very best company in this empire. . . .

And with this, and a profound bow to his patrons, the Manager retires, and the curtain rises.

There is a great quantity of eating and drinking, making love and jilting, laughing and the contrary; smoking, cheating, fighting, dancing, and fiddling; there are bullies pushing about, bucks ogling the women, knaves picking pockets, policemen on the look-out, quacks . . . bawling in front of their booths, and yokels looking up at the tinselled dancers and poor old rouged tumblers, while the light-fingered folk are operating upon their pockets behind. Yes, this is Vanity Fair. . . .

Some people consider fairs immoral altogether, and eschew such, with their servants and families: very likely they are right. But persons who think otherwise, and are of a lazy, or a benevolent, or a

lofty horse-riding, sor life, and some of very some love-making for and some light comic b accompanied by appro brilliantly illuminated own candles.

What more has the Manager of the Performance to say? To acknowledge the kindness with which it has been received in all the principal towns of England through which the Show has passed, and where it has been most favourably noticed by the respected conductors of the public Press, and by the Nobility and Gentry. He is proud to think that his Puppets have given satisfaction to the very best company in this empire. . . .

And with this, and a profound bow to his patrons, the Manager retires, and the curtain rises.

There is a great quantity of eating and drinking, making love and jilting, laughing and the contrary; smoking, cheating, fighting, dancing, and fiddling; there are bullies pushing about, bucks ogling the women, knaves picking pockets, policemen on the look-out, quacks . . . bawling in front of their booths, and yokels looking up at the tinselled dancers and poor old rouged tumblers, while the light-fingered folk are operating upon their pockets behind. Yes, this is Vanity Fair. . . .

Some people consider fairs immoral altogether, and eschew such, with their servants and families: very likely they are right. But persons who think otherwise, and are of a lazy, or a benevolent, or a

Toni Tvcritic is the author of *I Only Have Eyes for You: Television as the Romantic Other.*

Jeremy Irons, collage by Carl Barile, from a photograph by Duane Michals

Some people consider fairs immoral altogether, and eschew such, with their servants and families: very likely they are right. But persons who think otherwise, or a and are of a lazy, or a benevolent, or a sarcastic mood, may perhaps like to step in for half-an-hour, and look at the performances. There are scenes of all sorts; some dreadful combats, some grand and the women, knaves picking pockets, policemen on the look-out, quacks . . . bawling in front of their booths, and up at the tinselled dancld rouged tumblers, while ered folk are operating ckets behind. Yes, this is o say? To acknowledge the e consider fairs immoral aleschew such, with their milies: very likely they are right. But persons who think otherwise, or a and are of a lazy, or a benevolent, or a sarcastic mood, may perhaps like to step in for half-an-hour, and look at the performances. There are scenes of all sorts; some dreadful combats, some scenes of high lofty horse-riding, some scenes of high life, and some of very middling indeed; some love-making for the sentimental, and some light comic business; the whole accompanied by appropriate scenery and brilliantly illuminated with the Author's own candles.

What more has the Manager of the Performance to say? To acknowledge the kindness with which it has been received in all the principal towns of England through which the Show has passed, and where it has been most favourably noticed by the respected conductors of th public Press, and by the Nobility an Gentry. He is proud to think that Puppets have given satisfaction to very best company in this empire. . . .

And with this, and a profound bo his patrons, the Manager retires, an nces. There are scenes of all ere is a great quantity of eatin ing, making love and jilting, ld the contrary; smoking, ch ng, dancing, and fiddling ullies pushing about, buck omen, knaves picking poc licemen on the look-out, qu bawling in front of their bo yokels looking up at the tinse ers and poor old rouged tumb the light-fingered folk are upon their pockets behind.

Paul Davis:
A Master of Change

BY STEVEN HELLER

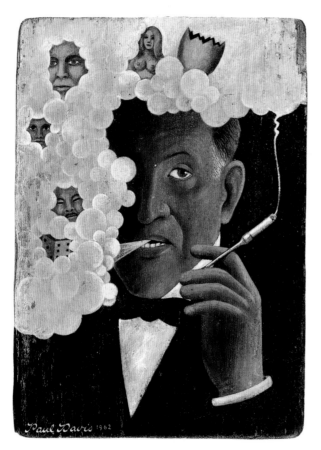

Portrait of Ian Fleming for *Show* Magazine, acrylic on wood, 1962, above. Portrait of Stevie Wonder for series in Rolling Stone Magazine, collage and acrylic on board, 1989, opposite.

The revolution was already in full swing when in the late 1950s a young artist named Paul Davis entered the fray. Some renegade illustrators and art directors had already begun to revolt against the saccharine realism and sentimental concepts prevalent in most American magazines and advertising. Among the vanguard artists were Robert Weaver, Bob Gill, Jack Beck, Robert Andrew Parker, Tom Allen, and Philip Hays, who advanced journalistic illustration; art directors Cipe Pineles, Leo Lionni, Otto Storch, and Henry Wolf gave outlet to these and other new realists; and Push Pin Studios which, in addition to reinvigorating historical styles, returned narrative and figurative illustration to the design equation after it had been deemed passé for many years.

Although Paul Davis was not among this first wave, he was swept up by it and soon contributed to the illustration and design of the epoch. By the early 1960s, he had developed a distinct visual persona which, owing to a unique confluence of primitive and folk arts, brought a fresh new American look to illustration. In a relatively short time he was among the most prolific of the new illustrators, and his style had a staggering impact on the field. Yet by the late 1960s, during a period of personal success, he was no longer content to simply repeat his triumphs. Davis enjoyed looking in new directions and indeed change and surprise have been his trademark. From the sixties to the present, he has contributed some paradigmatic approaches to the eclectic mix of American graphic art.

"I don't feel like I've ever thrown anything away," says Davis about these varied directions in illustration, book jacket and poster design that define a career of over thirty years. "One of the artists I admire most is Picasso because experimentation is one of his strengths. He neither felt the need to be consistent nor to reject one method simply because he found another...He said that 'some artists just turn out little cakes.' If I wanted to do that I would have become a baker—that's not why I became an artist. Style is a voice one chooses for its effect, and I want to be able to use as many voices as possible."

A decade ago Davis' voice was heard primarily through his illustration and posters. Today he is the principal of a small graphic design studio located in a downtown New York loft which he runs with his writer and editor wife, Myrna. He has garnered a diverse client roster and, in addition to editorial illustration, the occasional mural, the periodic book project, the print advertising account for a New York classical radio station, and frequent pro bono work for various advocacy groups, Davis serves as the art director for Joseph Papp's New York Shakespeare Festival, as well as for *Normal* and *Wigwag* magazines. It is as an art director that Davis shows new creative ferment.

Davis was born on February 10, 1938 in Centrahoma, Oklahoma. His father who was a Methodist minister was given assignments that took him to different towns, including Tulsa, Oklahoma, where Davis attended Will Rogers High School. He was always interested in drawing, so at fifteen he took a job with a local illustrator, Dave Santee, doing odd jobs around the studio. He left Tulsa for New York City when he graduated at seventeen. New York in the early fifties was the place where a young illustrator could either flourish or be stuck in the salt mines of the art

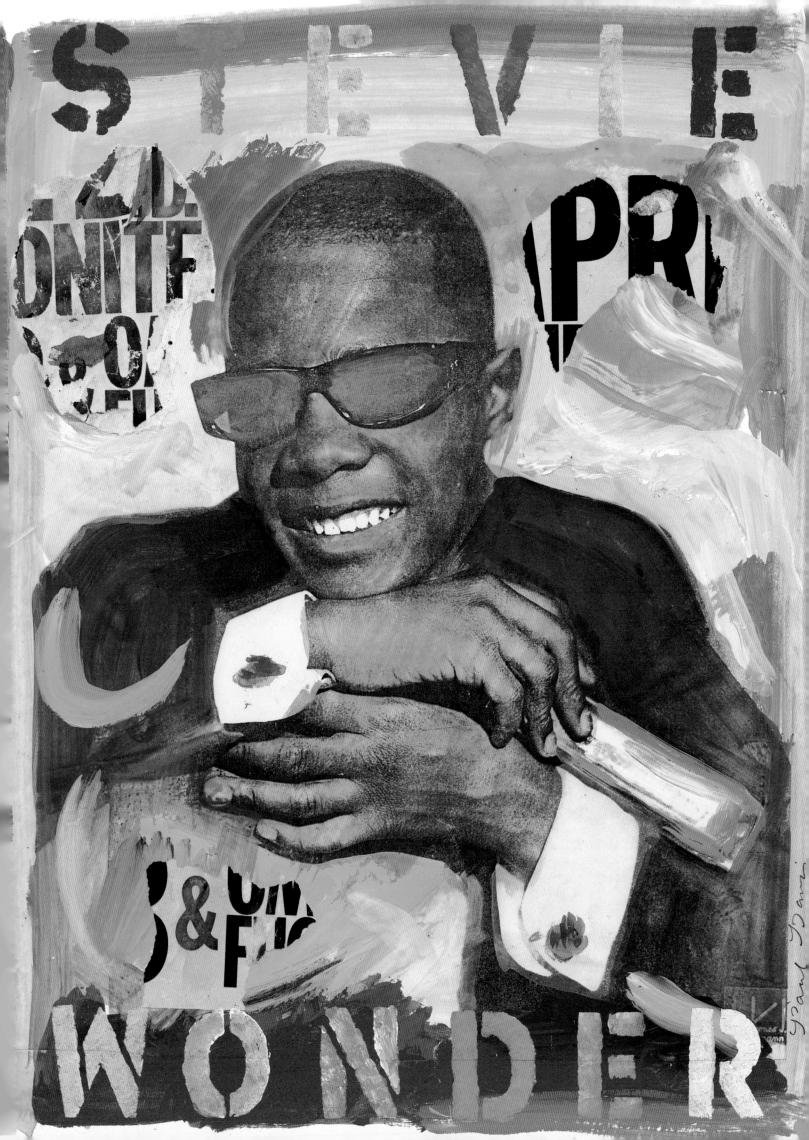

Paul Davis, above. Two student drawings, 1959; and target painting from series on wood for *The Push Pin Graphic*, 1962, opposite.

service agencies. Davis was lucky for at this time a revolution with a profound impact on the method and content of illustration was beginning at The Cartoonists and Illustrators School (later renamed The School of Visual Arts) where he attended both day and night classes. Robert Weaver, Phil Hays, George Tscherny, Sal Bue, Tom Allen, and Eugene Karlin offered classes in illustration and design that engaged the young Davis. "It was a turning point in American illustration," he says. "It was a rejection of Norman Rockwell, who was at his best a great Flemish painter and at his worst a bad cartoonist, as well as of the entrenched Westport style of romantic illustration."

Davis' high school art teacher, Hortense Bateholts, introduced him to the paintings of Georgia O'Keeffe and the Regionalists, Thomas Hart Benton and John Steuart Curry, he also had a grounding in Western art including work by Alexander Hogue and Charles Banks Wilson. Tulsa's Gilcrease Museum has an excellent collection of Western Art including many paintings by Russell, Remington, Bierstadt, and Catlin. Davis therefore became rather skilled at realistic rendering. Art school taught him how to see, feel, and expressionistically record his observations. But when the time came to make a commercial portfolio, Davis decided to set this knowledge aside and draw like a five-year old. "I became interested in artists like Joan Miro and Paul Klee and their child-like approach to painting," he says. His teachers responded with mixed reviews: Weaver was against it. Hays, Bue, and Tscherny approved, reasoning that it was a fascinating and necessary return to elemental form. At the end of the semester Hays arranged for Davis to have a small exhibition at the school. "Some students were upset that I was violating the rules of academic drawing," he recalls. "And Weaver, as he said years later, was disappointed that I did not become one of his imitators. He felt that I could have carried the torch—I consider that a huge compliment." Not only did Davis get some needed reinforcement from his teachers, but he also got an agent who landed him a freelance assignment with *Playboy.* A job from Art Paul, art director of *Playboy*, represented the epitome of professional success.

"As a student I got several freelance projects, and so I thought illustration was going to be really easy," recalls Davis. "Of course, it turned out that I was only able to get one job every three or four months—and for a meager $50 to $75 at that." Everyone who saw the portfolio liked Davis' work but would invariably refer him to other art directors. And since assignments were not forthcoming he took a freelance mechanical job at *Redbook* magazine. Sal Bue suggested that he present his work to Push Pin Studios. It was 1959, and Seymour Chwast and Milton Glaser had already become the "hottest designers in New York" for their graphic revivals and inventions. "I'm not certain why, but I had never thought of taking my portfolio there," says Davis about the first meeting. "In those days, you could sort of walk into someone's office unannounced, and they would actually see you. I remember showing my work to [Push Pin's agent] Jane Lander who called in Seymour and Milton. Though they apparently liked it, Milton said, 'You can never sell that stuff.' I said, 'What are you talking about? You sell stuff that's just as outrageous...' Anyway they didn't offer me a job. Three months later I was working

for *Redbook*, and Jane called to ask if I'd bring my portfolio around again. I assumed they might offer me an apprenticeship, but they didn't. When I was offered the job of assistant art director at *Good Housekeeping*, I called Push Pin to tell them that I'd prefer working for them, and Seymour said, 'Well, why don't you come in the next Monday?' That's how I finally got a job doing comps and mechanicals."

One couldn't have found a better place to work. Not only was Push Pin's star on the rise, but Glaser, Chwast, and co-founder Reynold Ruffins were terrific teachers of art history and technique. Among the many useful tricks of the trade, Davis learned how to render a kind of cross-

hatched "Push Pin drawing" using a speedball pen on thick watercolor paper. It was decorative and exactly what the clients wanted, particularly for spots, which is what Davis was assigned to do from time to time. "After a few months Milton said, 'We'd like to represent you.' You could have knocked me over," Davis recalls. "At twenty-two, I was made a bona-fide member of the studio." Push Pin represented many up-and-comers, later most notably James McMullan, and was well-known for its ambitious thematic self-promotional pieces (among them the early *Push Pin Almanack* followed by the *Push Pin Graphic*) which allowed Push Pin artists the freedom to make images and design. Davis and another new member, Isadore Seltzer, jointly illustrated an issue on how the Kings and Queens of England died. It was witty and smart. However, while many art directors liked Davis' work, few assignments resulted from this promotion piece. So he continued to do "utility" work at the studio as well as drawings for a children's book, spots for Chemical Bank, and designs for some book jackets (which was a fruitful proving ground for his poster style). "I continued to try to find a way to do work that was both gratifying and salable," says Davis.

Davis developed an interest in American primitive painting and folk art as well as in the faded wooden signs that defined 18th- and 19th-century American commerce. The fifties were a particularly nationalistic time, especially in the arts," he says about the search for a native culture that was occurring then. "People were talking about what is American. [Despite abstract expressionism,] Europe was still the acknowledged leader in the arts, and many people did not believe that Americans even had a culture. But in 1959 Jasper Johns showed his American flag paintings. It was unmistakably American. I also remember going to the

Whitney Museum annual exhibitions where Larry Rivers and Robert Rauschenberg were shocking people with their new American visions." Davis' interest, like these other proto-Pop artists, was in American indigenous art because "there was no school here, there was no academia."

From these influences, Davis developed a benchmark series of targets painted on old bread boards. They had the patina of the naive and were deliberately evocative of American folk art. These paintings were published in a special issue of the *Push Pin Graphic* in 1962. An eight-page feature of celebrity caricatures in *Horizon* magazine followed and suddenly brought Davis to the attention of some influential New York magazine and book art directors, including Bill Cadge of *Redbook* and Otto Storch of *McCall's*, who had built his magazine's typographic identity on Victorian woodtypes consistent with Davis' American theme. Regular appearances in other nationally distributed publications soon followed as did a plethora of book jackets and record covers.

Given the tenor of the times, it is logical that Davis became a sought-after illustrator. Through Push Pin's revivals of art nouveau and art deco, advertising agencies had been conditioned to accept nostalgia as an effective selling tool. But in the early 1960s, there was no other American illustrator drawing inspiration from regionalism, folk art, and colonial paintings (though it is now a cliche). "I was trying to distill their essence and not make my pictures eccentrically styled or distorted," says Davis about the introduction of an American-ness to illustration. But he soon combined this with the language of the Belgian surrealist painter, René Magritte, whose symbolic and metaphorical approach was virtually untapped by other commercial artists before Davis incorporated it into his own work. It was Glaser who informed Davis that he was unintentionally applying Magritte's vocabulary. "One day I was painting one of my folk paintings as Milton passed by. He said that it looked like a Magritte. I didn't really know much about him, but I quickly got very interested in a surrealistic approach as a way to convey ideas."

As much as he learned and as happy as he was at Push Pin Studios, Davis felt compelled to leave in 1963 owing to creative, but more importantly, financial reasons. "I was

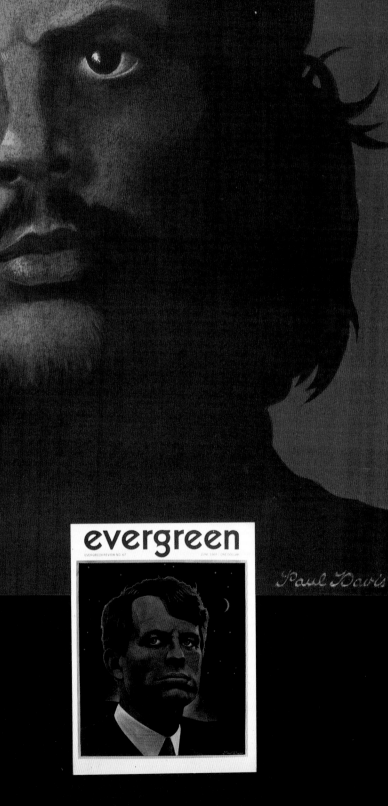

**Portrait of Che Guevara for *Evergreen Review*
magazine cover and poster, 1967. Inset, cover
portrait of Robert F. Kennedy, 1969.**

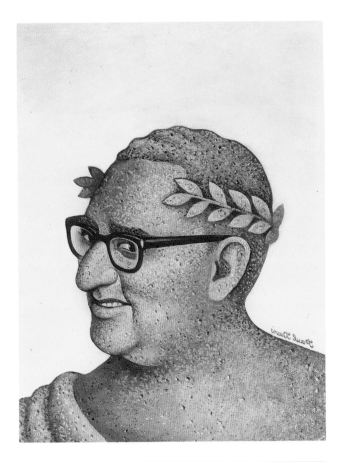

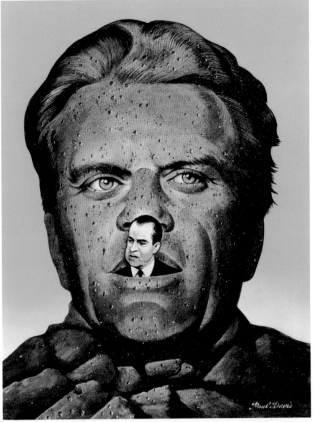

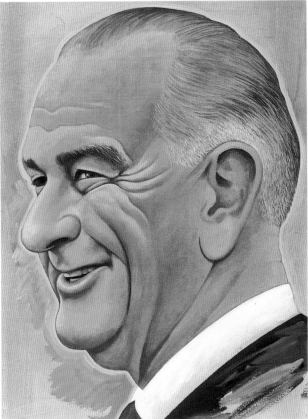

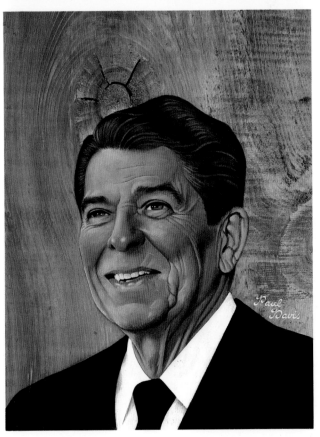

Cover portraits of Henry Kissinger, *New York*
Magazine, 1971, above; and Lyndon B. Johnson,
1981, unpublished.

Billy Graham with Richard Nixon, *New York*
Magazine, 1970, above; and Ronald Reagan,
1983, unpublished.

Two paintings from series for Olivetti Agenda, 1974, above. Poster for the New York Shakespeare Festival in a New York subway station, 1975, opposite. Photograph courtesy of Mike Schacht.

getting divorced [from his first wife]…and I really had to make some more money to support myself, my ex-wife, and child." Within months of leaving the fold he began doing a lot of work for Robert Benton at *Esquire* and Henry Wolf at *Show*. The freedoms he was given by Dick Gangel at *Sports Illustrated* and Frank Zachary at *Holiday* also allowed Davis to hone his conceptual skills over time.

One of Davis' stylistic evolutions occurred between the late sixties and early seventies, and manifested itself in, among other things, a cover (and poster) for *Evergreen Review* in 1967 and a daybook/calendar for Olivetti published in 1974. For the left-wing arts and politics journal *Evergreen*, Davis contributed iconographic portraits of Robert F. Kennedy and other sixties celebrities, but the most memorable was an almost religious depiction of Cuban revolutionary Ernesto Che Guevara, whose exploits in South America had become mythologized by the American New Left. In this image, Davis eschewed the Early American conceit for a synthesis of Italian religious art and socialist realism. "I was trying to make the image of a martyr," says Davis about this now famous artifact of the era. "I didn't realize the potency of the symbol at the time, but when the cover and later the poster appeared, *Evergreen*'s offices were firebombed [by Cuban emigres]." For the elegantly designed Olivetti daybook, Davis painted over a dozen images in which one can trace the rejection of certain technical conceits and see radical changes in perspective and composition from the stiffness and motionlessness of his primitives to a more photographic sensibility. "I tried to erase the traces of American primitive art because it was becoming a trap," he admits. "I wanted to rid my work of all the elements that referred to other styles. And within a year or two, I had eliminated a lot of self-consciousness from my work." With the most successful paintings in this book, and subsequent images too, Davis began to "depend more on the beauty of objects" and depict scenes rather than ideas.

Probably Davis' most significant contribution to American graphic design is his theater posters. His *Hamlet* and subsequent posters for Joseph Papp's New York Shakespeare Festival done during the mid-1970s challenged the conventions of contemporary theater advertising (particularly posters) in three ways: First, they were not encumbered by the usual bank of "ego" copy. "Those early posters didn't say anything: no Joe Papp; no Shakespeare Festival; no actors. I didn't even sign them at first (and only self-consciously used my initials when I first began to do so). The only lettering was the title of the play and the name of the theater, though we realized later that it wouldn't hurt to mention that this was, in fact, a Shakespeare Festival production and began to include a logo." Second, without mimicking style, Davis' posters referred to the late 19th-century European tradition of poster art which was ignored by the contemporary posterists. "I don't think there's anyone better than Toulouse Lautrec when it comes to posters," says Davis about Lautrec's distinctive balance between complexity and simplicity. Davis' early posters were also quite stark, employing a central image with simple type either stenciled or silkscreened directly on the artwork (as he did on *Hamlet* in collaboration with art direc-

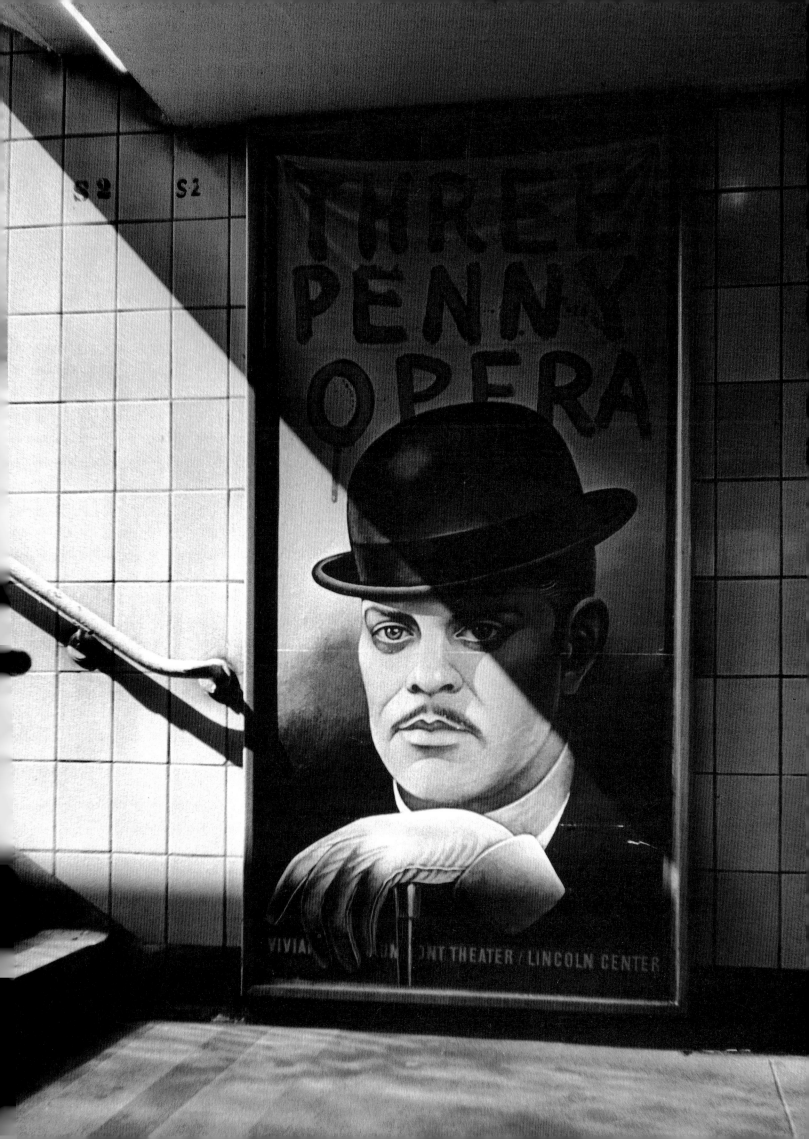

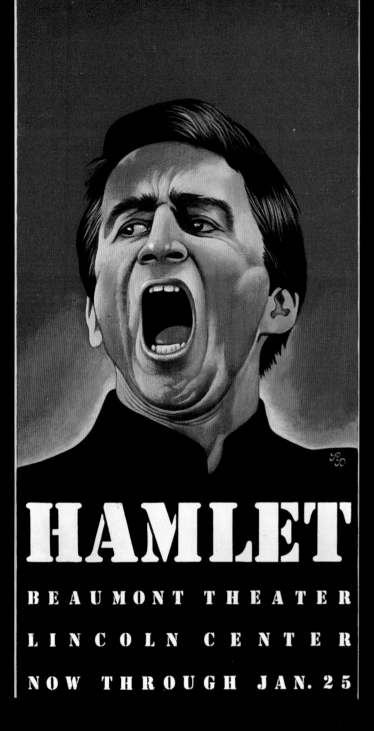

Poster for New York Shakespeare Festival production with Sam Waterston, 1975, left. Poster for New York Shakespeare Festival production with Irene Worth, 1977, right.

ASHES

PUBLIC THEATER

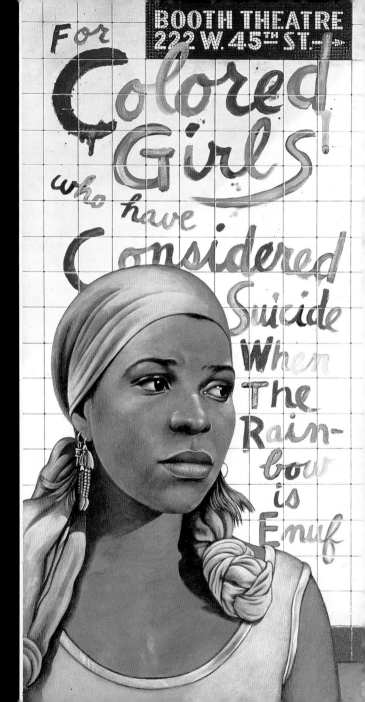

For Colored Girls who have Considered Suicide When The Rainbow is Enuf

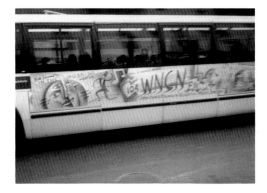

tor Reinhold Schwenk) or seamlessly integrated into the composition (as with the *Three Penny Opera*). "The history of The Shakespeare Festival posters says a lot about the way the posters are used," he says. "I have often made comments in the posters about the way posters look on walls and in the environment in which they are hung. Many of my posters for the Festival have had that self-conscious quality about being a poster." One of his classic examples, *For Colored Girls Who Have Considered Suicide When the Rainbow is Enuf*, shows the main figure with the title lettering scrawled on a tiled subway wall where, in fact, the poster was intended to be hung. The third, and final, challenge to conventional theater posters was his basic methodology. Davis read the play, went to the rehearsals or readings, and talked to the actors and directors. "They seemed to think," he says, "that I was doing this revolutionary thing by actually reading the scripts."

New York bus posters for radio station WNCN, above. 1989 poster and series of brochures for Joseph Papp's Festival Latino, opposite.

By the eighties, Davis had created a rather impressive body of posters, many reproduced in *The Poster Art of Paul Davis* (1977) and *Faces* (1985). Most of them were realistically and eloquently painted with acrylic. But, true to form, Davis was not content to limit himself to any one stylistic method. He had always been an expert draftsman and drew with ease. Many of his more recent posters are simple sketch-like drawings in colored pencil or pastel. He also enjoyed working with collage, which in recent years, has become one of his methods of choice. He says, "Leonardo Da Vinci advised artists to 'look at the stains on the walls.' Collage is a similar process of uncovering images and ideas." Davis also likes collage because the approach is counterpoint to painting. "One of the ways I make a painting is to photograph an object and then try to paint it as real as possible. In other words, I start with an image in my mind and then try to make it happen on the canvas, which can get very tedious towards the middle of the process. With collage I cut up some magazines and start sticking pictures into place, and then my imagination begins to work." But reality does have a strong place in Davis' repertoire, and he says, "Every so often I really enjoy making things faithful to the way they appear to me."

Consistent with his characteristic wanderlust, Davis always resists the status quo. Responding to a need to follow his muse, he moved his family to Sag Harbor, Long Island, in 1968 with the hope of devoting himself to painting. He accepted only a few commercial jobs from his agent

to pay the bills. The interlude did provide a modicum of freedom, but it had its downside, too. "Sometimes I think one of the best periods of my work was the worst period of my life in a way. I isolated myself and was not very social. Everyday life with its interruptions is much more interesting, but is not as conducive to painting. On the other hand, if you isolate yourself, you run out of things to say."

In 1984 Davis returned to New York City and opened Davis & Russek, a short-lived advertising agency, with the goal of creating considerably better theatrical ads and promotion than convention had previously allowed. Davis had already worked on campaigns for The New York Shakespeare Festival and The Big Apple Circus with his new partner Jim Russek, but found that doing it from the advertising side was not as interesting as being a designer/illustrator. The agency was dissolved, but Davis maintained a good creative relationship with Russek and their former clients.

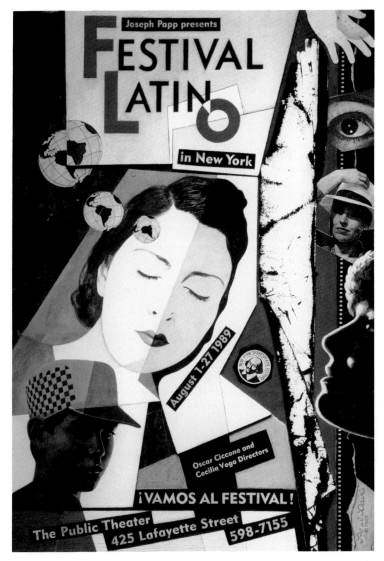

He also assumed the art directorship of the New York Shakespeare Festival, overseeing daily ads, posters, and Broadway theater marquees. As art director, Davis has had to muster all his skills and tools. He also got to exercise his typographic sensibility.

Given the needs of the Shakespeare Festival for what Davis calls a "critical mass" of printed material, one might have assumed that his hands were full enough when he was approached by editor Gini Alhadeff to design a new cultural magazine called *Normal*. Davis had never designed a magazine before, but he saw this as a good opportunity to follow another muse. In lieu of a strict format, he devised a strategy. Every story was to be independently designed so that the layout itself would illustrate the content of the piece. Each of the dozen or so stories was treated to a different typographical approach right down to the page numbers. The first two issues received mixed reviews, some saying that it looked too much like a student project, others praising it highly. Paul Gottlieb, the publisher of Harry N. Abrams, called it "the most beautiful magazine since *Verve*" [an elegant French revue of the arts published between 1937–60]. Davis was pleased with his baptism into publication design and the lessons it taught

him. "I work with young designers who are terrific with type and whom I encourage to have fun," says Davis with pride. "Sometimes I think I'm being very experimental, but I'm always concerned with legibility and communication. So while I try to shake things up, I'm probably not as experimental as others who are pushing the limits with approaches I haven't even dreamed of."

Davis is afforded considerable freedom owing to *Normal*'s sporadic schedule (only four issues in three and a half years) and refusal to carry advertising (each issue is intended to be underwritten by one or more sponsors). *Wigwag*, the next magazine he was asked to art direct has more conventional commercial ambitions, including a regular schedule of ten issues a year and advertising. *Wigwag* was conceived in 1988 as a literate, lively, alternative to the venerable *New Yorker*. Davis was asked to be its art director because its editor, Alexander Kaplen, was reminded that he liked Davis' work when he saw the bus and telephone booth posters that Davis had done for the New York classical radio station, WNCN. These colorful, collage-like drawings are rendered with colored pencil and effectively celebrate the youthful vitality of the radio station while emphasizing its classical orientation. "Lex is exceptional," says Davis. "Most people don't think about hiring a magazine art director based on his or her drawing ability." Indeed, art directors for the major magazines are often selected from the same *gene* pool—they've either designed highly visible publications or were the associates of those

PAUL DAVIS 1987

MYSTERY! presents
Dorothy L. Sayers'

LORD PETER WIMSEY

The gentleman detective and the lady sleuth

Starring
Edward Petherbridge
and Harriet Walter

Begins Saturday, October 3
9pm Channel 13 PBS
Host: Vincent Price

A ten-part series
in three stories

Strong Poison
Have His Carcase
Gaudy Night

Mobil

**Posters for television productions sponsored by
the Mobil Corporation, 1984–90.**

Front and back covers for *Normal* No. 1, a literary and arts magazine, left. Davis also art directed the first four issues, 1986–90. Some magazine cover portraits, below, 1965–1989.

Book jacket designs, 1986–1990; first of a series of covers for the New York 92nd Street Y catalog; cover for the first issue of *Wigwag* Magazine, October 1989, which Davis also art directs, and colophon; all opposite.

who have—and that is why most magazines today look alike. *Wigwag* wanted to be different in look and content. And Davis, still fresh in terms of magazine art direction, provides that character.

Davis has given *Wigwag* a more standardized format than *Normal*, but the identity is less to be found in the typography, than in the visual contents. "I function as an editor of illustration," says Davis. *Wigwag* is awash with drawings and illustration of all description and styles because Kaplen and Davis love illustration. Its covers are primarily illustrative, having been done by the old masters (among them Robert Weaver and Ivan Chermayeff) and newcomers alike. Inside most of the stories are illustrated with drawings, collages, or 3-dimensional pieces. Even the column headings are rendered by illustrators who combine "expressionistic lettering" and image. Concerning the abundant use of illustration over photography, Davis admits it is his bias, though photography is being introduced.

The June 1990 cover, in fact, features a young woman on a beach photographed by Davis himself. In answer to the question, "How do the readers like having their senses jarred by unusual graphic approaches?" He says, "I believe that people are much more sophisticated than most of us imagine. And one of the ways of finding our audience is by treating them as literate." Despite the fact that *Wigwag* is still too young to attract a loyal audience, Davis' art directorial strategy has pumped new life into the curiously tired field of illustration.

Davis' own illustration seems to have taken more turns in the past few years than during his whole career. The word "reinvention" comes to mind. The first inkling of this came in 1985 with his Mobil poster for *The Adventures of Sherlock Holmes.* Although the realistic painting of Holmes and Watson (modeled after photographs of the actors) is definitely Davis' signature, the typography is a mixture of Russian constructivism and art deco, unlike anything Davis had done before. Given that the Holmes tales are pre-European avant-garde, on the surface this seemed like an odd juxtaposition of forms. In fact, it was Davis in his experimental mode. His quotation of historical form is both

a means of learning about and playing with that form. "I did this when I first opened the studio. I had been getting to the point where I had been doing too much of the same. So I began to think about typography as being equal to the image. I looked more closely at El Lissitzky and other avant-gardists. In this case my assistant, Jose Conde, and I took their typographic forms and just started playing with them until we achieved a combination that was pleasing to our eyes.

But is this kind of appropriation too nostalgic? "I don't think so," answers Davis. "I was trying to *avoid* being nostalgic. Particularly because it was Sherlock Holmes, I was really trying to do something that was 1985 rather than 1890. What I saw in the juxtaposition of the image and type was not nostalgia, but power. It is really going back to the roots of graphic design. So I'd call it research and development."

"Some uses of history are both personal and practical," writes John Olive in the essay *The Use of the Past.* "...some knowledge of history...enables me to solace myself with the reflection that others before me tried to work while in pain, failed for a while, but in the end managed to finish the task at hand." Davis' process underscores this notion. For over thirty years he has used history for the goal of researching and developing his art. But despite the numerous routes taken, he says, "It seems to me that you always have to come back to being simple, essential and topical." That this has resulted in so many influential approaches is a tribute, not to what Paul Davis calls his wanderlust but to an unending aesthetic journey to find truth, discover form, develop ideas, and create distinctive art.

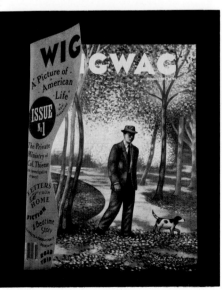

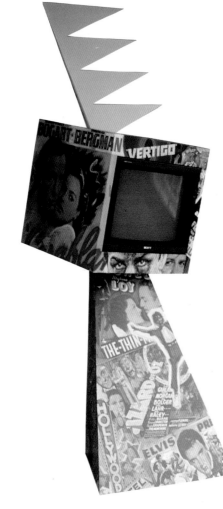

Computer drawing, 1989, above. Sculpture for
the American Museum of the Moving Image,
1988, left. Assemblage on wood, 1989, opposite.

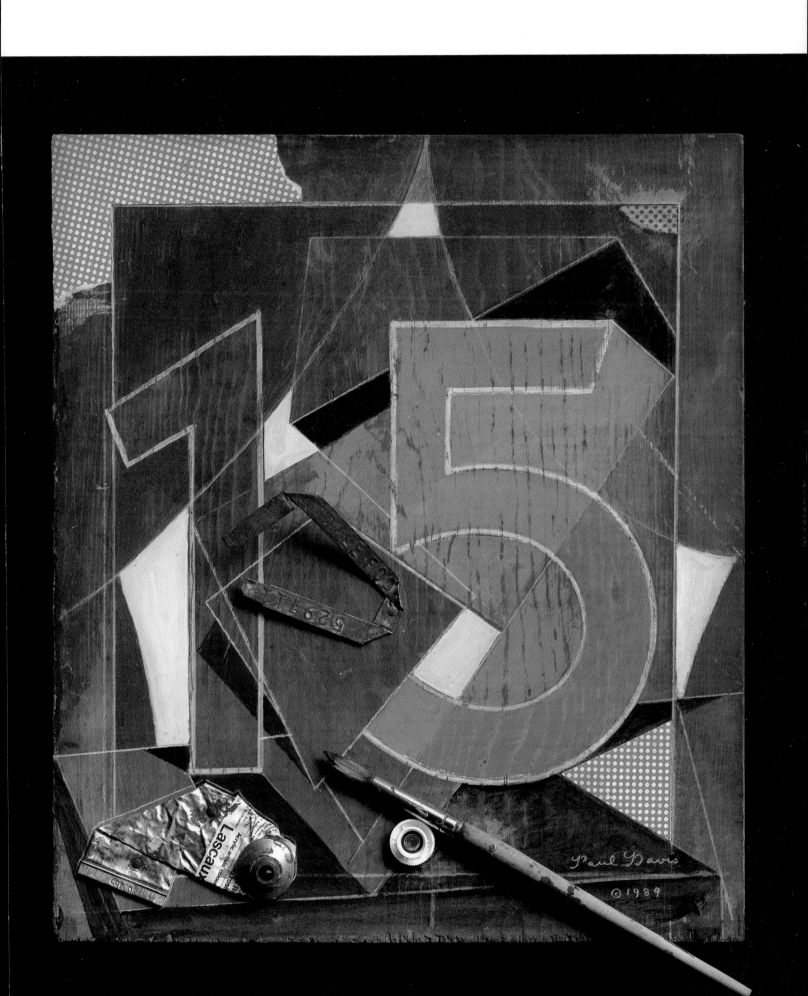

The Design Leadership Award of the American Institute of Graphic Arts has been established to recognize the role of the perceptive and forward-thinking organization which has been instrumental in the advancement of design by application of the highest standards, as a matter of policy. Recipients are chosen by an awards committee, subject to approval by the Board of Directors.

PAST RECIPIENTS

IBM Corporation, 1980
Massachusetts Institute of Technology, 1981
Container Corporation of America, 1982
Cummins Engine Company, Inc., 1983
Herman Miller, Inc., 1984
WGBH Educational Foundation, 1985
Esprit, 1986
Walker Art Center, 1987
The New York Times, 1988

Apple and Adobe:

Stills from the Chiat/Day agency's "Big Brother" television commercial introducing the first Macintosh computer during the January, 1984 Super Bowl.

BY CHUCK BYRNE

Changing the Technology of Design

It would be difficult for the most ardent of opponents to deny that after years of struggle, and for better or worse, the computer is finally taking a place in graphic design. Its introduction surely rivals in significance that of photography, off-set lithography, or even movable type. Two American companies, Apple Computer Inc. and Adobe Systems Inc., have more than any others advanced this revolution.

To mark the significance of this event the AIGA is, for the first time in the history of the Design Leadership Award, bestowing that honor on these two companies for technological achievements and contributions to the advancement of graphic design.

History is affected by developments isolated by character and time that converge in such a way as to forever alter the course of what follows. Gutenberg's development of movable type using molten lead poured into elaborately produced molds was made possible by his training as a goldsmith. This new technology merged with the by-then-centuries-old Chinese papermaking process, and propelled by Martin Luther's need to get The Word out, brought about a revolution in visual communications that we take for granted today.

Similarly, the adventure of the computer in graphic design is a story of technology and commerce in which many of the influences and participants are often not directly related to design. In the last decade the information and technology pertaining to computer graphics and visual ergonomics moved freely between individual researchers, public institutions, and manufacturers with breathtaking speed. Rather than being inventors in the classic sense, Apple and Adobe are not unlike Henry Ford's enterprise, which, while not inventing the automobile, provided the means for the average person to own one.

In the 1960s, graphic designers were using late 19th century hot metal typesetting technology with no inkling of the radical changes that were to follow in the next three decades. During the 1960s, the large type houses, common to the design, advertising, and publishing industry, began to be supplanted by smaller operations using phototypesetting machines that projected letterforms onto photographic paper. These machines were based on optical and electro-mechanical advancements brought on by the need for improved aerial photography during the second World War. Within a few years, even smaller type operations developed using digital computers whose origins are found in 18th and 19th century counting devices. These digital machines were able to generate letterforms from purely electronic information and transferred the image to photographic paper by various means.

Researchers and writers in the 1970s, such as Aaron Marcus, familiar with graphics, typesetting and printing, began to envision a time when designers would be able to use these new digital computers in their own studios for nearly all phases of their work. These dreams became reality as MIT's Visible Language Workshop provided the fertile ground for designer Nathan Felde and others to begin to actually develop graphic design-oriented computer workstations. For the first time, these machines provided, in real hardware, software and ease of use, what was specifically required for graphic designers to do "graphic design." The devices, which proved to be expensive for the average studio, were restricted to design activities and at

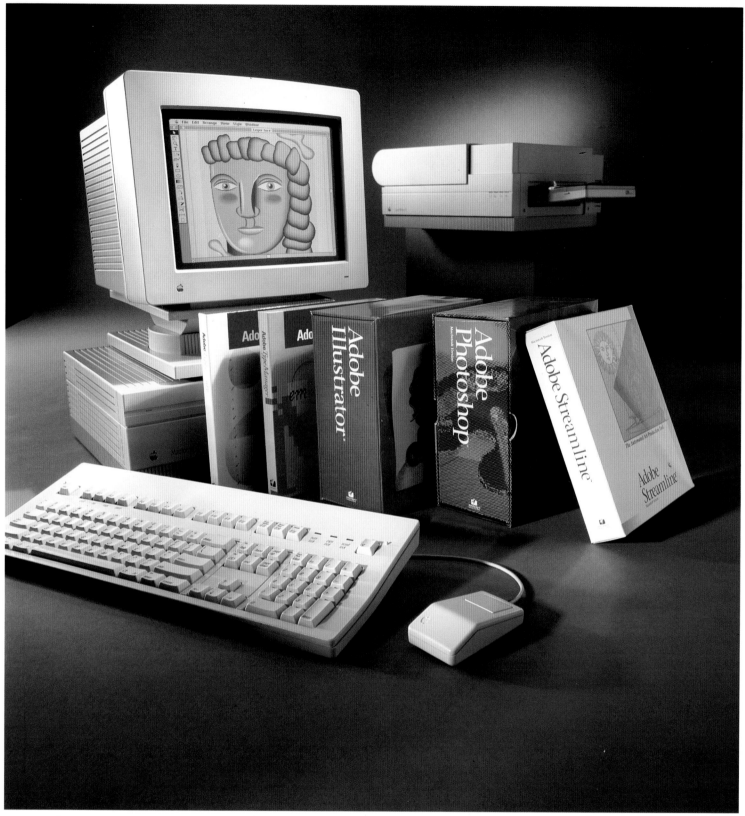

apple computer

Apple and Adobe products make it possible for designers to electronically perform the traditional work of graphic designers as well as explore new directions, above. Various incarnations of the Apple logo, left.

the same time limited in their ability to communicate with a wide variety of graphic arts output devices, all factors that proved to be critical to the acceptance of computers in graphic design. Nevertheless, they provided the paradigm for the electronic studio and the foundation for most of what was to follow.

A few software developers attempted to produce programs that would operate on newly introduced personal computers from IBM. While reasonably inexpensive, these solutions had severe limitations, one of which was that the machine required the designer to type in memorized commands, which many designers proved either unable or unwilling to do.

With no specific interest in solving the problems of graphic designers, the Apple Computer Inc. of Cupertino, California, introduced the Lisa computer in January 1983. Despite its $10,000 price tag, it did attract the interest of a few designers. The collateral material for this product, which was produced by Steve Tolleson and Mike Kunisaki at Mark Anderson Design in Palo Alto, California, presented concepts to the public that were to become the hallmark of the term "user friendly." Introduced were the computer mouse (devised by engineer Doug Englebart in the 1960s,) pull-down menus and visual icons, all developed for those millions of people who could neither type nor remember the complex commands that were needed to operate other computers.

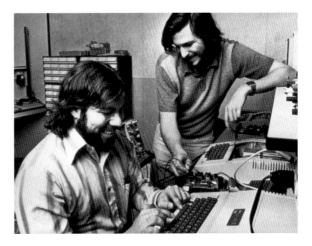

This "user interface," as it is referred to, was primarily a graphic design solution to the problem of how the average person interacts with a computer. It incorporated years of research by many organizations and individuals in addition to those at Apple. The outgrowth of this approach is in use every day by millions of people otherwise precluded from using computers. Its success distinguishes the graphic computer interface as one of the most important and successful pieces of graphic design in the latter half of the 20th century. This solution created what Apple copywriters would astutely call "the computer for the rest of us."

The guru for this revolutionary approach to the personal computer was Steve Jobs. He and Steve Wozniak met as teenagers and were involved with the "Homebrew Computer Club" of Palo Alto, California. With the proceeds from the sale of a VW van, and a programmable calculator, they started Apple Computer Inc. on April Fool's Day 1976. Three characteristics distinguished Jobs in the thick entrepreneurial atmosphere of the time in California's Silicon Valley: unusually good motivational skills, a belief that profits and good products were not mutually exclusive,

and an interest in good design.

Even before the public introduction of the Lisa, Jobs began to assemble a team to develop the first Macintosh computer. The group incorporated several of the individuals involved in the Lisa, including legendary programmer Bill Atkinson, who was instrumental in the development of the Lisa interface and had primary responsibility for the MacPaint and later HyperCard programs. At various times, graphic designers Tom Suiter, Clement Mok, Tom Hughes, Susan Kare, Christi Kriteman, John Casado, Tim Brennan, Thom Marchionna, Paul Pruneau, and even French illustrator Jean Michele Folon were involved in the Macintosh program either as staff or as consultants. Although individual designer's tasks dealt with either the interface look and feel or collateral graphic material for the machine, given the structure and free-spirited nature of Apple at the time, these lines of distinction were repeatedly blurred.

Hartmut Esslenger and Peter Muller, German founders of the Silicon Valley firm of frogdesign, had been charged with the industrial design of the new computer and the Chiat/Day Agency had been charged with planning the advertising campaign for a national introduction. So extensive was the product and market planning that even a new magazine, *MacWorld*, the first of many magazines devoted solely to the Macintosh, was being developed by art director Bruce Charonnat of PCW Publications and design consultant Marjorie Spiegelman.

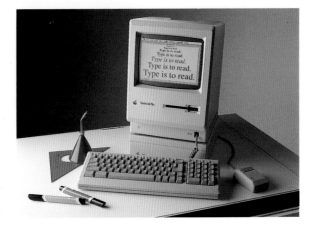

Screen showing typical **MS DOS** commands necessary to operate most personal computers prior to the introduction of the Lisa and Macintosh, left. Steve Wozniak and Steve Jobs founded Apple Computer, Inc. on April Fool's Day, 1976, top. The first Macintosh "Plus" found its way into design studios in spite of its slow speed and limited capabilities, above.

In January 1984, the $2,500 Macintosh was unveiled to the world in a television commercial broadcast during that year's Super Bowl. Graphic designers rushed to computer dealers to take a look, only to leave disappointed with what appeared to be little more than an "electronic Etch-a-Sketch." It was to be years before many designers, turned off by the outrageous statements of Apple salesmen who proclaimed that the new Mac would "do graphics" and "set type," would renew their interest in the computer. The output from the accompanying Apple dot-matrix printer, the ImageWriter, bore absolutely no resemblance to commercial typography.

Claims about type were based on Apple's delight with the idea of "WYSIWYG," an acronym for "What you see is what you get." The personal computer industry had for years been struggling with the problem of crude letters on a computer screen not resembling the equally crude, but different, letters produced by printers. On the Macintosh this had been resolved by using so-called screen fonts which the accompanying printer could reproduce accurately—including the jagged edges.

It was not until the following year that serious graphic design interest was aroused in the Macintosh by the introduction of the Apple LaserWriter. This dead-silent printer was a strong contrast to its noisy predecessor and partially justified its $7,000 price tag by permitting many computers to access it through an inexpensive network. But the most important aspect of the LaserWriter to graphic designers was the quality of the smooth type it displayed on its 8 1/2 by 11 inch page.

The LaserWriter contained two essential items that generated this radically improved type. A new "laser engine" manufactured by Canon in Japan and incorporated into the printer was able to generate a 300 dots-per-inch image on plain paper, much like a high-quality laser photocopier. Running the printer was an actual computer, referred to as a controller, which interpreted the information coming to it from a Macintosh and passed it along to the laser engine to produce the image. This controller, as well as the electronic type outlines it contained, used a new computer language called PostScript that had been developed by a young firm named after a small stream running through the Silicon Valley called Adobe Creek.

Adobe Systems had been formed in 1982 by John Warnock

and Charles Geschke. Both had worked on graphics software at the Xerox Corporation's Palo Alto Research Center, the legendary computer think tank where Steve Jobs had at one time been introduced to advancements in interface design. At Adobe, Warnock and Geschke continued with their efforts to develop a computer "page description language" rigorous enough to assemble type, illustration, and photography and at the same time pass the information along to a wide variety of output devices. Simultaneously, they developed a font technology which incorporated several important mathematical algorithms that Adobe engineers had formulated to produce reasonable quality type at low resolutions. All of these advancements took the form of the PostScript programming language.

Warnock and his associates had planned to use PostScript to link the components of a large, complete graphic arts workstation they hoped to build. However, at the end of 1983 Steve Jobs convinced them instead to market the PostScript technology to other manufacturers for incorporation into their equipment. Adobe agreed and subsequently began licensing both its font technology and controllers for printers, the first being Apple's new LaserWriter.

With this move, Adobe took a major step toward the creation of a universal standard for the exchange of graphic information between computer-operated devices.

Steve Jobs had felt that the Macintosh, coupled to the right output device, could make "everyman" a publisher, uninhibited by the cost of conventional typesetting and printing. But even taking into consideration the type problems, at the time of its first appearance the Mac was only able to accomplish this in the most rudimentary fashion.

In Seattle, Washington, Paul Brainerd, with a background in publishing, was one of the first to see the potential of combining Apple and Adobe's technologies in a way to make Job's concept work. He developed a new kind of software

Low resolution, "bit mapped," Garamond Regular type character as displayed on a Macintosh screen. Outline description of the Garamond character displayed on a Macintosh screen. PostScript language code sent from a Macintosh to an output printer to produce the type character. High-resolution, Linotronic printer output of the type character, above.

```
%!
/AGaramond-Regular
findfont
400 scalefont setfont
100 200 moveto
(A) show
```

to run on the Mac which did a reasonable job of typesetting and page make-up and could output sixteen complete pages to the LaserWriter at a time. Brainerd coined the phrase "Desktop Publishing" and his company, Aldus Corporation, produced "PageMaker," making it a reality. PageMaker and others, such as Ready Set Go and Quark XPress have become the principal page make-up tools to be used by graphic designers on the Macintosh.

The PostScript standard also offered the potential for graphic designers to gain access to professional typesetting output devices with higher resolution than a laser printer. In 1985, the same year PageMaker was introduced, the Linotype Corporation, founded in the late 19th century, began selling machines combining their existing electronic type output technology with Adobe-designed PostScript controllers. Almost overnight a new kind of operation, referred to as a "service bureau," began appearing. By 1986, these operations, using the less-than $100,000 Linotronic set-ups, could take a designer's Macintosh-generated PostScript information and, when everything went perfectly, provide output at a resolution of 1270 dots-per-inch on photographic paper to the customer for as little as ten dollars per page.

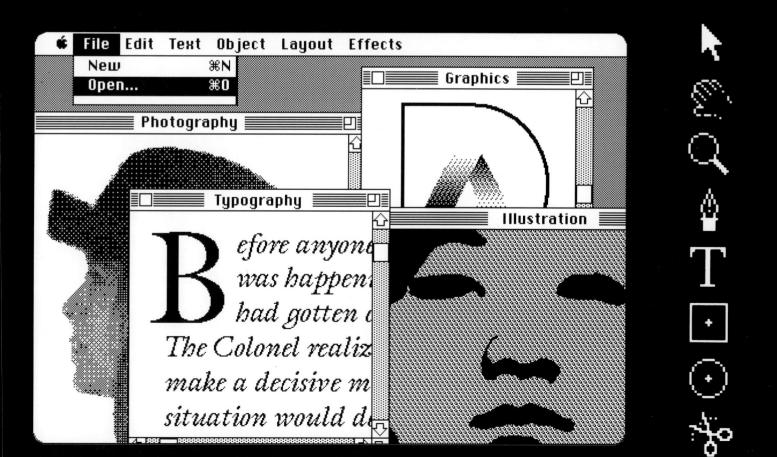

Macintosh is on the job.

Apple AEC Party

Apple Expo Center

Open me first.

Apple Computer, Inc.
1989 Annual Report

Macintosh.

A U C 89

Power UP

Power TRIP

Power UP

HOT LUNCH!

Cinco de Mayo Celebration

Music, Festivities, and Food
in the Spirit of Mexico
Thursday — In All Cafeterias
11 A.M. TO 2 PM

Apple Food and Catering

The human mind works by association.

So why don't computers?

Martini glass, used for Apple Expo Center invitation. Creative team: Carl Stone, Mark Drury.
Macintosh is on the job. Giveaway promotion piece from Apple Expo Center. Art director: Mark Drury.
Open Me First, product guide book. Art Director: Peter Allen.

1989 Apple Annual. Art Director: Andy Dreyfus. Production Art: Patty Taylor. Production: Linda Moyer.
Copy: Steve Hayden.
Original Macintosh product packaging. Art Directors: Clement Mok, Tom Suiter.
1989 Apple University Consortium banners. Art Director: Mark Drury.

1989 Apple USA sales conference kit. Creative team: Mark Drury, Peter Allen, Andy Dreyfus, Liz Sutton.
Poster for in-house celebration at Cinco de Mayo. Art Director: Steve Sieler. Copy: Keith Yamashita.
Illustrator: Jose Ortega.
Hypercard brochure. Creative Directors: Hugh Dubberly, Thom Marchionna, Clement Mok.

YOU CAN DREAM IN COLOR WITH ADOBE PHOTOSHOP

POSTSCRIPT SOFTWARE FROM ADOBE

ADOBE ILLUSTRATOR FROM LINE ART TO FINE ART

GOOD

EVIL

1989 Annual Report for Adobe Systems Incorporated. Adobe Photoshop was used to create the illustrations. Art Director: Luanne Cohen. Designer: Karla Wong. Illustrator: Michael Cronan.

Playing cards, used as a promotional item at the Seybold trade show in Las Vegas, 1988. Art Director: Russell Brown. Designers: Russell Brown, Paul Woods, Gail Blumberg, Joss Bratt-Parsey, Ruth Kadar.
Colophon 6, an end-user newsletter produced at Adobe, 1989. Art Director: Russell Brown. Designer: Laurie Szujewska.
Poster, promotional piece for Adobe Photoshop, 1990. Art Director: Karen Ann. Illustrators: Karen Ann, Russell Brown, Donald C. Craig, Steve Guttman, Chris Krueger.

T-shirt with advertising illustration for PostScript, Adobe's page description language, 1989. Art Director: Dianne Tapscott. Designer: Kim Brown. Illustrator: J. Otto Seybold.
Poster with advertising illustration for Adobe Streamline, 1989. Art Director: Russel Brown. Illustrator: Charles Spencer Anderson.
Dealer postcard promoting Adobe Illustrator 88, 1988. Art Director: Luanne Cohen. Illustrator: Max Seabaugh.

Fan, used as a promotional item at the MacWorld tradeshow in Boston, 1989. Designer: Donald C. Craig.

STONE
STONE
STONE
STONE
STONE

From this point on packages of economical desktop publishing software and type fonts combined with comparatively inexpensive hardware, all purchased at a local computer store, could be used to create layouts, including type and graphics, which could be proofed on a laser printer and then output at the local service bureau. This remarkable and historic feat could be accomplished by anyone—designer or dilettante.

While professionals without Macs recoiled in horror at the implications of "desktop pollution" giving "everyman" the means to do his own layouts and typesetting, those designers with Macs hailed Linotype and Aldus for providing the means to exploit the true potential of the Macintosh and PostScript. Ironically, within the graphic design world desktop publishing was being viewed concurrently as threat and salvation.

Adobe had an appreciation of the needs of the design profession and the printing industry from the beginning. Warnock's wife, Marva, was a graphic designer, and Geschke's father had been a photoengraver and printer. In January 1987, Adobe brought onto the market an inexpensive, easy-to-use PostScript software drawing program called "Adobe Illustrator." Until this time it had been necessary to keyboard the complex PostScript language in order for it to generate drawings. When combined with high resolution output from a Linotronic printer, Illustrator generated line work and shapes of extraordinary professional quality. The introduction of Illustrator marked the first time that a piece of desktop publishing software was capable of clearly out-performing the comparable conventional graphic arts process.

While the marketing strategists at Adobe had seen the product as a tool to replace mechanical pens in drawings by editorial illustrators, it instead proved an instant success with graphic designers for creating logos and graphic symbols, manipulating type, and making technical drawings. Illustrator and its counterpart from Aldus, FreeHand, have in fact become the major tools used to execute this type of work.

Apple also introduced the Macintosh II in 1987. This first color Mac signaled a major shift in outlook, not only at Apple but in the design, pre-press, and printing world, of what the machine could potentially do. It had been developed under the direction of former Pepsi-Cola president John Sculley, who had become Apple's CEO in 1983. The "open architecture" of the Mac II meant that it could be internally reconfigured, or upgraded, to suit the specific needs of the user. Properly equipped, the new Mac could offer many of the capabilities of the large graphics workstation, while still maintaining the Macintosh characteristics designers had begun to take for granted. Although representing substantial investments, the Macintosh II and its descendants have become the standard computer platform for graphic design.

In the years since the introduction of these revolutionary products, Apple and Adobe continue to produce high-quality, dependable products that fit the needs of graphic designers. They also continue working with outstanding staff designers and consultants to produce promotional and educational materials that make clear the often complex, confusing information in ways that both the public and the profession find useful and intriguing.

It had been clear with the introduction of the LaserWriter that to succeed, the fledgling industry of desktop publishing needed a steady supply of high-quality type fonts prepared in PostScript form. In the summer of 1984, Sumner Stone was asked to head a department at Adobe that would engage in translating existing faces into PostScript, as well as to develop entirely new faces. With the help of type designers Cleo Huggins, Carol Twombley, Robert Slimbach, Dan Mills, and others, Stone was able to put more than 500 faces into PostScript form before he left Adobe at the end of 1989.

To develop promotional materials that demonstrated the capacity and personality of Adobe products, then director of marketing Liz Bond in 1985 hired Russell Brown, a designer with a strong interest in computers. Brown ultimately was to head a staff that included among others Luanne Seymour Cohen, and Gail Blumberg.

Adobe used its designers for far more than simply preparing collateral material. Staff designers had, from their first appearance, been encouraged to fully participate in the evolution of this unique company's products. The success of the company in the graphics marketplace reflects this enlightened attitude.

Apple, with occasional help from Bay Area design firms such as Clement Mok Design, relies primarily on its staff of outstanding young designers led by Roger Sliker for the production of materials that help Apple customers better understand and enjoy their computers.

At the same time, the company underwrites investigations that explore the boundaries of traditional graphic design, such as the exciting Hypermedia work of Hugh Dubberly, and Doris Mitch.

In the computer world, Hyper refers to unlimited avenues of accessing or manipulating a body of information. In Hypermedia the computer is the actual media. The user or viewer controls the sequence and speed, as well as interacts with text, illustrations, animations, sound, and still and moving video. This control by the user means that the designer has to plan not knowing the order in which events will occur. This non-linear quality in all probability represents a structural change to the formal aspect of graphic design.

With every exciting possibility the computer offers design, it comes with an equally potent stipulation.

For many sectors of the design business, the ability to set type and produce mechanical art using PostScript and Macintosh offers an important means to stay competitive in a world obsessed with cost savings. The computer appears to have freed many from some of the creative confinement associated with restrictive budgets. It does this by economically permitting as many variations and refinements to be examined as the user is capable of determining. At the same time, it offers vast capabilities to perform almost unlimited illustrative, photographic, and typographic experimentation. But these powers can just as easily stun the imagination as excite it. The instrument's karma is to contribute possibilities—it is incapable of making aesthetic decisions. Good designers are still required to do good design.

The creative freedom offered by the computer may have lured graphic design from one economic prison to another. The evolving desktop publishing technology has meant computer usage costs a fraction of what it did less than a decade ago. But to a profession where often a T-square, triangle, and kitchen table suffice as a studio, even this comparatively small technology investment is formidable.

Art schools, which for the last few decades survived by offering popular and profitable graphic design courses, as well as publicly supported institutions, are confronted with the brutal reality of having to invest hundreds of thousands of dollars in computer equipment if they are to continue to attract and properly train increasingly discerning and demanding design students.

Heads of established design firms are getting to know their local bankers and learning the real meaning of "capital intensive" as the pressure to acquire more and newer equipment grows. Younger designers are staying with larger firms longer, precluded from striking out on their own by the need for substantial capital, where before only a little was needed.

Some aspects of the typesetting and the art production process refuse to be compressed. Early predictions that client-keyboarded text would eliminate typos and changes failed to take into account that mistakes and alterations are a natural byproduct of translating words into type. Most designers using the new technology have had to face the simple reality that producing high-quality typography and mechanicals is as much a matter of the skills of the person operating the machine as the capabilities of the machine.

But the production aspects of the machine are resolving themselves as procedures and software are refined. The typographer and the production artist, both of whom it appeared would disappear from the face of the earth, are finding life much as it was before, only now it's in front of a Macintosh. The unaccustomed and formidable financial burdens caused by the new technology appear to be simply becoming the cost of doing design.

Through the comparatively economical and usable Macintosh computer and the functional PostScript programming language and its ability to communicate to a broad spectrum of output devices, Apple and Adobe have provided the means for change in graphic design.

Historically, the first pursuit of a new media technology is to imitate what immediately preceded it, and the computer in graphic design clearly is no exception. Every effort is made to cause software to produce design the way it was produced before and to make the visual outcome look exactly as it did before.

While a new media technology is the steward of what preceded, it soon becomes the agent of change. We are about to experience one of those truly exciting periods where the transition occurs: Inquisitiveness will reveal the unique visual personality, and insight will foster the aesthetic potential of the computer for graphic design. History will judge the results.

Computer based Hypermedia requires that the designer plan text, graphics, video and sound information that the viewer can use in new non-sequential, interactive ways.

COMMUNI

Jury
Pat Samata, Chair, Partner, Samata Associates, Dundee, IL
Robert Appleton, President, Appleton Design, Hartford, CT
Leslie Avchen, Principal, Avchen & Jacobi, Minneapolis, MN
Jeff Barnes, Principal, Barnes Design Office, Chicago, IL
Ray Honda, Designer, Primo Angeli, Inc., San Francisco, CA
Michael Manwaring, Principal, Office of Michael Manwaring,
San Francisco, CA
Woody Pirtle, Partner, Pentagram Design, New York, NY
Valerie Richardson, Principal and Creative Director, Richardson
or Richardson, Phoenix, AZ
Nancy Skolos, President, Skolos, Wedell and Raynor, Boston, MA
Tyler Smith, Art Director, Providence, RI
Ron Sullivan, Partner, Sullivan Perkins, Dallas, TX
Lucille Tenazas, Principal, Tenazas Design, San Francisco, CA
John Van Dyke, Principal, Van Dyke Company, Seattle, WA

Call for Entries
Pat and Greg Samata, Design
IPP LithoColor, Chicago, IL, Engraving
George Rice and Sons, Los Angeles, CA, Printer
Typographic Resource Limited, Chicago, IL, Typography
Astrolite 70# Smooth Text, Manadnock Paper Mills, Inc., Paper
Bob Tolchin, Photographer
Evan Wilder Samata, Model

A simple statement. An obvious concept. The birth of an idea.

This was the theme of the call for entry of the AIGA

Communication Graphics Show 1989–90 which was inspired

by the birth of my son this past year.

Although the judges represented a diverse scope of back-

grounds and disciplines, they each seemed to have similar

criteria in mind when judging this show. On the second day

of judging, I realized a pattern had been set and that there

was an overall look to the show. The final selections had depth

and thought; continuity and simplicity. The formula solutions

were quickly discarded as were the designs that were purely

ornamental. Sound ideas won out over applied technique.

The judges were dedicated in selecting entries. I thank them

and the AIGA staff for their generous contribution of time

and insistence on excellence.

—Pat Samata, Chair, Communication Graphics

a **Agouron Pharmaceuticals Inc. 1989,** Annual Report
 Rik Besser, Douglas Joseph, Art Directors
 Rik Besser, Designer
 Jeff Zaruba, Photographer
 Besser Joseph Partners, Santa Monica, CA, Design Firm
 Agouron Pharmaceuticals Inc., Client
 Composition Type, Typographer
 George Rice & Sons, Printer

b **The L.J. Skaggs and Mary C. Skaggs Foundation,** 1988 Annual Report
 Michael Vanderbyl, Art Director
 Various, Illustrators/Photographers
 Vanderbyl Design, San Francisco, CA, Design Firm
 The L.J. Skaggs and Mary C. Skaggs Foundation, Client
 Andresen Typography, Typographer
 George Rice & Sons, Printer

c **Eloquence/Virtuosity,** Promotional Booklet
Kevin B. Keuster, Art Director
Bob Goebel, Designer
John Wong, Greg Booth & Associates, Photographer
Madsen & Kuester, Minneapolis, MN, Design Firm
Potlatch Corporation, Client
Dahl & Curry, Typographer
Woods Lithographics, Printer

a **TGI Friday's Inc.,** 1988 Annual Report
 Richard Gavos, Arthur Simmons, Art Directors
 Richard Gavos, Designer
 Jim Olvera, Photographer
 TGI Friday's Inc., Client
 HarrisonSimmons, Inc., Design Firm
 Southwestern Typographics, Typographer
 Williamson Printing, Printer

REMEMBER THE LITTLE GUY WITH THE CAP AND HIS MOTORCYCLE LOOKING VEHICLE DELIVERING A LETTER. THE GUY ON THE "SPECIAL DELIVERY" STAMP SEVERAL LIVES AGO? THE SAME guy, a bit larger and in full motion, came by my home every Sunday afternoon. My mom would receive a letter from her sister who lived in Indiana. My mom and her sis were extremely close and wrote long letters to each other. It was a Sunday ritual, along with roast beef, lemon icebox pie, Drew Pearson, and The Colgate Comedy Hour.

Predictably there was always a newspaper clipping in the letter: an award, a business venture going great, or going bust. A wedding, another birth, and sometimes a clipping that brought sad news, but strengthened the ties between two sisters who dearly loved each other and were separated by fourteen years and hundreds of miles. The letters, clippings and the occasional snapshot were a glue that kept their bond for many years.

The keeping of articles represents a need to hold, keep and carefully maintain our memories in the attic of our soul. Those clippings, snipped, saved, yellowed reminders, are so vital in sustaining our everyday sense of being and seeing. Tomorrow will bring another event that will be cherished, and neatly pressed for posterity. And celebrated forever.

SPECIAL DAY AT THE HAWKINS HOME

MEMBERS OF THREE GENERATIONS OF THE HAWKINS FAMILY were present on Sunday to welcome home the newest member, Daniel Allen Hawkins, born December 27th. Proud parents are Mr. and Mrs. Nelson Hawkins. Mrs. Hawkins is the former Miss Betty McCrary of Dothan, Alabama. Pictured above are (left to right) grandfather Charles Hawkins, great grandfather Allen L. Hawkins (holding Daniel Allen) and happy new father Nelson Hawkins.

1989 ANNUAL REPORT

b

I THINK THERE IS MORE DEODORANT SOLD DURING THE PROM SEASON THAN ANY OTHER TIME OF THE YEAR. WHY ARE PROMS SO WILLY-NILLY, NERVOUS-NELLY? IN A CERTAIN SENSE THEY ARE A SOCIAL RIGHT OF PASSAGE DURING THE LAST crucial years of high school. True celebration. The smelly gymnasium transformed into a magical wonderland. Dogwoods entwined with flowing crepe paper (school colors of red and gray which I always loathed, why didn't I get royal blue and gold?) those colors were all over the ceiling. And, we were the first generation with the right band (the most vital ingredient next to your date) to go with our new found music. The earliest of early Rhythm and Blues—now eighties' labeled "golden-oldies." DooWop. BeBop. DooWeeDooWah.

The guys looked so uncomfortable dressed in coats and ties, but so handsome too. The girls radiant with their hair up, perfume on, eyes sparkling. With rows and rows of crinoline, we couldn't get close to dance. Soft shoulders and wilting corsages. And the evening didn't want to stop. Later we forget about those proms, but by doing so, we can rediscover them and remember. And laugh.

And laugh and cut up we did at all the after-prom parties and cook-outs. Pearl Bartlett carried on an ongoing tradition. (She really was a direct descendant of the pear people.) Every year after senior prom, she held her famous feasts. They were at her house and, aptly named "Pearl's Porky Party." Really.

The spread was a BBQ blowout with baked hams, pork chops, ribs, so much slaw, potato salad, deviled eggs, baked beans and iced tea by the gallons.

Like birthdays, like anniversaries, like Thanksgiving and Christmas, we should scratch brief "ten-year" reunions, and relive our prom every year, and go back to Pearl's parlor, and celebrate life and love, and the wilting dogwoods.

Junior-Senior Prom Held At East High

LAST EVENING THE JUNIOR CLASS OF EAST HIGH SCHOOL entertained at the annual Junior-Senior Prom given in honor of the members of the Senior Class. The highlight of the evening was the crowning of Miss Marian Morris (pictured above with escort Charles Finney) as prom queen.

PEARL'S BAKED HAM

b **Cracker Barrel Old Country Store,** 1989 Annual Report
Thomas Ryan, Art Director
Cathy Wayland, Designer
McGuire, Photographer
Cathy Wayland, Hand Tinting
Thomas Ryan Design, Nashville, TN, Design Firm
Corporate Communications, Agency
Cracker Barrel Old Country Store, Client
Allan Waller & Associates, Typographer
Jones Printing Co., Printer

a

MARK JACKSON CHRIS MULLIN

b

a **Wings,** Poster
 Ron Dumas, Art Director
 Ann Schwiebinger, Designer
 Gary Nolton, Photographer
 Nike Design, Portland, OR, Design Firm

b **Flight and Force,** Poster Series
 Ron Dumas, Art Director
 Ron Dumas, Michael Tiedy, Designers
 Lee Crum, Photographer
 Nike Design, Portland, OR, Design Firm
 Nike, Inc., Client

No bird soars too high,
soars with his own wings.
—William Blake

David Robinson

Ron Harper

a

b

c

a **"The Z Car"**, Delivery Vehicle Signage
Mark Anderson, Art Director
Earl Gee, Designer
Earl Gee, Illustrator
Mark Anderson Design, San Francisco, CA, Design Firm
Z Typography, Client
Z Typography, Typographer
Mark Anderson, Art Director

b **Jacobson Glasair III,** Airplane Graphics
Susan Karasic, Art Director/Designer
Lorna Moy-Masaki, Designer
S K F Design Group, Los Angeles, CA, Design Firm
Marty Jacobson, Client

c **Helix and Wave Wall,** Exhibit and Environmental Design
Graham Hughes, Design Director
Marco Comoglio, Chris Herringer, Graham Walker, Project Designers
Keith Panel Products, Ltd., Letter Art Neon Ltd., Panorama Drywall Ltd, Fabricators
Peter Timmermans, Photographer
Karo Design Resources, Vancouver; BC, CAN, Design Firm
Science World; BC, CAN, Client

d **Blue Sky Research: Textures,** Poster
Robin Rickabaugh, Heidi Rickabaugh, Art Directors
Paul Mort, Robin Rickabaugh, Don Rood, Designers
Paul Mort, Barry Smith, Illustrators
Principia Graphica, Portland, OR, Design Firm
Blue Sky Research, Client
Principia Graphica, Typographer
Dynagraphics, Printer

a

a

b

a **The Louvre Museum, Visitor Information System and**
Sign Program, Signage
Ken Carbone, John Plunkett, Art Directors
Ken Carbone, John Plunkett, Barbara Kuhr, Claire Taylor,
Beth Bangor, Eric Pike, William Green, Designers
Carbone, Smolan Associates, New York, NY, Design Firm
Etablissement Public du Grand Louvre, Client

b **13 Hour Sale,** Banners
Bill Thorburn, Art Director
Dayton Hudson Department Store, Minneapolis, MN, Design Firm
Dayton Hudson Department Store Co., Client
Great Faces, Typographer

c

d

c **Mellon Bank Center,** Construction Fence
 Peter Ross, Art Director/Designer/Illustrator
 Ross Culbert Holland & Lavery, New York, NY, Design Firm
 Richard I. Rubin, Client

d **Crate & Barrel Construction Barricade,** Environmental Graphics
 Allesandro Franchini, Art Director/Designer
 Crate & Barrel, Northbrook, IL, Design Firm
 Crate & Barrel, Client
 Alexander Enterprises, Fabricator

Stacy was the only female student in her San Francisco high school to receive a "golden hammer" award for excellence in wood design. After a year and a half at a community college, Stacy recognized a desire to focus her interests. She came to CCAC as an Illustration major; like most transfer students, she entered the Core Program. During this first year she recognized that the Industrial Design program required all the skills and interests she had developed; she is now a junior in this program.

[STACY MAR]

[STEVE DYE]

In choosing a career in the arts, Steve is following a path set by both his mother and his aunt. CCAC has provided an environment of diversity and experimentation, and the opportunity to have been involved in several shows through the film/video department. He has already sold some of his work, and is now a senior in the Fine Arts Department with a double major in film/video and printmaking.

a **California College of Arts and Crafts,** 1990-1991 Catalog
Michael Mabry, Designer
Leslie Flores, Monica Lee, John Degroot, Photographers (Students)
Michael Mabry Design, San Francisco, CA, Design Firm
California College of Arts and Crafts, Client
On Line Typography, Typographers
Cal Central, Alonzo Printing, Printers

b **IN: Winter 1989,** Corporate Magazine
Kent Hunter, Art Director
Kin Yuen, Kent Hunter, Designers
Mark Jenkinson, Stuart Watson, Photographers
Phillipe Weisbecker, Gene Greif, Jose Ortega, Illustrators
Frankfurt Gips Balkind, New York, NY, Design Firm
MCI Communications, Client
Frankfurt Gips Balkind, Typographer
Lebanon Valley Offset Co., Printer

c **Salsa,** Poster
Kent Hensley, Art Director
Alex Boies, Illustrator
Dayton Hudson Department Store, Minneapolis, MN, Design Firm
Dayton Hudson Department Store Co., Client
Kent Hensley, Typographer

a **SHOW I,** Poster

Michael Vanderbyl, Art Director

Vanderbyl Design, San Francisco, CA, Design Firm

California College of Arts and Crafts, Client

Andresen Typography, Typographer

Mastercraft Press, Printer

b **Chart a Good Course,** Poster

McRay Magleby, Art Diirector/Designer/Illustrator

BYU Graphics, Provo, UT, Design Firm

Brigham Young University, Client

Jonathan Skousen, BYU, Typographer

Ray Robinson, Printer

Norm Darias, Copywriter

c **Reach for the Stars,** Poster

McRay Magleby, Art Director/Designer/Illustrator

BYU Graphics, Provo, UT, Design Firm

Brigham Young University, Client

Jonathan Skousen, BYU, Typographer

Ray Robinson, Printer

Norm Darias, Copywriter

a

b

c

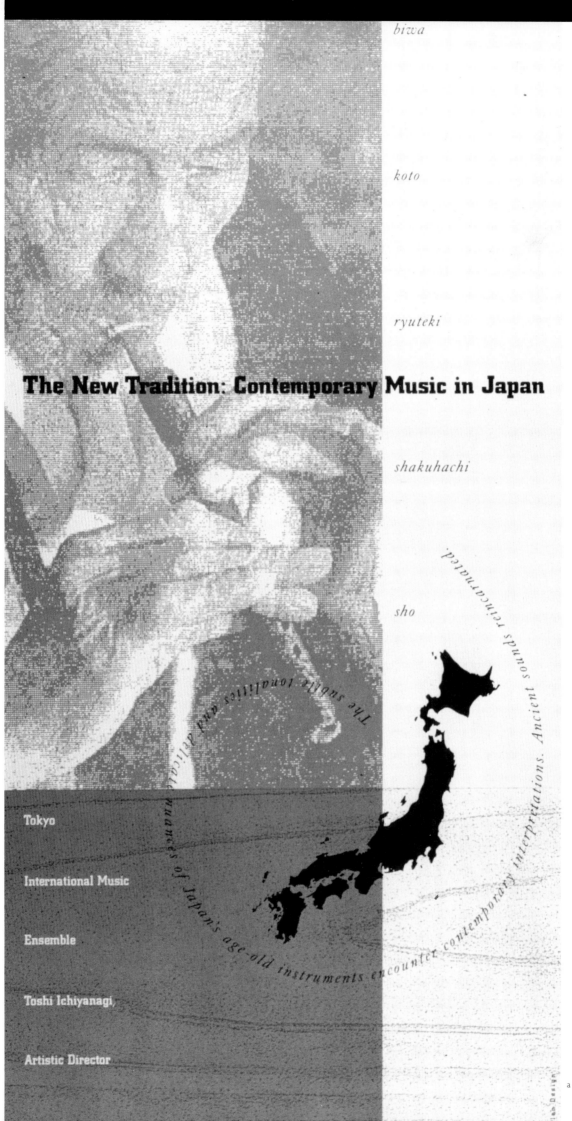

biwa

koto

ryuteki

The New Tradition: Contemporary Music in Japan

shakuhachi

sho

The subtle tonalities and delicate nuances of Japan's age-old instruments encounter contemporary interpretations. Ancient sounds reincarnated.

Tokyo

International Music

Ensemble

Toshi Ichiyanagi,

Artistic Director

TOYOTA CAME TO CANADA FOR ITS ENERGY RESERVES.

With the opening of the new Corolla manufacturing plant in Cambridge, Ontario, Toyota has tapped into Canada's best energy resource: Our people. People who are helping to shape not only the future of Toyota, but the future of Canada itself.

At the Cambridge plant, new techniques in business and manufacturing are being perfected. Working with teammates from Japan and around the world, Canadians are learning Toyota concepts like Kaizen, or continuous improvement. And they're discovering something about themselves: that our Canadian craftsman-

ship is as good as any in the world. Already, a Canadian Corolla has won the prestigious Automobile Journalists' Association of Canada award for "The best vehicle built in Canada". By 1990, the Cambridge plant will be producing 50,000 Corollas a year, for sale throughout North America.

As one of the largest selling cars in history, the Corolla has an outstanding heritage. And so it is with Canadians. Our heritage of spirit and energy is our most valuable natural resource.

TOYOTA

b

TOYOTA CAME TO CANADA FOR THE NATURAL RESOURCES.

TOYOTA CAME TO CANADA FOR THE DURABLES.

a **The New Tradition: Contemporary Music in Japan,** Poster
David Mellen, Art Director/Designer
David Mellen Design, Los Angeles, CA, Design Firm
Japanese American Cultural and Community Center, Client
Ellatype, Typographer
Modernage, Printer

b **Toyota Came to Canada....,** Advertising Campaign
Richard Talbot, Art Director
Michael Rafelson, Photographer
Saatchi & Saatchi Compton Hayhurst, Agency
Toyota Canada, Inc., Client
The Composing Room/Ed Cleary, Toronto, CAN, Typographer

b

a **You Don't Know Diddley,** Poster
Ron Dumas, Art Director
Ron Dumas, Jim Nudo, Michael Tiedy, Designers
Ken Merfield, Photographer
Nike Design, Portland, OR, Design Firm
Nike, Inc., Client

b **Nike Design,** Promotional Box
Sara Legard, Art Director
Ron Dumas, Creative Director
Nike Design, Portland, OR, Design Firm
George Rice & Sons, Typographer
VIP, Printer

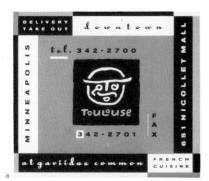

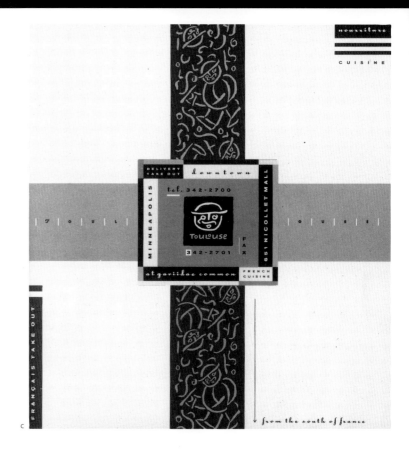

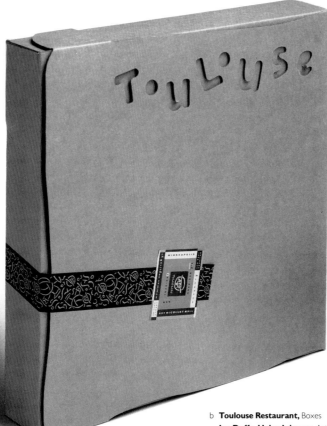

b **Toulouse Restaurant,** Boxes
Joe Duffy, Haley Johnson, Art Directors
Haley Johnson, Todd Waterbury, Designers
Haley Johnson, Todd Waterbury, Illustrators
The Duffy Design Group, Minneapolis, MN, Design Firm
D'Amico & Partners, Client
Todd Waterbury, Typographer
Halper Box Company, Printer

c **Toulouse Restaurant,** Menu
Haley Johnson, Art Director/Designer
Haley Johnson, Todd Waterbury, Illustrators
The Duffy Design Group, Minneapolis, MN, Design Firm
D'Amico & Partners, Client
Great Faces, P & H Photo, Typographers
Print Craft, Printer

a **Toulouse Restaurant,** Logo
Joe Duffy, Art Director
Todd Waterbury, Designer/Illustrator/Typographer
D'Amico & Partners, Client
The Duffy Design Group, Minneapolis, MN, Design Firm

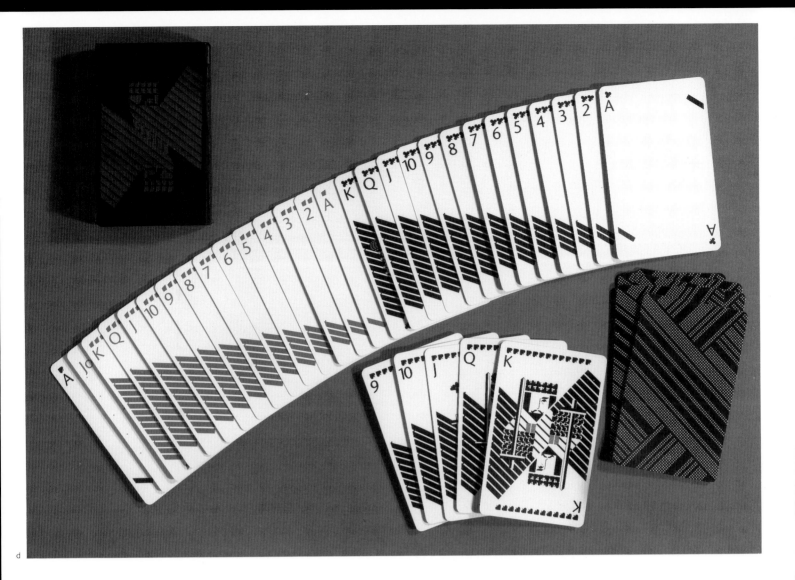

d

e

d **The Analog Deck,** Self Promotional Playing Cards
Ruth Kedar, Art Director/Illustrator
Ruth Kedar Designs, Palo Alto, CA, Design Firm
Ruth Kedar Designs, Client
Carta Mundi, Playing Card Printer
Simon Printing, Inc., Package Printer
Ruth Kedar, Art Director/Illustrator
Ruth Kedar Designs, Palo Alto, CA, Design Firm
Ruth Kedar Designs, Client
Carta Mundi, Playing Card Printer
Simon Printing, Inc., Package Printer

e **Wallace Church Holiday Greetings,** Jam Jar
Stanley Church, Robert Wallace, Art Directors
Stanley Church, Designer
Marilyn Montgomery, Illustrator
Wallace Church Associates, Inc., New York, NY, Design Firm
Wallace Church Associates, Inc., Client

a

a **Rosarito to Ensenada Bike Ride,** Poster
Gerald Bustamante, Art Director/Designer/Illustrator
Studio Bustamante, San Diego,CA, Design Firm
Bicycling West, Inc., Client
Gerald Bustamante, Letterer
A & L Lithographers, Printer

b **Sculpture Chicago 1989,** Catalogue
Kurt Meinecke, Art Director/Designer
Hedrich-Blessing, John Von Dorn, Photographers
Group Chicago, Inc., Chicago, IL, Design Firm
Sculpture Chicago 1989, Client
Chicago Art Production Services, Typographer
The Bradley Printing Co.,

c **Pablo,** Poster
Alicia Messina, John Evangelista, Art Directors
Seymour Chwast, Designer/Illustrator
The Pushpin Group, New York, NY, Design Firm
Serigrafia, Printer

SCULPTURE CHICAGO '89

VITO ACCONCI
RICHARD DEACON
RICHARD SERRA
JUDITH SHEA

JOSH GARBER
SHEILA KLEIN
DANIEL PETERMAN
DAVID SCHAFER
THOMAS SKOMSKI
ROGELIO TIJERINA

CITYFRONT CENTER

NORTH MICHIGAN AVENUE AT THE CHICAGO RIVER

MAY 10–OCTOBER 27

b

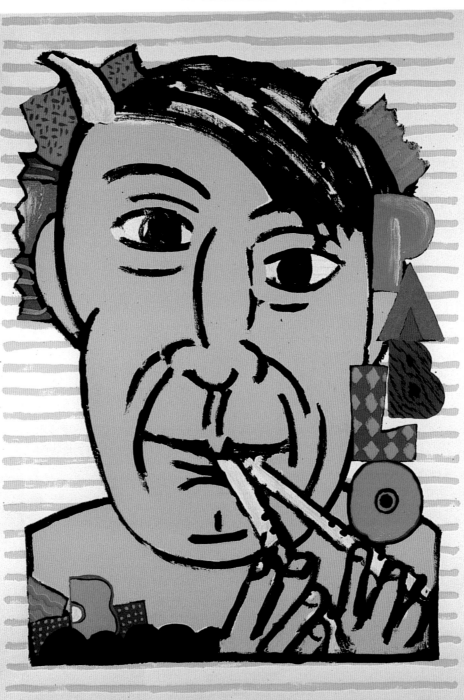

c

a **The Bike,** Promotional Brochure
Del Terrelonge, Art Director/Designer
Ron Baxter-Smith, Photographer
Terrelonge Design Inc., Toronto, CAN, Client
Ron Baxter-Smith Photography, Client
Arthurs Jones Lithographing, Printer
SOS Inc., Separators

It's the point part of view that matters. Where you go in your own mind when you see what you see. Your perspective, that's the point of view.

b

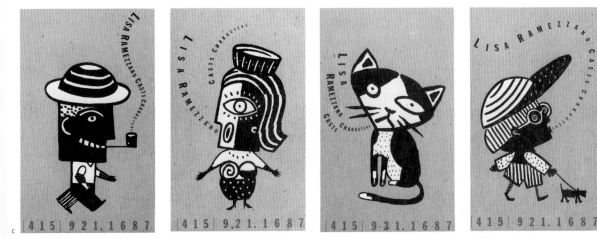

c

b **Gordon Willis: Point of View,** Promotional Booklet
Steve Gibbs, Art Director
Gordon Willis, Photographer
Gibbs Design Inc., Dallas, TX, Design Firm
Gordon Willis, Client
Characters Typography, Typographer
Heritage Press, Inc., Printer

c **Lisa Ramezzano Characters,** Promotional Mailers
Michael Mabry, Designer
Michael Mabry, Illustrator
Michael Mabry Design, San Francisco, CA, Design Firm
Lisa Ramezzano, Casting Agent, Client
On Line Typography, Typographers
Technigraphics, Printer

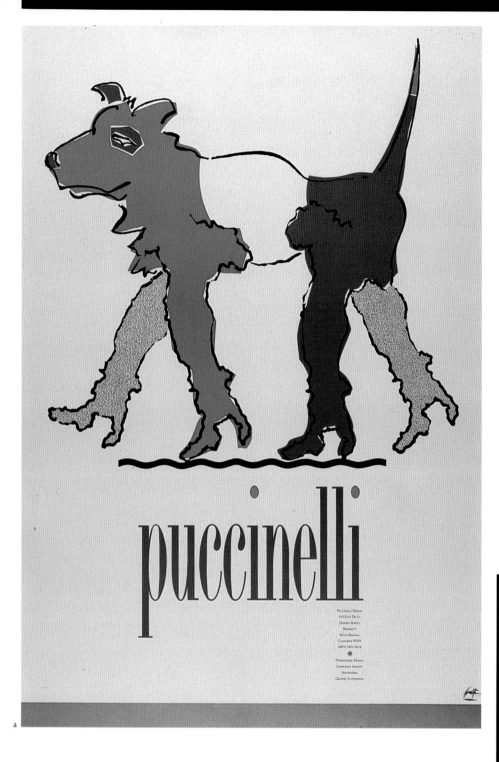

a

b

b **David Byrne: Rei Momo,** CD Package
Jane Kosstrin, David Sterling, David Byrne, Art Directors
Jane Kosstrin, David Sterling, Designers
Kuragami: Michael Mazzeo, AP/ World Wide Photo, Photographer
Doublespace, New York, NY, Design Firm
Warner Brothers Records, Client
Macintosh, Typographer
Ivy Hill Graphics, Printer

c **David Byrne: Rei Momo,** Poster
Jane Kosstrin, David Sterling, David Byrne, Art Directors
Jane Kosstrin, David Sterling, Designers
Kuragami: Michael Mazzeo, AP/ World Wide Photo, Photographer
Doublespace, New York, NY, Design Firm
Warner Brothers Records, Client
Macintosh, Typographer
Ivy Hill Graphics, Printer

a **Puccinelli,** Self-Promotional Poster
Keith Puccinelli, Art Director/Illustrator
Puccinelli Design, Santa Barbara, CA, Design Firm
Puccinelli Design, Client
Tom Buhl Typographers, Typographer

DAVID BYRNE

REI MOMO

a

a **Martex Spring '90,** Brochure
James Sebastian, Art Director
James Sebastian, Junko Mayumi, Designers
Bruce Wolf, Photographer
Designframe Inc., New York, NY, Design Firm
West Point Pepperell, Client
Typogram, Typographer
The Hennegan Co., Printer/Separator

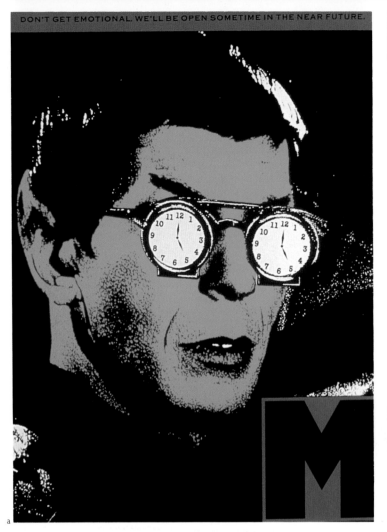

DON'T GET EMOTIONAL. WE'LL BE OPEN SOMETIME IN THE NEAR FUTURE.

WE KNOW BEST. WE'LL BE OPENING ANYTIME NOW.

a **Mission Shopping Center,** Poster Series
John Muller, Art Director
John Muller, Kent Mulkey, Designers
Muller & Co., Kansas City, MO, Design Firm
Copaken, White and Blitt, Client
Cicero Typographers, Typographers
Missouri Poster Co., Printer

a **Brian Kane,** Booklet
Michael Vanderbyl, Art Director
Thomas Heinser Studios, Photographer
Vanderbyl Design, San Francisco, CA, Design Firm
Bernhardt Furniture Co., Client
Andresen Typography, Typographer
Mastercraft Press, Printer

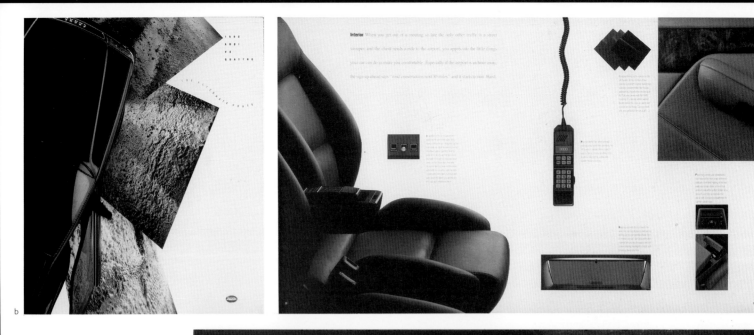

b **1990 Audi V8 Quattro,** Booklet
Barry Shepard, Karin Burklein Arnold, Steve Ditko, Art Directors
Karin Burklein Arnold, Miles Abernethy, Designers
Rick Rusing, Photographer
Carol Hughes, Illustrator
SHR Design Communications, Scottsdale, AZ, Design Firm
Audi of America, Inc., Client
Mary Meek/SHR, Typographer
Bradley Printing, Printer

c **The Byblos Boutique at Marc Laurent,** Booklet
Del Terrelonge, Art Director/Designer
Ron Baxter-Smith, Photographer
Terrelonge Design Inc., Toronto, CAN, Design Firm
Marc Laurent, Client
Arthurs Jones Lithographing, Printer

b

c

a **F. Schumacher & Co.,** Centennial Shopping Bags
James Sebastian, John Plunkett, Art Directors
Kathleen Wills, David Reiss, Junko Mayumi, Designers
Neil Selkirk, Photographer
Designframe Inc., New York, NY, Design Firm
F. Schumacher & Co., Client
Typogram, Typographer
Pac 2000, Printer
The Hennegan Co., Separator

b **Zolo II,** Playsculpture Packaging
Byron Glaser, Sandra Higashi, Art Directors/Designers
Don Chiappinelli, Photographer
Higashi Glaser Design, New York, NY, Design Firm
Zolo, Inc., Client
Trufont, Typographer
Jakarta Glory Offset, Printer
Indonesia Pradhika, Fabricator

c **5 Heads Are Better Than One,** CD Labels
Jerry King Musser, Art Director/Designer/Illustrator
Musser Design, Harrisburg, PA, Design Firm
American Helix Technology, Client
Jerry King Musser, Hand Typography
American Helix Technology, Printer
Jerry King Musser, Art Director/Designer/Illustrator

a

Signature is a bright white,
number-one coated paper
from Mead.
A glance reveals its superior qualities.
Its gloss finish,
as you can see from the cover,
provides you with dazzling dots
for crackling contrasts.
Its dull finish,
as you can see from this page,
has a combination
of low reflection and high resolution
that no other paper can match.

Put Your Best Foot Forward on Signature from Mead

b

c

a **Art Center Review 5,** Quarterly Journal
Kit Hinrichs, Art Director
Terri Driscoll, Designer
Steven A. Heller, Dennis Potokar, Photographers
Rom Impas, John Mattos, Nicholas Wilton, Illustrators
Pentagram, San Francisco, CA, Design Firm
Art Center College of Design, Client
Eurotype, Typographer
Colorgraphics, Printer

b **Put Your Best Foot Forward,** Brochure
John Van Dyke, Art Director/Designer
Terry Heffernan, Photographer
Van Dyke Company, Seattle, WA, Design Firm
The Mead Corporation, Client
Typehouse, Typographer
MacDonald Printing, Printer

c **Handbook of Direct Response Production,** Booklet
John Cleveland, Art Director/Designer
Bright & Associates, Santa Monica, CA, Design Firm
S. D. Warren Paper Co., Client
Photo Typehouse—, Typographer
Anderson Lithograph Co., Printer

a

a **Portrait: Weyerhaeuser Paper Company,** 1988 Annual Report
John Van Dyke, Art Director/Designer
Jeff Corwin, Terry Heffernan, Photographers
Van Dyke Company, Seattle, WA, Design Firm
Weyerhaeuser Paper Company, Client
Graphic Arts Center, Printer
Typehouse, Typographer

COMMUNICATION GRAPHICS

a **Concrete,** Self Promotional Booklet
Jilly Simons, Art Director
Jilly Simons, David Robson, Designers
Geof Kern, Photographer
Deborah Barron, Copywriter
Concrete, Chicago, IL, Design Firm
Concrete, Publisher
Master Typographers, Typographer
Rohner Printing Co., Printer

b **Minneapolis College of Art & Design (MCAD),** Stationery
Charles S. Anderson, Dan Olson, Art Directors/Designers
Charles S. Anderson, Randall Dahlk, Illustrators
Charles S. Anderson Design Co., Minneapolis, MN, Design Firm
Minneapolis College of Art & Design, Client
Typesetters, Inc., Typographers
Print Craft, Printer

c **Modern Living,** Opening Announcement
Jim Heimann, Art Director
Terry Phipps, Designer
Jim Heimann Design, Culver City, CA, Design Firm
Modern Living, Client
Independent Projects Press, Printer

CONTRASTS

THE PAPER PUBLICATION ON PUBLICATION PAPER.

COLONNADE

a

On the lighter side, let's talk for a moment about our new 40 lb. Colonnade. Simply, its lighter weight gives you more linear feet of paper without sacrificing brightness, opacity or holdout. Colonnade is also available in 45 lb. and 50 lb. If you are cost conscious, the possibilities will hit you like a ton of bricks.

WEIGHT

The fact is, home cooking is not only better for you, it probably costs less. The same can be said of Colonnade paper. It's at the high end of the brightness scale and near the lower end in price. Even Colonnade's new 40 lb. is an uncommonly tasteful paper at a price that's very easy to swallow.

VALUE

a **Contrasts,** Promotional Booklet
Deb Miner, Art Director
Mike Haberman, Tom Connors, Arthur Meyerson, Photographers
McCool & Company, Minneapolis, MN, Design Firm
Weyerhaeuser Paper Co., Client
P & H/Letterworx, Typographer
The Hennegan Company, Printer

COMMUNICATION GRAPHICS

b **The Progressive Corporation,** 1988 Annual Report
Joyce Nesnadny, Art Director
Joyce Nesnadny, Ruth Diener, Designers
Various, Illustrators
Nesnadny & Schwartz, Cleveland, OH, Design Firm
The Progressive Corporation, Client
Typesetting Services Inc., Typographer
Fortran Printing, Printer

c **Central and South West Corporation,** 1988 Annual Report
Jack Summerford, Art Director/Illustrator
Summerford Design, Inc., Dallas, TX, Design Firm
Central and South West Corporation, Client
Southwestern Typographics, Typographer
Heritage Press, Printer

We are pleased to announce the consolidation of JCH Graphics with ArtintypeMetro and the opening of our new office. **JCH Group Ltd.**, 352 Park Avenue South, New York, New York 10010. ✆ 212.532.4000 Service 212.532.4718 FAX 212.689.8568

b

"WHEN COMPANIES
CONTRIBUTE TO
THE ALLEY, THEIR
CONTRIBUTIONS PASS
DIRECTLY TO THEATRE-
GOERS IN THE FORM
OF LOWER TICKET
PRICES. THIS MAKES
THE ALLEY AVAILABLE
TO MORE PEOPLE
THAN IT OTHERWISE
WOULD BE."

•

WILLIAM J. JOHNSON
PRESIDENT, U.S.A.
BP EXPLORATION, INC.
AND PRESIDENT OF
ALLEY THEATRE
BOARD

GLOCK NINE

ICE WOLF

HOLY GHOSTS

THE DINING ROOM

MISS FIRECRACKER CONTEST

QUARTERMAINE'S TERMS

give in a manner that best suits their philanthropic posture. Contributions can be made in the following ways: giving to the General Operating Fund; sponsoring, in whole or part, a production, program or event; and supporting the Endowment and/or Capital campaigns.

Contributions made to the General Operating Fund are used for day-to-day operational costs of the Alley Theatre: administrative salaries, utilities and marketing.

In sponsoring a production or event, contributors can select from among numerous activities. They can underwrite or partially sponsor a production or a single performance. In addition, there are numerous other activities for which funds can be contributed: Lunchtime Theatre; guest or resident artists; Informances; Humanities forums; the Tiny Tim Fund; TREAT transportation; music for a specific production; and membership in OnStage, CenterStage and/or Corporate Producers' Council.

Contributions to the Endowment Campaign create funds from which the Alley can offset the effects of inflation on the cost to produce and attend theatre. There is also a Capital Campaign to renovate the existing Alley facility and complete the third theatre space, the Alley Theatre Center.

"THE BROADER THE
EDUCATION OF THE
COMMUNITY-AT-LARGE,
THE BETTER OFF THE
COMMUNITY. THE
ALLEY IS A MAJOR
CONTRIBUTOR TO
HOUSTON IN THIS
REGARD, NOT ONLY IN
THE THEATRE IT PRE-
SENTS, BUT ALSO
THROUGH EDUCATIONAL
PROGRAMS. THAT'S
ONE OF MANY REASONS
AT&T GIVES TO THE
ARTS, THE ALLEY IN
PARTICULAR."

•

VIRGIL WILDER
PUBLIC RELATIONS
DIRECTOR
AMERICAN TELEPHONE
& TELEGRAPH

a **MOVED,** Poster
Takaaki Matsumoto, Michael McGinn, Art Directors
Takaaki Matsumoto, Designer
M Plus M, Inc., New York, NY, Design Firm
JCH Group, Ltd., Client
JCH Group, Ltd., Typographer
Monarch Press, Printer

b **Alley Theatre,** Brochure
Lowell Williams, Art Director
Lowell Williams, Bill Carson, Cindy White, Designers
Terry Vine, Photographer
Lowell Williams Design, Inc., Houston, TX, Design Firm
Alley Theatre of Houston, Client
Mac/I Works, Typography
Heritage Press, Printer

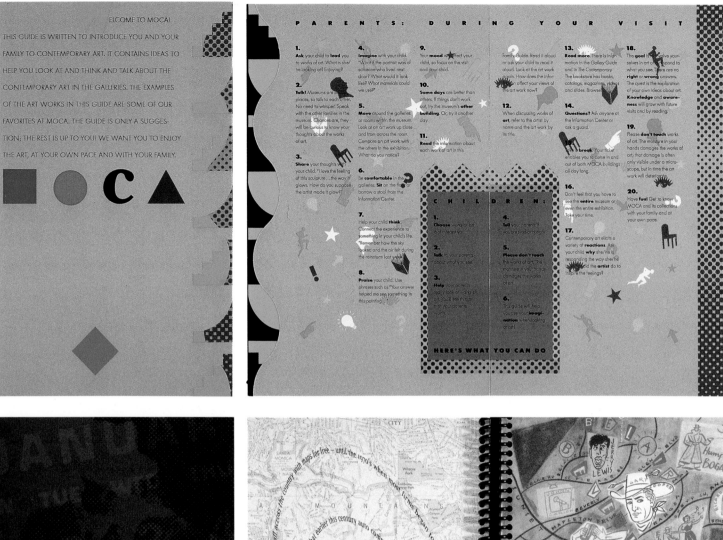

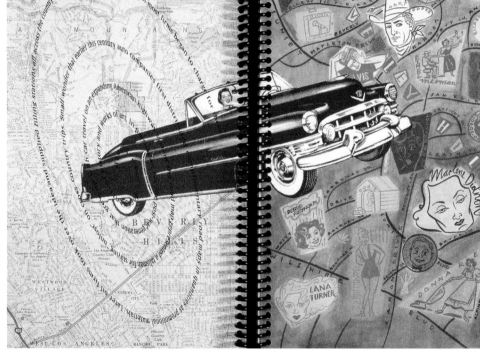

a **MOCA,** Guide Booklet
Kit Hinrichs, Art Director
Belle How, Designer
Pentagram, San Francisco, CA, Design Firm
Museum of Contemporary Art, Los Angeles, CA, Client
Euro Type, China Cultural Printing, Katherine Lou Design, Typographers
Color Graphics, Printer

b **Simpson 1990,** Desk Calendar
Steven Tolleson, Art Director
Steven Tolleson, Renee Sullivan, Designers
Various, Illustrators
Various, Photographers
Tolleson Design, San Francisco, CA, Design Firm
Lindsay Beaman, Copywriter
Spartan Typographers, Euro Type, Typographers
Graphic Arts Center, Printer/Separator

c **Crossroads Films,** Stationery
 Woody Pirtle, Art Director
 Woody Pirtle, Jennifer Long, Designers
 Pentagram Design, New York, NY, Design Firm
 Crossroads Films, Client
 Pentagram Design, Typographer
 Monarch Press, Printer

d **Steven Guarnaccia,** Stationery
 Steven Guarnaccia, Art Director/Designer
 Steven Guarnaccia, New York, NY, Design Firm
 Steven Guarnaccia, Client
 Steven Guarnaccia, Typographer
 West Print, Printer

a **Selling Design,** Booklet
Kym Abrams, Art Director
Mike Stees, Designer
Ray Fredericks, Illustrator
Kym Abrams Design, Chicago, IL, Design Firm
American Center for Design, Publisher
The Typesmiths, Typographer
Rider Dickerson, Printer

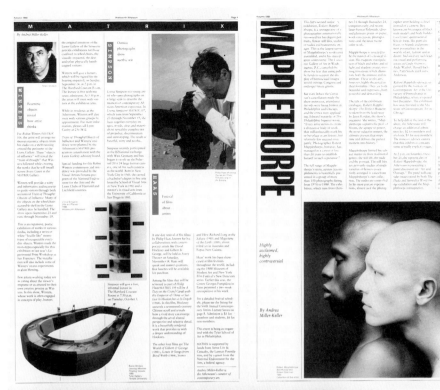

b **Atheneum,** Quarterly Magazine

Peter Good, Art Director

Peter Good, Ed Kim, Designers

Various, Illustrators

Peter Good Graphic Design, Chester, CT, Design Firm

Wadsworth Atheneum, Client

Comp One, Typographer

Cromwell Printing, Co., Printer

c **The Expression of Color,** Brochure

Tyler Smith, Art Director/Designer

George Petrakes, Photographer

Tyler Smith, Providence, RI, Design Firm

Rising Paper Company, Client

TM Productions, Typographer

Universal Press, Printer

RED BEET

RICH IN IRON, THIS HEARTY BIENNIAL

WAS FIRST CULTIVATED FOR ITS LEAFY

TOP. EASY TO GROW, BUT PREFERS COOL

WEATHER. SOW SEEDS ONE-HALF INCH DEEP.

DON'T BE A DEADBEET. MAIL FEES NOW.

SUMMER TERM TUITION DEADLINE—JUNE 7.

R A D I S H

GROWS BEST IN COOL BUT SUNNY
WEATHER. PLANT SEEDS ONE-HALF INCH
DEEP, THIN SEEDLINGS TO ONE INCH
APART, AND HARVEST IN ABOUT 24 DAYS.
RELISH A SAVORY SPRING TERM SCHEDULE.
COMPLETE YOUR REGISTRATION TODAY.

T U R N I P

MATURING IN ABOUT FIFTY DAYS, THIS
TANGY MUSTARD FAMILY MEMBER GROWS
BEST IN TEMPERATE CLIMATES. EXCESSIVE
HEAT CAN CAUSE BITTER ROOTS AND TOPS.
DON'T TURN UP YOUR NOSE AT SCHEDULING.
REGISTER FOR A TOP SUMMER TERM TODAY.

C A R R O T

AN IMPORTANT SOURCE OF VITAMIN A.
SOW SEEDS IN LOOSE, WELL-DRAINED SOIL
TO ENCOURAGE GOOD ROOT DEVELOPMENT.
FULL GROWTH IS OBTAINED IN 70 TO 80 DAYS.
PULL UP A SNAPPY SPRING TERM SCHEDULE.
BYU REGISTRATION DEADLINE — APRIL 15.

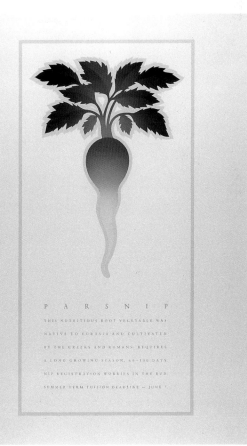

P A R S N I P

THIS NUTRITIOUS ROOT VEGETABLE WAS
NATIVE TO EURASIA AND CULTIVATED
BY THE GREEKS AND ROMANS. REQUIRES
A LONG GROWING SEASON, 60–100 DAYS.
NIP REGISTRATION WORRIES IN THE BUD.
SUMMER TERM TUITION DEADLINE — JUNE 1.

a **Red Beet, Radish, Carrot, Turnip, Parsnip,** Posters
McRay Magleby, Art Director/Designer/Illustrator
BYU Graphics, Provo, UT, Design Firm
Brigham Young University, Client
Jonathan Skousen, BYU, Typographer
Ray Robinson, BYU, Printer
Norm Darias, Copywriter

WHEN IS COATED

SPORTCOAT?

OVERCOATED?

Viewpoints

Viewpoint

A popular Denver Country and Western radio personality, Rick Jackson and his wife Gina exemplify many younger couples who have made the decision to plan for their future today.

Gina: "Most people in our age group don't start planning early enough. We only started ourselves about a year ago, when we made a little money on a real estate transaction. We wanted to keep our profit from being eaten up by taxes, and we knew we needed to start thinking about our daughters' educations and our retirement."

Rick: "We had this romantic notion of retiring at 50 and building a log cabin, so we could spend the rest of our days canoeing and fishing. The first thing our planner did was to help us break down the next 20 years, where we wanted to be in 10, 10, 5, 4, 3, 2, 1 years. And he put our goals together with our yearly car rentals, our expenses, what kinds of investments were best for us. We decided that annuities were the best course for educating our children. We opened an IRA and changed our insurance. Computerized stuff especially because we're not very disciplined when it comes to money."

Gina: "We needed someone who could explain things very explicitly and in very simple language. Our planner gave us a workable program, but it's not a one-time shot. He sits down with us every few months to make sure we're still on track."

Rick: "The more we follow our program, the more we realize what kind of commitment it takes. Even if we're remiss in following through, we know where we stand. We weren't looking for someone to take total control of our money but we did want direction, someone who had the tools and the systems to make us look at our future realistically. Sometimes we wish things looked better than they do, but our goals don't seem so insurmountable. We know they're achievable if we just take the necessary steps."

Gina: "I think we have a healthier respect of money without being completely preoccupied with it. We still have our dream of retiring at 50, but now we know what kind of position we might have to be in to do it."

Rick: "A lot of people in our generation don't either see money as corrupt or put all their energy into earning more now in their 20s. Now I think we're concentrated between the two extremes."

RENAISSANCE SCRIBES FOUND CLASSICAL FORMS STRAINED GEOMETRY FOR BEAUTY'S SAKE. IN THE ORIENT FINE WRITING WAS ALWAYS CONSIDERED AN ART.

CUPID USED A BOW, BUT SINCE ARROWS WENT OUT OF STYLE HE HAS ALWAYS WIELDED A PEN. WHEN ZOOT SUITS DROVE FAST CARS, A STYLUS WAS IN STYLE.

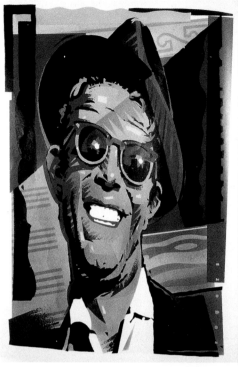

108

a **L. A. X. /Language, Art, Expression,** In-House Magazine
David Willardson, John Van Hammersveld, Art Directors
John Van Hammersveld, Designer
Various, Illustrators
L. A. X. Magazine, Glendale, CA, Design Firm
Miller Graphics, Printer

b **The Fall Herrald, 1989,** Corporate Newsletter
Bob Dennard, Art Director
Chuck Johnson, Designer/Illustrator
Dennard Creative, Inc., Dallas, TX, Design Firm
Herring Marathon Group, Client

c **The Printed Page,** Brochure
Del Terrelonge, Art Director/Designer
David Whittaker, Photographer
Terrelonge Design, Inc., Toronto, CAN, Design Firm
Adelaide Printing, Client
Adelaide Printing, Printer

a **Minneapolis College of Art & Design (MCAD),** Poster
Charles S. Anderson, Dan Olson, Art Directors/Designers
Charles S. Anderson, Illustrator
Charles S. Anderson Design Co., Minneapolis, MN, Design Firm
Minneapolis College of Art & Design, Client
P & H Photo Composition, Typographer
Process Displays, Printer

b **Specific Sites,** Poster
Michael Vanderbyl, Art Director
Vanderbyl Design, San Francisco, CA, Design Firm
San Francisco Chapter of American Institute of Architects, Client
Hester Typographers, Typographer
Serifics, Printer

c **Manufacturing, Engineering, Technology,** Poster
McRay Magleby, Lily McCullough, Art Directors/ Designers
Lily McCullough, Illustrator
BYU Graphics, Provo, UT, Design Firm
Brigham Young University, Client
Jonathan Skousen, BYU, Typographer
Ray Robinson, Printer

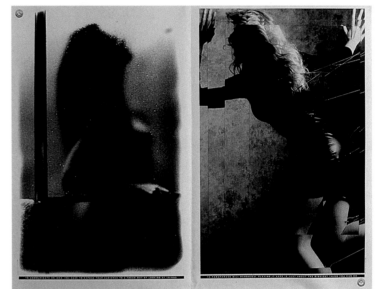

a

a **Kansas City Art Directors Club,** Call for Entry
John Muller, Art Director
Patrice Eilts, Jane Weeks, Lee Ernst, John Muller, Designers
David Ludwigs, Mike Regnier, Nick Verdros, Hollis Officer, Photographers
Muller & Co., Kansas City, MO, Design Firm
Kansas City Art Directors Club, Client
Fontastic, Typographer
Ashcroft, Inc., Printer

c

PAULA
SCHER AND
TERRY KOPPEL
CORDIALLY INVITE
YOU TO STAIN THEIR
NEW CARPETS AND
BURN THEIR LINOLEUM
AT A COCKTAIL PARTY IN
CELEBRATION OF THEIR
NEW DESIGN OFFICES. DATE:
MARCH 2, 1989 TIME: 6-9
KOPPEL & SCHER
156 FIFTH AVENUE R.S.V.P. BY FEB. 22
THIRTEENTH FLOOR (212) 627-9330

b

b **Koppel & Scher,** Invitation
 Terry Koppel, Art Director
 Koppel & Scher, New York, NY, Design Firm
 Koppel & Scher, Client
 JCH Group, Typographer
 Ambassador Arts, Printer

c **Michael Tolleson Architect,** Stationery
 Steven Tolleson, Art Director
 Steven Tolleson, Bob Awfuldish, Designers
 Tolleson Design, San Francisco, CA, Design Firm
 Spartan Typographers, Typographer
 Bolling & Finke, Printer

a **Fall Registration in a Nutshell,** Poster
 McRay Magleby, Art Director/Designer/Illustrator
 BYU Graphics, Provo, UT, Design Firm
 Brigham Young University, Client
 Jonathan Skousen, BYU, Typographer
 Ray Robinson, BYU, Printer
 Norm Darias, Copywriter

b **Fall Registration/Juicy Details,** Poster
 McRay Magleby, Art Director/Designer/Illustrator
 BYU Graphics, Provo, UT, Design Firm
 Brigham Young University, Client
 Jonathan Skousen, BYU, Typographer
 Ray Robinson, BYU, Printer
 Norm Darias, Copywriter

c **Littleleaf Linden,** Poster
McRay Magleby, Art Director/Designer/Illustrator
BYU Graphics, Provo, UT, Design Firm
Brigham Young University, Client
Jonathan Skousen, BYU, Typographer
Ray Robinson, BYU, Printer
Norm Darias, Copywriter

d **Japanese Flowering Crab,** Poster
McRay Magleby, Art Director/Designer/Illustrator
BYU Graphics, Provo, UT, Design Firm
Brigham Young University, Client
Jontahan Skousen, BYU, Typographer
Ray Robinson, BYU, Printer
Norm Darias, Copywriter

a

a **Gelinas,** Posters
Margo Chase, Art Director
Lorna Stovall, Designer
Mindas, Photographer
Margo Chase Design, Los Angeles, CA, Design Firm
Trinne Research, Client
Westland Graphics, Printer

b **Gelinas,** Packaging
Margo Chase, Art Director
Lorna Stovall, Designer
Margo Chase Design, Los Angeles, CA, Design Firm
Trinne Research, Client
Graphic Magic, Printer

a **Robert A. M. Stern,** Booklet
Michael Vanderbyl, Art Director
Omega Studios, Photographer
Vanderbyl Design, San Francisco, CA, Design Firm
Hickory Business Furniture, Client
Andresen Typography, Typographer
Mastercraft Press, Printer

Scotch Pine

When there's a nip in the air, the
Scotch Pine's cones turn from
gray to red-brown. Young trees can
be perfect pyramids. They're hardy
and perennial favorites for their
shape and blue-green needles.

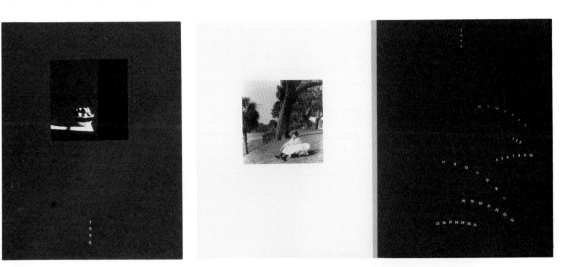

It was past midnight by
the time we headed
back home. In the road,
something brought us
to an unscheduled stop.
I couldn't tell what. I
wasn't tall enough yet to
see over the dashboard,
or touch the floor with
my toes.

b **O'Tannenbaum,** Self Promotional Christmas Card
Jennifer Morla, Art Director
Jeanette Aramburu, Designer
Kathryn Kleinman, Photographer
Morla Design, San Francisco, CA, Design Firm
Morla Design, Client
Omnicomp, Typographer
Singer Printing Co., Printer
Apex Die Corp., Stamping and Embossing

c **1990,** Self Promotional Calendar
Leslie Smolan, Art Director
Allison Meunch, Designer
Rodney Smith, Photographer
Carbone Smolan Associates, New York, NY, Design Firm
**Carbone Smolan Associates, Rodney Smith, Dolan/Wohlers Printing
Company,** Publishers/ Clients
Typogram, Typographers
Dolan/Wohlers Printing Company, Printer
Color Logic, Separators
Kohl & Madden Printing Ink Corporation, Ink Colors
Dolan/Wohlers Printing Company, Die Cutting

d **Your Brother's Keeper/Group Health Plan,** Booklet
Brent Croxton, Art Director/Designer
Altman & Manley, San Francisco, CA, Design Firm
Group Health Plan, Client
Andresen Typographics, Typographer
Stiner Printing, Inc., Printer

Natural beauty evolving from function. Door handles that greet you like a firm handshake. Cool, die cast metal, not plastic. A design as smooth and graceful as the car itself.

a **The Tool Book,** Brochure
John Van Dyke, Art Director/Designer
Terry Heffernan, Photographer
Van Dyke Company, Seattle, WA, Design Firm
The Mead Corporation, Client
Typehouse, Typographer
MacDonald Printing, Printer

b **Infiniti Auto Show 1990,** Brochure
Vic Cevoli, Art Director
John Avery, Designer
Clint Clemens, Photographer
Hill Holliday Design, Boston, MA, Design Firm
Nissan Infiniti Car Division, Client

c

c **A History of Baseball,** Promotional Booklet

Leslee Avchen, Laurie Jacobi, Art Directors/ Designers

Terry Heffernan, Photographer

John Vasiliou, Jonathan Poor, Illustrators

Avchen & Jacobi, Minneapolis, MN, Design Firm

Consolidated Papers, Inc., Client

Alpha Graphics One, Typographer

Watt Peterson, Printer

COMMUNICATION GRAPHICS

a **AIDS,** Poster
McRay Magleby, Art Director/Designer/Illustrator
BYU Graphics, Provo, UT, Design Firm
Shoshin Society, Client
Jonathan Skousen, BYU, Typographer
Ray Robinson, BYU, Printer

b **Lino,** Posters
Charles S. Anderson, Dan Olson, Art Directors/Designers
Charles S. Anderson, Dan Olson, Randy Dahlk, Illustrators
Charles S. Anderson Design Co., Minneapolis, MN, Design Firm
Linotypographers Fort Worth, Client
Linotypographers, Typographer
Wipson Posters, Printer

c **Ex Libris,** Poster
Gerald Reis, Art Director/Designer
John Malmquist, Illustrator
Gerald Reis & Co., San Francisco, CA, Design Firm
California College of Arts & Crafts, Client
EuroType, Typographer
Forman Leibrock, Printer

a **The Rincon Center,** Environmental Graphics
Michael Manwaring, Art Director/Designer
The Office of Michael Manwaring, San Francisco, CA, Design Firm
Perini Land Development, Client

b **The Mercado Project,** Environmental Graphics
Ann Morton Hubbard, Art Director
Ann Morton Hubbard, Julie Henson, Lisa Johnson, Pat Rudnyk Miller,
Designers
Bill Timmerman, Photographer
Hubbard and Hubbard, Phoenix, AZ, Design Firm
The Symington Company, Client
Cornoyer-Hedrick Architects & Planner, Architectural Firm

a **Madeleine Corson,** Stationery
Madeleine Corson, Art Director
Madeleine Corson Design, San Francisco, CA, Design Firm
Madeleine Corson Design, Client
MH Type, Typographer
Hillside Press, Printer

b **Libby Carton,** Stationery
Woody Pirtle, Art Director
Pentagram Design, New York, NY, Design Firm
Libby Carton, Client
Hand Lettering, Typography
Rubber Stamp, Printing

Less is most... **Reduction to essentials is the direct path to successful design realization. Paramount provides these essentials for you, with an economy of time and effort.** ▶ Skilled engineers and craftspeople. The ultimate in materials, equipment, techniques. Classic wooden patterns to three-dimensional digitizing and CNC programming. ▶ Between your idea and the physical realization, we give you the material essentials; models, samples, patterns, molds--everything that moves your concept towards the marketplace with the most chance to succeed. ▶ The most *is* less at Paramount--where superior execution is based on technical expertise, backed with experience, ready to help your design take shape.

2475 Big Oak Road, Langhorne, PA 19047 • 215 757 9611 • FAX 215 757 9784 Paramount Industries

c **Tudhope Associates Opening,** Party Invitation
 Beverly W. Tudhope, Ian C. Tudhope, Art Directors
 Todd Richards, Designer
 Tudhope Associaates Inc., Toronto, CAN, Design Firm
 Tudhope Associates Inc., Client
 Arthurs-Jones Lithographing Ltd., Printer

d **Less is Most,** Advertisement
 Roger Cook, Don Shanosky, Art Directors
 Arthur Beck, Photographer
 Cook and Shanosky Associates, Inc., Princeton, NJ, Design Firm
 Paramount Industries, Client
 Elizabeth Typesetting Co., Typographer

127

a **Pentagram Papers 17: The Many Faces of Mao,** Self Promotion Periodical
Linda Hinrichs, Art Director
Natalie Kitamura, Designer
Barry Robinson, Photograpaher
Pentagram, San Francisco, CA, Design Firm
Pentagram, Client
Reardon & Krebs, Typographer
Lithographix, Printer

b **Great Moves,** Self-Promotional Booklet
Sandy Farrier, Art Director
Jeff Boettcher, Designer
Various, Illustrators
Evans/Spangler Design, Seattle, WA, Design Firm
Evans/Spangler Design, Cient
Type Gallery, Typographer
Artcraft Printing Co., Printer

c **Survival School,** Handbook
Brent Croxton, Steven Guarnaccia, Art Directors/Designers
Steven Guarnaccia, Illustrator
Steven Guarnaccia, New York, NY, Design Firm
Altman & Manley, San Francisco, Agency
Physician's Health Services, Client
Andresen Typographers, Typographer
The Evsey Press, Printer

d **1990,** Promotional Calendar
Malcolm Waddell, Art Director
Jay Maisel, New York, NY, Photographer
Eskind-Waddell, Design Firm
Cooper & Beatty, Typographer
MacKinnon-Moncur, Ltd., Printer
Graphic Specialties, Separator
Mead Paper, Paper

One reason for looking at a number of possible typefaces is to satisfy one's curiosity. Another, and perhaps more meaningful one, is to study the relationship of different letter combinations, to look for visual analogies, and to try to elicit ideas that the design of a letter or group of letters might inspire.

Here are some further choices, but no matter how one may look at these different examples: sans serifs, hairline and slab serifs, condensed, expanded, bold, light, outline...they still say *next*...like *next time, what's next?, next in line,* or even *next of kin.* The word is in such common usage that it is simply taken for granted.

Personal preferences, prejudices, and stereotypes often dictate what a logo looks like, but it is *needs,* not wants, *ideas,* not type styles which determine what its form should be. To defamiliarize it, to make it look different, to let it evoke more than the mere adjective or adverb it happens to be is, it seems, the nub of the problem.

a **NeXT,** Logo Presentation Book
Paul Rand, Art Director/Designer
Paul Rand, Writer
Paul Rand, Weston, CT, Design Firm
NeXT, Inc., Client
Pastore Depamphillis & Rampone, Typographer
Mossberg Printing Co., Printer

b **Georgetown University Graphic Identity,** Identity Manual
Rob Szabo, Art Director
Michael D. Feinstein, Editor
Georgetown University, Publisher
Bogart Szabo Design Inc., Washington, DC, Design Firm
General Typographers, Typographer
Stephenson, Inc., Printer

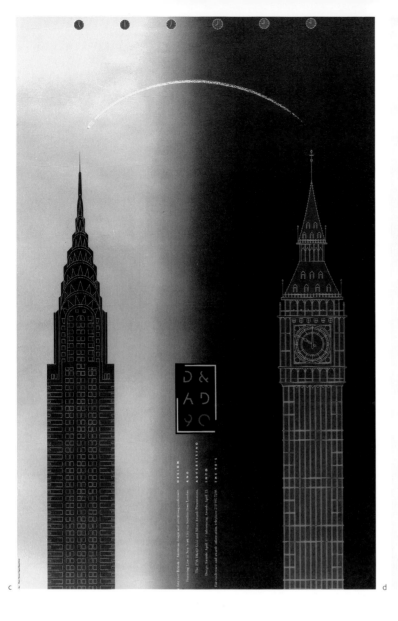

FRENCH REVOLUTION

c **D & AD '90,** Show Awards Poster
 Woody Pirtle, Art Director
 Woody Pirtle, Penny Rowland, Designers
 Jared Schneidman, Libby Carton, Illustrators
 Pentagram Design, New York, NY, Design Firm
 Designers & Art Directors Association, Client
 Pentagram Design, Typographer
 Sterling Roman Press, Inc., Printer

d **French Revolution,** Poster
 McRay Magleby, Art Director/Designer/Illustrator
 BYU Graphics, Provo, UT, Design Firm
 Brigham Young University, Client
 Jonathan Skousen, BYU, Typographer
 Ray Robinson, BYU, Printer

Reacting to the mass production and mechanization of the Industrial Revolution,

TYPOGRAPHY

emphasized the idea that

should determine FUNCTION

FORM

With the advent of offset printing and the development of photographic processes, artists and writers, freed from the limitations of traditional type composition, used typography as a medium of creative expression. Typography became a design component, not merely a vehicle for the written word. As the use of color, geometry, and modern production techniques increased the number of available design elements, a new professional played a key role:

The Graphic Designer

a

OLD STYLE TYPOGRAPHY

Was Influenced by Humanism,

THE RENAISSANCE REVIVAL

of classical learning. At first, rubrics or initial caps were handlettered after printing to emulate the look of handwritten manuscripts; later, woodcut borders, ornaments,

A and illustrations decorated the typeset pages. Well-formed, gracefully fitted letters with beautifully proportioned word spacing and line spacing created a classic evenness of texture. The capital letters are direct descendants of the Roman lapidary letters used on Trajan's column. Old Style lowercase characters come from the ninth-century Carolingian forms that humanist scholars believed had been used by the Romans for the classics. The italics are a cursive, compressed variety of lowercase; originally used to save space, they were later utilized to complement the roman letterforms. Old Style letterforms had to be substantial enough to withstand the uneven pressure of the early presses on the rough, handmade paper of the day. For this reason, there is very little contrast between thick and thin strokes, and the shape of the serifs is virtually triangular.

A PORTFOLIO *of Typography*

a **A Portfolio of Typography,** Promotional Portfolio
Leah Toby Hoffmitz, Art Director
Terry Irwin, Leah Toby Hoffmitz, Designers
Letterform Design, Los Angeles, CA, Design Firm
Characters & Color, Client
Characters & Color, Typographer/Printer

b

c

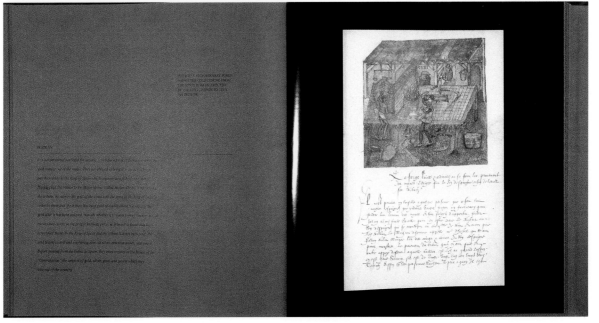

b **Martex Fall '89,** Brochure
James Sebastian, Art Director
James Sebastian, Junko Mayumi, Designers
Bruce Wolf, Photographer
Designframe Inc., New York, NY, Design Firm
West Point Pepperell, Client
Boro Typographers, Typographer
The Hennegan Co., Printer/Separator

c **Sir Francis Drake: Images of Discovery,** Promotional Book
Nancye Green, Julie Riefler, Art Directors
Julie Riefler, Designer
Greg Dearth, Illustrator (Binding)
Donovan and Green, New York, NY, Design Firm
The Carvill Group, Client
Graphic Technology, Typographer
The Hennegan Co., Printer

a **"224 1989/1990"**, New Year's Eve Party Poster Invitation
 Valerie Richardson, Art Director
 Forrest Richardson, Creative Director
 Neil Fox, Designer
 Richardson or Richardson, Phoenix, AZ, Design Firm
 Siegel Photographic Inc., Client
 Woods Lithographics, Printer
 Arizona Embossing & Die Co., Embossing/Die Cutting

b

b **Actual Size,** Promotional Poster
Richard Gavos, Art Director/Designer/ Illustrator
HarrisonSimmons, Inc., Dallas, TX, Design Firm
Southwestern Typographics, Client
Southwestern Typographics, Typographer
Southwestern Typographics, Printer

a

a **Potlatch,** 1988 Annual Report
　Kit Hinrichs, Art Director
　Terri Driscoll, Designer
　Will Nelson, Illustrator
　Tom Tracy, Photographer
　Pentagram, San Francisco, CA, Design Firm
　Potlatch Corporation, Client
　Spartan Typographers, Typographer
　Anderson Lithograph Co., Printer

b **Immunex,** 1988 Annual Report
　Kit Hinrichs, Art Director
　Belle How, Designer
　Steve Firebaugh, Photographer
　Wilson McClean, Jack Unruh, Ed Lindlof, Doug Fraser, John Craig,
　Dave Stevenson, Illustrators
　Pentagram, San Francisco, CA, Design Firm
　Immunex Corporation, Client
　Reardon & Krebs, Typographer
　Graphic Arts Center, Printer

IMMUNEX 1988 ANNUAL REPORT

b

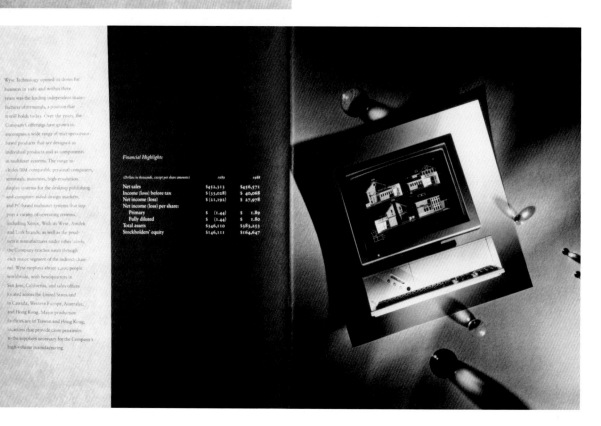

Wyse Technology Inc. Annual Report 1989

a

a **Wyse Technology Inc.,** 1989 Annual Report
Michael Mabry, Art Director/Designer
R. J. Muna, Photographer
Michael Mabry Design, San Francisco, CA, Design Firm
Wyse Technology, Inc., Client
On Line Typography, Typographers
Anderson Lithograph, Printer

A
Visible
Case
For
UltraDot™

It is refreshing
to know that tradition
has not given way
to more
modern methods
and machinery.

b

MINDING YOUR OWN BUSINESS

AIGA

Perhaps you're starting your own studio. Or
you already have—and you've become inter-
ested in earning more than spiritual fulfillment. Come join us for an
evening of round table discussions with some experts on three hot busi-
ness topics: sales tax, proposals and contracts, and business develop-
ment and marketing. We've structured the evening so you can take
part in all three of the roundtables, with plenty of time for Qs and As. To
keep up your spirits, we'll provide substantial hors d'oeuvres and a vari-
ety of beverages. **When:** September 21, 6:30 pm. **Where:** Gensler and
Associates, Architects, 550 Kearny Street, Ninth Floor, San Francisco.
Registration is limited. To reserve space, send $30.00 with your name to:
Doug Akagi, 17 Osgood, San Francisco, 94133; 415-397-4668.

c

b **A Visible Case for Ultra Dot/The Grande Tortilla Factory,**
Promotional Booklet
Forrest Richardson, Debbi Young-Mees, Art Directors/Designers
Rick Gayle, Photographer
Richardson or Richardson, Phoenix, AZ, Design Firm
Rick Gayle Photographers, Client
Arizona Type, Typographer
Woods Lithographics, Phoenix, AZ, Printer/Client

c **Minding Your Own Business,** Informational Booklet
Steven Tolleson, Art Director/Designer
Tolleson Design, San Francisco, CA, Design Firm
AIGA/San Francisco, Client
Linda Peterson, Copywriter
EuroType, Typographer
Graphic Arts Center, Printer

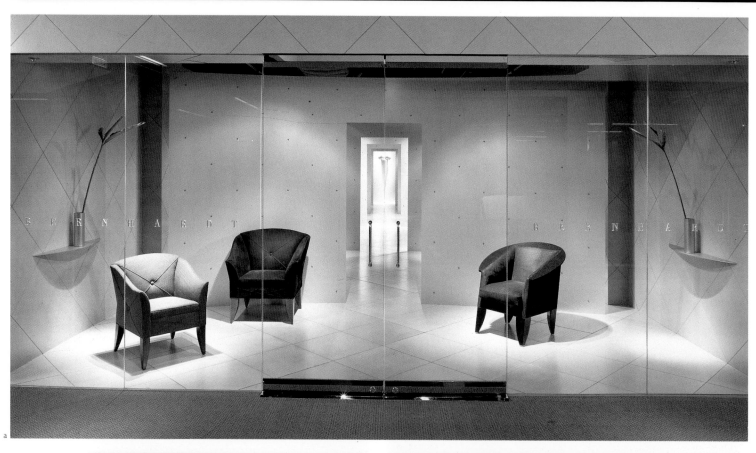

a **Bernhardt Furniture/Los Angeles Showroom,** Environmental Graphics
 Michael Vanderbyl, Art Director/Interior Designer
 Vanderbyl Design, San Francisco, CA, Design Firm
 Bernhardt Furniture, Client
 Peter Fishel, Project Manager
 Ebbe Videriksen Architect & Assoc., Special Consultants

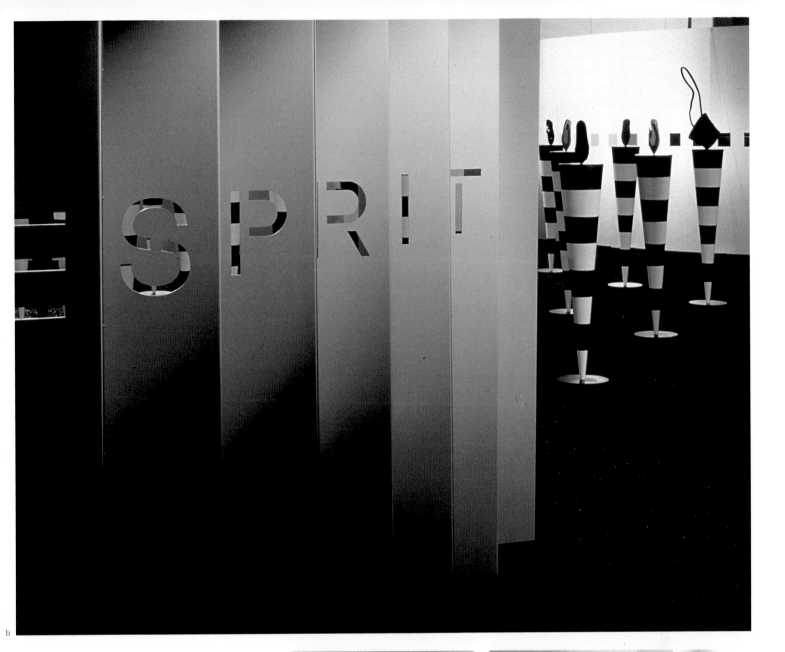

b **Esprit Show and Accessories Showroom/New York,** Environmental Graphics
Michael Vanderbyl, Art Director/Interior Designer
Vanderbyl Design, San Francisco, CA, Design Firm
Esprit, Client
Peter Fishel, Project Manager

a

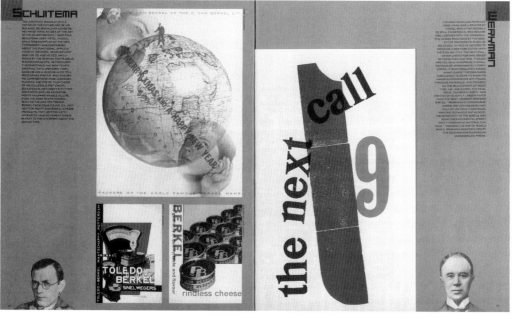

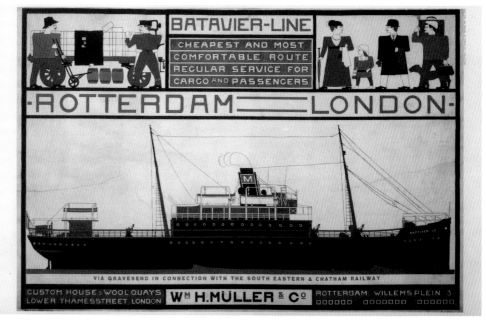

a **Design and Style 5/DeStijl,** Promotional Portfolio
Seymour Chwast, Art Director
Seymour Chwast, Roxanne Slimak, Designers
The Pushpin Group, New York, NY, Design Firm
Mohawk Paper Mills,Inc., Client

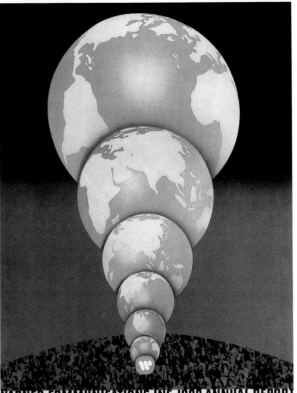

b **WARNER COMMUNICATIONS INC. 1988 ANNUAL REPORT**

will have representation in a total of 51 countries.

WARNER/CHAPPELL MUSIC

In its first full year of operation since WCI's October 1987 acquisition of Chappell Music, Warner/Chappell Music turned in an outstanding performance in revenues and operating earnings throughout the world. Warner/Chappell's excellent results were enhanced by the increased use of music in commercials and theatrical films. The division also recorded major gains through the success of newly-signed foreign artists and strong industry sales of prerecorded music.

■ The largest worldwide music publishing company, Warner/Chappell today administers over 700,000 popular and histori-cal music titles in 21 countries. Artists whose new releases contri-

buted to the year's excellent performance included George Michael, Michael Jackson, U2, White Lion, Midnight Oil, Keith Sweat and Van Halen.

■ In early 1989, Warner/Chappell Music completed the acquisition of Birch Tree Music Group Ltd., a music publishing company whose 50,000 title catalogue includes "Happy Birthday."

WARNER SPECIAL PRODUCTS

Warner Special Products, as the licensing agent and special marketing arm for the WCI labels, reported gains in revenues and operating income in 1988.

■ The Company's primary product line and source of revenue is specially-created compilation albums that utilize recordings from WCI's vaults as well as those of third parties. The Company also benefits from the licensing of recordings to movies, TV shows, commercials, airlines, food and fashion outlets. ■

IVY HILL CORPORATION

Acquired in November 1988, Ivy Hill Corporation specializes in high quality colored printing and packaging. Ivy Hill is a principal supplier of packaging for records, audiocassettes, CDs, and videocassettes for the WCI Record Group and Warner Home Video. ■

For the fourth consecutive year, WCI's cable and broadcasting division achieved record operating results in 1988. Operating income for the year showed a sharp increase of 63% to $75 million. Revenues for the year totalled $456 million, an increase of 18% over 1987's revenue of $387 million.

WARNER CABLE

Warner Cable's 1988 results are attributable to gains in basic subscribers and increased revenue per subscriber. A resurgence in pay unit subscriptions, increased pay-per-view purchases and the continuing development of advertising sales all contributed to the Company's revenue

gains. These areas should continue to provide significant growth in 1989.

■ Warner Cable increased its subscriber base by more than 105,000 basic subscribers in 1988. The 8% gain lifted the Company to the rank of fifth-largest MSO (Multiple System Operator), with a total of 1,528,917 subscribers in 22 states.

■ The increase in basic subscribers results from net gains in Warner Cable's established operations, highly successful marketing activity at the "new build" in Brooklyn and Queens, and the acquisition of additional cable systems.

■ 1988 marked the cable industry's second year since the deregulation of basic rates. As a result, during the past two years, Warner Cable has developed sales strategies that are more in

keeping with the consumers' perception of the relative value for basic and pay services. These strategies have led to a resurgence in pay subscriptions in addition to overall increases in basic penetration. The Company achieved a net gain of 133,500 pay units in 1988, an 11% increase, for a total of 1,339,675 units.

■ Overall, the cable industry enjoyed another year of growth as the total number of cable households reached 45.6 million, or nearly 51% of the 90.4 million TV households in the United States. This subscription total represents 59% of the 76.8 million households passed by cable. Pay cable units total 37.2 million, which constitutes an 82% pay-to-basic ratio.

■ Cable system values have continued to escalate and Warner Cable has become an increasingly important asset for WCI. In 1988, the cable industry recorded numerous sales reflecting values of $2,500-$2,800 per sub-

CABLE AND BROADCASTING

16 17

b **Warner Communications Inc.,** 1988 Annual Report
Peter Harrison, Harold Burch, Art Directors
Harold Burch, Peter Harrison, Designers
Gene Greif, Illustrator
Pentagram Design, New York, NY, Design Firm
Warner Communications, Inc., Client
Cromwell Type-Ad Service Inc., Typographer
George Rice & Sons, Inc., Printer

a **Art Center Review 6,** Quarterly Journal
Kit Hinrichs, Art Director
Terri Driscoll, Designer
Steven A. Heller, Rick Eskite, Photographers
Pentagram, San Francisco, CA, Design Firm
Art Center College of Design, Client
Euro Type, Typographer
Color Graphics, Printer

b **Packaging Directions I,** Promotional Booklet
Terry Koppel, Art Director
Various, Illustrators
Koppel & Scher, New York, NY, Design Firm
Queens Group Inc., Client
Boro Typographers, Typographers
Queens Group Inc., Printer

c **Packaging Directions II,** Promotional Booklet
Terry Koppel, Art Director
Various, Illustrators
Koppel & Scher, New York, NY, Design Firm
Queens Group Inc., Client
JCH Group, Typographer
Queens Group Inc., Printer

a

a **Consort Royal 1990,** Calendar
Joyce Nesnadny, Art Director
Joyce Nesnadny, Ruth Diener, Designers
Michael Book, Photographer
Nesnadny & Schwartz, Cleveland, OH, Design Firm
Garden City Paper International, Client
Typesetting Services, Inc., Typographer
Fortran Printing, Printer

b

c

b **Azur Restaurant,** Facility Folder/Booklet
Sharon Werner, Art Director
Haley Johnson, Designer
Haley Johnson, Lynn Schulte, Illustrators
John Barnier, Photographer
Chuck Carlson, Copywriter
The Duffy Design Group, Minneapolis, MN, Design Firm
D'Amico & Partners, Client
Typeshooters/Typemasters, Typographer
Print Craft, Printer

c **Azur Restaurant,** Brochure
Sharon Werner, Art Director/Designer
Haley Johnson, Lynn Schulte, Illustrators
Chuck Carlson, Copywriter
The Duffy Design Group, Minneapolis, MN, Design Firm
D'Amico & Partners, Client
Typeshooters/Typemasters, Typographer
Print Craft, Printer

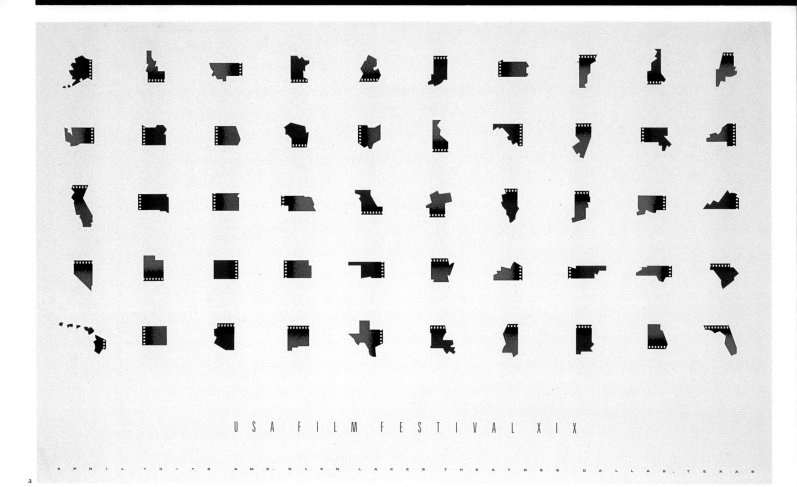

USA FILM FESTIVAL XIX

APRIL 13-19 AMC GLEN LAKES THEATRES DALLAS, TEXAS

a

a **USA Film Festival XIX,** Poster
Kenny Garrison, Art Director/Designer/Illustrator
Richards Brock Miller Mitchell & Assoc., Dallas, TX, Design Firm
USA Film Festival/Dallas, Client
Southwestern Typographics, Typographer
Heritage Press, Printer

DON'T LET
OVERDUE BILLS
MAKE YOU
GREEN AROUND
THE GILLS.
SCALE DOWN
REGISTRATION
WORRIES AND
PAY SPRING
TERM TUITION
BEFORE THE
DEADLINE—
APRIL 14.

UNDULATE
TRIGGERFISH
BALISTAPUS
UNDULATUS

b

GET IN
THE SWIM
OF THINGS
AND BE
AN ANGEL
IN OUR
SCHOOL.

COMPLETE
YOUR
TOUCH-TONE
REGISTRATION
FOR SPRING
TERM TODAY.

EMPEROR
ANGEL
POMACANTHUS
IMPERATOR

c

b **Overdue Bills,** Poster
McRay Magleby, Art Director/Designer/Illustrator
BYU Graphics, Provo, UT, Design Firm
Brigham Young University, Client
Jonathan Skousen, BYU, Typographer
Ray Robinson, BYU, Printer
Norm Darias, Copywriter

c **Get In the Swim,** Poster
McRay Magleby, Art Director/Designer/Illustrator
BYU Graphics, Provo, UT, Design Firm
Brigham Young University, Client
Jonathan Skousen, BYU, Typographer
Ray Robinson, BYU, Printer
Norm Darias, Copywriter

a

b

a **SUPRE Bottles,** Packaging
John Swieter, Art Director
John Swieter, Jim Vogel, Lee Collison, Designers
Swieter Design, Dallas, TX, Design Firm
SUPRE, Inc., Client
ARTLAB, Typographer
JM Screen Printing, Printer

b **Villa Ragazzi,** Wine Label
Melanie Doherty, Designer
Melanie Doherty Design, San Francisco, CA, Design Firm
Michaela and Gregory Rodeno/Rodeno Vineyards, Clients
Euro Type, Typographer
Bolling & Finke, Printer

c **CocoBliss,** Packaging
Steven Tolleson, Art Director
Steven Tolleson, Renee Sullivan, Designers
Tolleson Design, San Francisco, CA, Design Firm
CocoBliss, Client

Every time I've judged a graphic design competition, I've experienced at least a fleeting moment of disgust at the excess and wastefulness of our business. Usually it comes after looking at a pile of particularly slick capability brochures or self-conscious wedding invitations. One becomes disheartened at the cynicism of it all.

What a pleasure, then, to judge the AIGA Book Show. Every book, from the well-designed to the not-so-well-designed, bore the mark of someone's care and often passion. Even the humblest of books can be so obviously a labor of love; the fanciest annual report so seldom is.

Not to say the jury wasn't tough. Lavish picture books were viewed with more suspicion, if anything, than simpler trade books. I was also surprised at our impatience with the output of the small presses, much of which was prettily complacent rather than aggressively experimental. Textbooks seemed to be hurt rather than improved with the introduction of ever-higher production values. Hardcover fiction and non-fiction continue to be handicapped by the bizarre separation between the marketing-driven outside and the editorial-driven inside with never the twain meeting; why not break down the wall and make these books wholly satisfying objects?

Every choice was debated at length by a sometimes (slightly) combative but always thoughtful jury. The books that got in—and depending on how you count them, there were fifty, just like in the good old days—represent the very best of the noblest part of our profession. Critics looking for passion need look no further.

—Michael Bierut, Chairman, The Book Show

BOOKS ARE THE LEGACY THAT A GREAT GENIUS LEAVES TO MAN-kind, which are delivered down from generation to generation, as presents to the posterity of those who are yet unborn. *Joseph Addison* All good books are alike in that they are truer than if they had really happened. *Ernest Hemingway* Books are not absolutely dead things, but contain a potency of life in them to be as active as the soul whose progeny they are. *John Milton* Wherever they burn books, they will also, in the end, burn human beings. *Heinrich Heine* Books cannot be killed by fire. People die, but books never die. *Franklin Delano Roosevelt* Books, the children of the brain. *Jonathan Swift* You can cover a great deal of country in books. *Andrew Lang* I know some who are constantly drunk on books, as other men are drunk on whiskey or religion. *H.L. Mencken* It is chiefly through books that we enjoy intercourse with superior minds . . . God be thanked for books. *William Ellery Channing* I cannot live without books. *Thomas Jefferson* All that mankind has done, thought, gained or been: it is lying as in magic preservation in the pages of books. *Thomas Carlyle* No furniture so charming as books. *Sydney Smith* All books are divisible into two classes: the books of the hour, and the books for all time. *John Ruskin* Of making many books there is no end. *Ecclesiastes 12:12* If I read a book and it makes my whole body so cold no fire can ever warm me, I know that is poetry. *Emily Dickinson* A book must be the axe for the frozen sea within us. *Franz Kafka* We shouldn't teach great books; we should teach love of reading. *B.F. Skinner* Some books are to be tasted, others to be swallowed, and some few to be chewed and digested. *Francis Bacon* It is a great thing to start life with a small number of really good books which are your very own. *Sir Arthur Conan Doyle* Books think for me. *Charles Lamb* The true university these days is a collection of books. *Thomas Carlyle* There is no such thing as a moral or an immoral book. Books are well written, or badly written, that is all. *Oscar Wilde* How many a man has dated a new era in his life from the reading of a book. *H.D. Thoreau* My Book and heart/Must never part. *The New England Primer* A good book is the best of friends, the same today and forever. *Martin Farquhar Tupper* 'Tis a good reader that makes the good book. *Ralph Waldo Emerson* To produce a mighty book, you must choose a mighty theme. *Herman Melville* Only two classes of books are of universal appeal: the very best and the very worst. *Ford Madox Ford* A book may be very amusing with numerous errors, or it may be very dull without a single absurdity. *Oliver Goldsmith* No book is so bad that some good might be got out of it. *Pliny the Elder* A classic is a book that people praise but don't read. *Mark Twain* "What is the use of a book," thought Alice, "without pictures or conversations?" *Lewis Carroll*

A I G A
B O O K
S H O W
1 9 8 9

Call for Entries
The American Institute of Graphic Arts
Book Show 1989
Deadline: December 15, 1989

The Jury
Michael Bierut, Partner, Vignelli Associates, Chairman

Jury
Michael Bierut, Chairman, Partner, Vignelli Associates, New York, NY
Steven Heller, Senior Art Director, The New York Times Book Review, New York, NY
Maira Kalman, Writer, Illustrator and Shadowy Figure, M & Co., New York, NY
Andrew Stewart, President, Stewart Tabori & Chang, New York, NY
Douglas Wadden, Professor, University of Washington, Seattle, WA

Call for Entries
Michael Bierut, Design
Sterling Roman Press Inc., Printing
Warren 100 pd. Lustro Dull Cream Text, Paper
Typo Graphic Technology Inc., Typesetting

a **Dykelands**
b **Paul Manship**

a crazy collage, a hand-dipped chocolate
stamped with wild wedges, cracked logos

of a thousand sneakers, and giant biting gnats
in some unknown, unseen ritual, they did dance

on this likely place, exhausted with their whining
and walking, the gnats gave way to mincing moles

then gluttonous gulls, foot-stomping steamers
placing their webbed soles in gull-grip

so did those shapes shift into place for now
so did the oyster shells make their pattern

now they are gone except the wedged-wildness
of their dance, frozen in sandstone shapes.

a

2 · THE ART STUDENT

Before deciding on New York, Paul had considered going to Chicago. The second city was much closer to home, and it offered an excellent art school at the Art Institute. But New York was where the major artists lived and worked, so that was where he got off the train. He immediately signed up for classes at the Art Students League, where he studied sculpture with Hermon MacNeil—the first of several Beaux-Arts–trained sculptors with whom Manship was to study—and drawing with George Bridgman, a celebrated anatomist who taught at the League for more than forty years. Mac-Neil's assistant and class monitor was Jo David-son, later the most suc-cessful portrait sculptor who became a close of his time. Manship, Davidson with being the first to show him how to build an armature—one of a young sculptor's most important lessons. Manship tried to make his small savings stretch as far as possible in New York. For instance, he frequented bars that offered a free lunch with a nickel glass of beer. Even so, after a few months he knew he would have to find work. In the spring of 1905 Manship did get a job, which paid two dollars a week, as studio assistant to the sculptor Solon Borglum. Well known for his western themes, particularly depictions of American Indians, Borglum was a westerner, originally from Utah, and had been trained as a sculptor in Paris. He was habitually a loner, but the fact that he had two major public commissions to execute probably accounts for his hiring Manship. Once summer arrived, Borglum moved his work from his studio at 30 East Fourteenth Street to a rented house and barn in Mamaroneck, New York. Paul moved in with the Borglums and thus was able to save much of his salary.

Solon Borglum
3 MAN WITH WILD
HORSES, 1902
Detail of plate 12

b

a **Dykelands**
Thaddeus Holownia and Douglas Lochhead, Authors
Robert Tombs, Art Director
Thaddeus Holownia, Douglas Lochhead, and David Carruthers, Designers
Thaddeus Holownia, Photographer
McGill-Queen's University Press, Montreal, CAN, Publisher
Avant-Garde Ltd., Typographer
Herzig Somerville Ltd., Printer
Karma and St. Armand Handmade with Marshgrass, Papers
Anstey Graphic Ltd., Binder
Thaddeus Holownia, Jacket Photographer

b **Paul Manship**
John Manship, Author
James Wageman, Designer
Abbeville Press, Inc., New York, NY, Publisher
Dix Type Inc., Typographer
Toppan Printing, Printer/Binder

a **CCAIAX: The Art of Interior Architecture: 1979–1989**

b **Rolling Stone: The Photographs**

Certificate of Merit

Ashcraft & Ashcraft, Ltd.
Chicago, Illinois
Swanke Hayden Connell
Architects

For this 15,000-square-foot law office, the architects used inexpensive and readily available materials, including residential grade glass doors and castings. Careful integration of such common elements with a limited selection of more sophisticated materials and furnishings results in a highly finished environment that remains within strict budget limits. An ordered pattern of open and closed areas extends the grid on which the space is planned. Alternating glass and solid partitions allow views of Lake Michigan to reach interior work spaces.

The diagonally arranged squares of the architectural "art" on corridor walls reinforce the order of the planning grid. Colors and materials mirror Lake Michigan's hues of blue, green and gray. Secretarial stations were custom designed, and the reception desk was designed to coordinate with the Le Corbusier reception furniture.

Project Team
Roland L. Lieber, Janet Hahn Lougee, Vicki Loevy, Chris Conley

Client
Ashcraft & Ashcraft, Ltd.

Contractor
Turner Construction Company, Special Projects Division

Interior Photographer
Bruce Van Inwegen

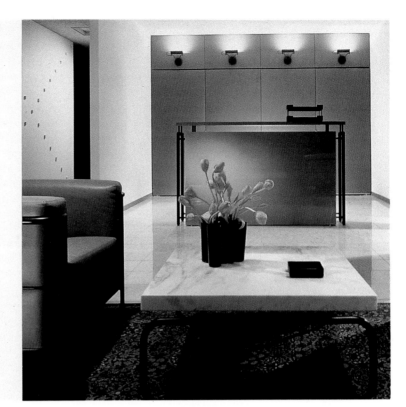

100 101

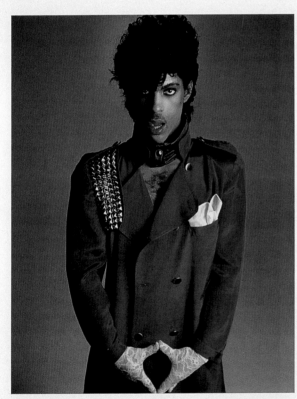

PRINCE by Richard Avedon

APRIL 28TH, 1983

50

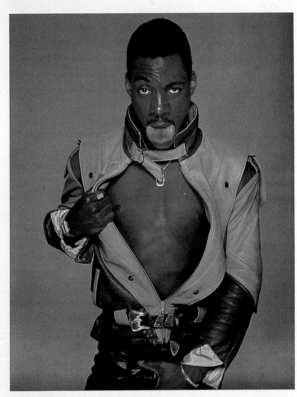

EDDIE MURPHY by Richard Avedon

JULY 7TH, 1983

51

a **CCAIAX: The Art of Interior Architecture: 1979-1989**
 Various, Authors
 Various, Designers
 Various, Illustrators/Photographers
 American Institute of Architects, Chicago Chapter, Chicago, IL, Publisher
 American Institute of Architects, Chicago Chapter, Typographer
 Everbest Printing Company, Ltd. for Four Colour Imports, Ltd., Printers
 Art Glossy, Paper
 Everbest Printing Company, Ltd., Binder
 Sam Silvio, Jacket Designer

b **Rolling Stone: The Photographs**
 Laurie Kratochvil, Editor
 Fred Woodward, Designer
 Various, Photographers
 Simon and Schuster, New York, NY, Publisher
 Dai Nippon Printing Co. Ltd., Printer
 Fred Woodward, Jacket Designer
 Steven Meisel, Jacket Photographer
 Dennis Ortiz-Lopez, Jacket Letterer

a **Frederick Kiesler**
b **Berenice Abbott, Photographer: A Modern Vision**
c **This is My Blood**
d **"Papa": A Play Based on the Legendary Lives of Hemingway**

Frederick Kiesler
Chronology 1890–1965

The Yolla Bolly Press

J. LAUGHLIN

THIS IS MY BLOOD

James Laughlin This Is My Blood

a

b

c

d

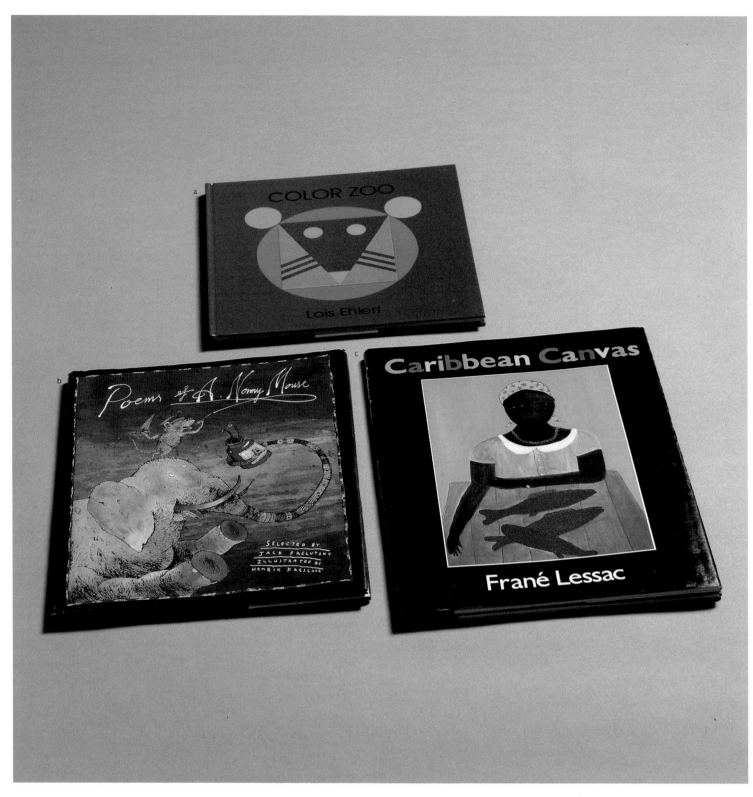

a **Color Zoo**
b **Poems of a Nonny Mouse**
c **Caribbean Canvas**

RECTANGLE MONKEY

a **Color Zoo**
 Lois Ehlert, Author
 Harriet Barton, Art Director
 Lois Ehlert, Designer/Illustrator
 J.B. Lippincott, New York, NY, Publisher
 Bettina Rossner, Typographer
 Tien Wah Press, Printer/Binder
 John Vitale, Production Manager

b **Poems of a Nonny Mouse**
 Jack Prelutsky, Author
 Denise Cronin, Art Director
 Mina Greenstein, Designer
 Henrik Drescher, Illustrator
 Alfred A. Knopf, Inc., New York, NY, Publisher
 CT + Photogenic Graphics, Inc., Typographer
 Rand McNally, Printer
 Elaine Silber, Production Manager
 Baldwin Makers Matte 80#, Paper
 Rand McNally, Binder
 Henrik Drescher, Jacket Illustrator
 Henrik Drescher, Letterer

c **Caribbean Canvas**
 Harriett Barton, Art Director
 Andrew Rhodes, Designer
 Frane Lessac, Selector and Illustrator
 J.B. Lippincott Junior Books, New York, NY, Publisher
 Linoprint Composition Co., Inc., Typographer
 General Offset Co., Inc., Printer
 John Vitale, Production Manager
 Patina Matt 80lb., Paper
 Book Press Inc., Binder
 Andrew Rhodes, Jacket Designer
 Frane Lessac, Jacket Illustrator

a **Close to Home/Seven Documentary Photographers**
b **Aaron Siskind/Road Trip: Photographs 1980–1988**
c **The Art of Zen**

BIRNEY IMES

The Whispering Pines

For almost fourteen years I have been photographing in two rural counties near my home in Columbus, Mississippi. Rather than approach this work in a systematic or methodical way, I often rely on whim or instinct in deciding where I go, and I strive to make the process leisurely and enjoyable. I ride out through the country with hopes of finding a site or a situation that will yield photographs, but there are certain people and places that serve as touchstones for me as I travel about. One of the places that I have been visiting over the years is called The Whispering Pines. The Pines is the shell of a restaurant and bar built by Blume Triplett for his wife Eppie in 1949. In its day, the Pines had a flourishing restaurant trade. One could eat a steak in the Yellow Canary Dining Room, then go outside and dance to jukebox music under a blue neon moon that hung in the swaying pine trees that surrounded the concrete dance floor. After Eppie's death in 1973, the Pines stopped serving food, and business slowly declined. The restaurant is now run by Rosie Stevenson, a fifty-two-year-old woman who has worked there for more than twenty-five years. The Pines was built with separate sides for its black and its white customers. Today, the white side is clogged with an assortment of debris that Blume has amassed over the years, and what business there is takes place on the black side. Some things that I have found — and sometimes photographed — while wandering through The Pines are dried chicken feet tied to a quart beer bottle, a "Hello Dolly" pinball machine, piles of old political campaign posters behind stacks of old cigar boxes each bearing the date of when it was first opened and a dozen or so old jukeboxes, one with the song "Whistling Pines" by Big Joe Williams, a bluesman who lived in nearby Crawford. These physical attributes, coupled with my interest in the interaction between Blume, a white Mississippian lacking ten years of being as old as the century, and his mostly black clientele, and later my deepening friendship with Blume and Rosie, have sustained my interest in The Whispering Pines as an ongoing photographic project for me. Most often my visits are random and unannounced, but sometimes I go there with some specific photographic idea in mind. This is usually when some scheduled event is taking place: the shooting of guns into the air at midnight on New Year's Eve, a birthday party for Blume, or a chitlin supper given for the regulars. One recent night I went out to The Pines for a visit, keeping a promise I had made to Blume over a month before to bring him a chocolate meringue pie from Buck and Helen's. Before Blume had finished his first piece of pie, John came in with a plastic jug of moonshine and offered Blume a drink. Later T.P., Rosie's brother, came in and for the rest of the evening we talked, told stories and laughed. In the more than ten years that I have been photographing in and around the Pines, I have used a variety of cameras and approaches. I have photographed the place and its contents with a large-format view camera, made portraits with a tripod-mounted rollfilm camera and photographed activities going on there with a handheld camera with flash. As one of the regulars at the Pines, I spend more time visiting and talking with the people than I do photographing. When I do get out my camera, it is part of the natural ebb and flow of events, and little changes unless we are taking posed pictures. Photography is as routine an activity as playing the jukebox or drinking a beer at the counter. The Pines has been a rich source of pictures for me. Though my primary concern has been the singular image, in the process I have generated a group of pictures that I hope will preserve the look and spirit of the place and the people who pass through it.

Blume and Mary 409 Thomas, New Year's Eve, 1988

a **Close to Home/Seven Documentary Photographers**
 David Featherstone, Editor
 Michael Mabry, Designer
 Shelby Lee Adams, Debbie Fleming Caffery, Doug DuBois, Roland L.
 Freeman , Birney Imes, Stephen Marc and Marilyn Nance, Photographers
 Friends of Photography, San Francisco, CA, Publisher
 On Line Typography, Typographer
 Gardner Lithograph, Printer
 Beau Brilliant Del Monte Red and Centura Dull Book, Papers

b **Aaron Siskind/Road Trip: Photographs 1980-1988**
 Charles Traub, Author
 Michael Mabry, Designer
 Aaron Siskind, Photographer
 Friends of Photography, San Francisco, CA, Publisher
 On Line Typography, Typographer
 Gardner Lithograph, Printer
 Kromekote and Centura Dull Book, Papers

c **The Art of Zen**
 Stephen Addiss, Author
 Elissa Ichiyasu, Designer
 Harry N. Abrams, Inc., New York, NY, Publisher
 The Sarabande Press, Typographer
 Sankyo Gravure Printing Co., Ltd., Printer/Binder
 Shun Yamamoto, Production Director
 Fukiage, Paper
 Elissa Ichiyasu, Jacket Designer

a **American Illustration 8**
b **German Expressionist Prints and Drawings**
c **American Photography 5**

a **American Illustration 8**
 Edward Booth-Clibborn, Editor
 Woody Pirtle, Art Director
 Woody Pirtle and Penny Rowland, Designers
 Various, Illustrators
 Lanie Kagan, Production Coordinator
 Rizzoli International Publications, New York, NY, Publisher
 Seven Graphic Arts, Typographer
 Toppan Printing Co. Ltd., Printer
 White Matte Coated, Paper
 Woody Pirtle, Jacket Designer
 Jack Unruh, Jacket Illustrator

b **German Expressionist Prints and Drawings**
 Various, Authors
 Deenie Yudell, Art Director/Designer
 Various, Artists
 Peter Brenner, Photographer
 Los Angeles County Museum of Art/Prestel-Verlag, Los Angeles, CA,
 Publisher
 Continental Typographics and Aldus Type Studio, Ltd., Typographers
 R. Oldenbourg GmbH, Printer/Binder
 Eileen Delson, Production Artist
 Scheufelen BVS Dull-Coated, Paper
 Deenie Yudell, Jacket Designer
 Conrad Felixmuller, Jacket Illustrator

c **American Photography 5**
 Edward Booth-Clibborn, Editor
 Stephanie Van Dine, Project Director
 Stephen Doyle, Art Director
 Rosemarie Turk and Christopher Johnson, Designers
 American Photography Inc. and Rizzoli International Publications,
 New York, NY, Publishers
 Dai Nippon Printing Co. Ltd., Printer/Binder
 Stephen Doyle, Jacket Designer
 Herb Ritts, Jacket Photographer

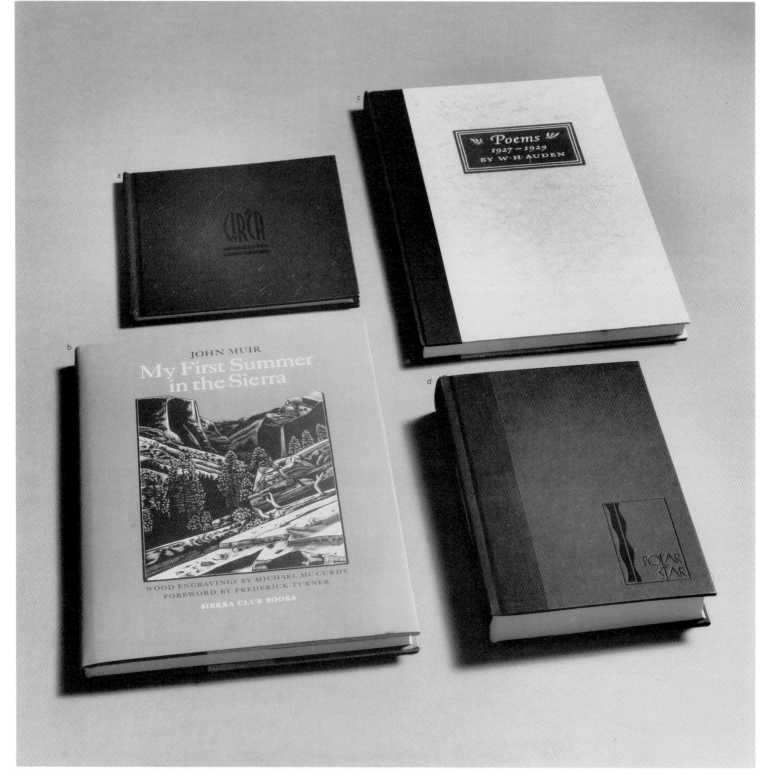

a **Circa—Voyage of All Time**

b **My First Summer in the Sierra**

c **Poems 1927–1929 W.H. Auden**

d **Polar Star**

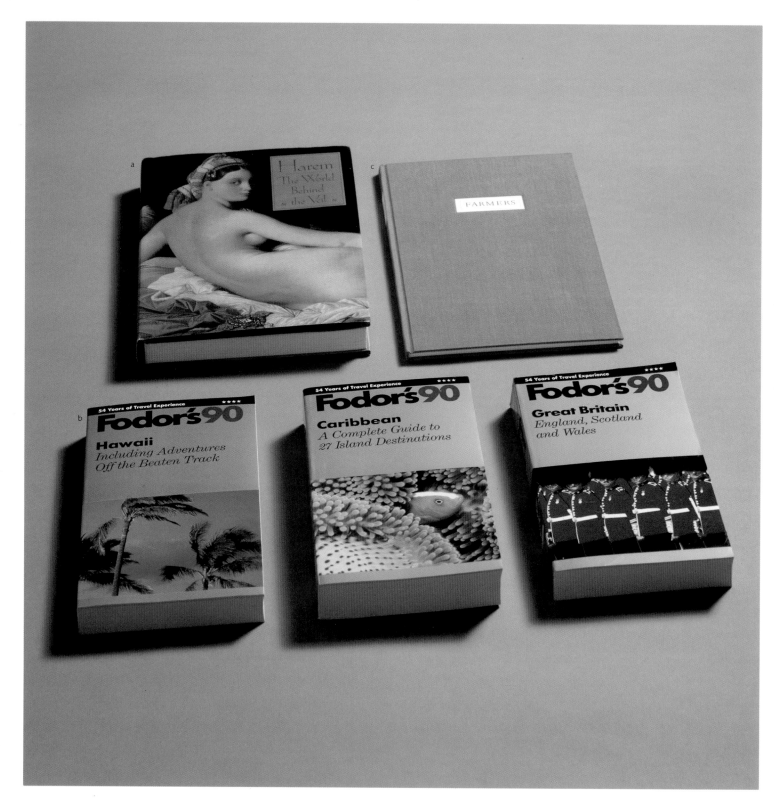

a **Harem: The World Behind The Veil**
b **Fodor's Travel Guides**
c **Farmers**

HERMAN SCHANILEC JR

a **Harem: The World Behind The Veil**
Alev Lytle Croutier, Author
Renee Khatami, Designer
Abbeville Press, Inc., New York, NY, Publisher
Dix Type Inc., Typographer
Toppan Printing Co., Ltd., Printer/Binder
Hope Koturo, Production Manager

b **Fodor's Travel Guides**
Fabrizio La Rocca, Art Director/Designer
David Lindroth, Inc., Cartographer
Karl Tanner, Illustrator
Various, Photographers
Fodor's Travel Publications, Inc., New York, NY, Publisher
Blackdot Graphics and Typogram, Typographers
Coral Graphics and R.R. Donnelley & Sons Co., Printers
C.R. Bloodgood, Production Manager
R.R. Donnelley & Sons Co., Binder

c **Farmers**
Clayton Schanilec, Editor
Gaylord Schanilec, Art Director/Designer
Gaylord Schanilec, Illustrator
Midnight Paper Sales Press, Stockholm, WI, Publisher
Gaylord Schanilec, Typographer
Gaylord Schanilec, Printer
Gaylord Schanilec, Production Manager
Mohawk Super Fine, Paper
Campbell-Logan Bindery, Binder

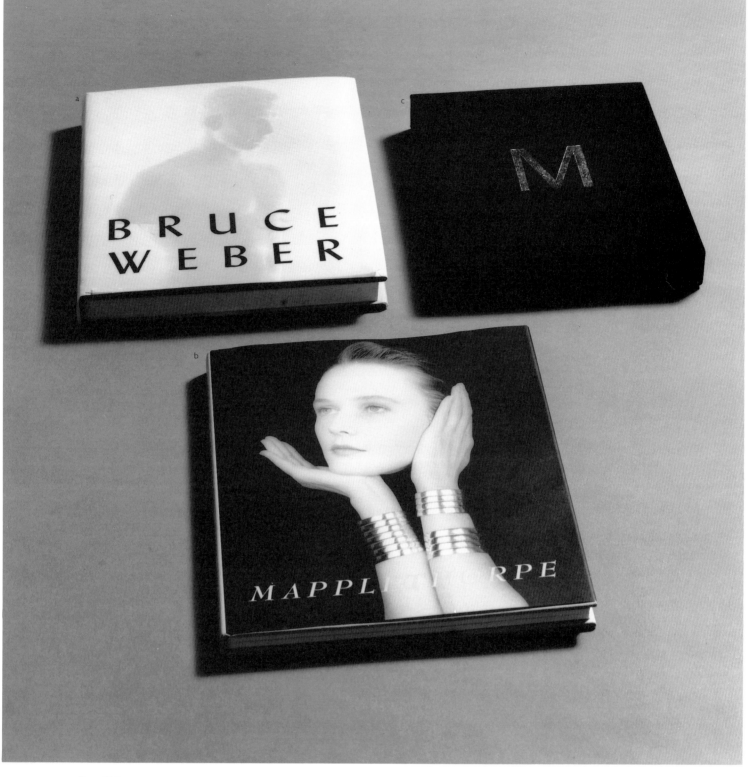

a **Bruce Weber**
b **Some Women**
c **Herb Ritts, Men/Women**

a

b

c

a **Bruce Weber**
 Bruce Weber, Author
 John Cheim, Art Director/Designer
 Bruce Weber, Photographer
 Alfred A. Knopf Inc., New York, NY, Publisher
 Heraclio Fournier, Printer/Binder
 Ellen McNeilly, Production Manager
 Dulcet, Paper
 John Cheim, Jacket Designer
 Bruce Weber, Jacket Photographer

b **Some Women**
 Robert Mapplethorpe, Author
 Dimitri Levas, Designer
 Robert Mapplethorpe, Photographer
 Bulfinch Press/Little, Brown & Co., Boston, MA, Publisher
 Typographic Images, Inc., Typographer
 Meriden-Stinehour Press, Printer
 Amanda Wicks Freymann, Production Manager
 Mohawk Superfine, Paper
 Nicholstone Book Bindery, Binder
 Dimitri Levas, Jacket Designer
 Robert Mapplethorpe, Jacket Photographer

c **Herb Ritts, Men/Women**
 Herb Ritts, Author
 Jack Woody, Designer
 Herb Ritts (c/o Fahey Klein Gallery), Photographer
 Twin Palms Publishers, Altadena, CA, Publisher
 Singapore National Printers Ltd. and Palace Press, Printers/Binders
 European Matte Art, Paper
 Jack Woody, Jacket Designer

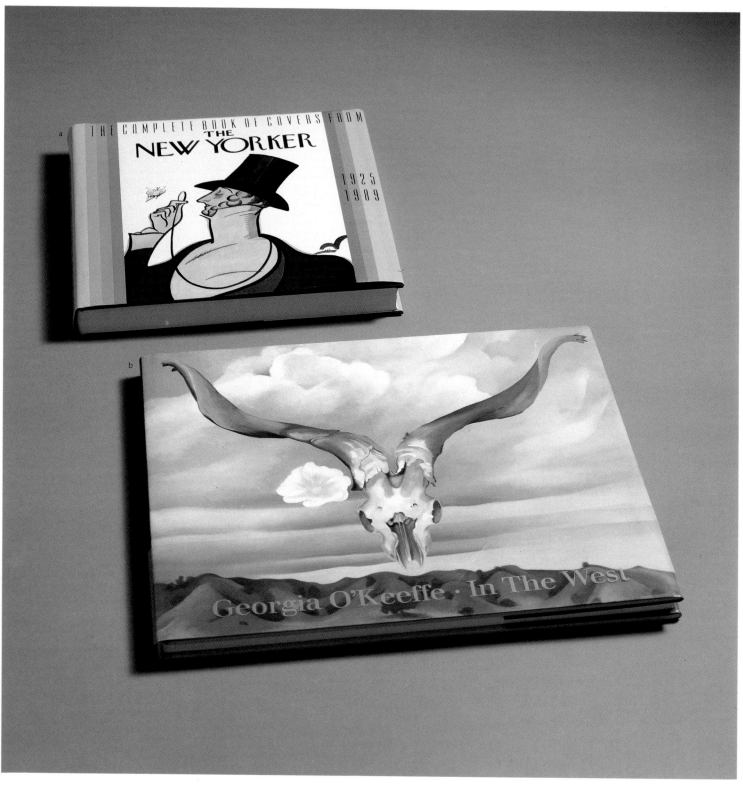

a **The Complete Book of Covers from the New Yorker**
b **Georgia O'Keefe: In the West**

a

b

Georgia O'Keeffe · In The West

Edited by Doris Bry and Nicholas Callaway

Alfred A. Knopf
in association with Callaway · New York · 1989

a **The Complete Book of Covers from the New Yorker**
John Updike, Author (Foreword)
Virginia Tan, Art Director/Designer
Tony Holmes, Photographer
Alfred A. Knopf Inc., New York, NY, Publisher
R.R. Donnelley & Sons Co. and Swift Typographers, Typographers
Williams Litho Services, Separators
Dai Nippon Printing Co. Ltd., Printer/Binder
Ellen McNeilly, Production Manager
U-Lite, Paper
Robert Scudellari, Jacket Designer

b **Georgia O'Keefe: In the West**
Doris Bry and Nicholas Callaway, Authors
Katy Homans, Art Director/Designer
Georgia O'Keefe, Artist
Steven Sloman, Photographer
Michael Bixler, Letterer
**Alfred A. Knopf in association with Callaway Editions, Inc.,
NY,** Publisher
Michael and Winifred Bixler, Typographers
Nissha Printing Co., Printer
Kathleen Giel, Production Manager
Espel, Paper
Toppan Printing Co., Binder
Nicholas Callaway and Katy Homans, Jacket Designers
Steven Sloman, Jacket Photographer

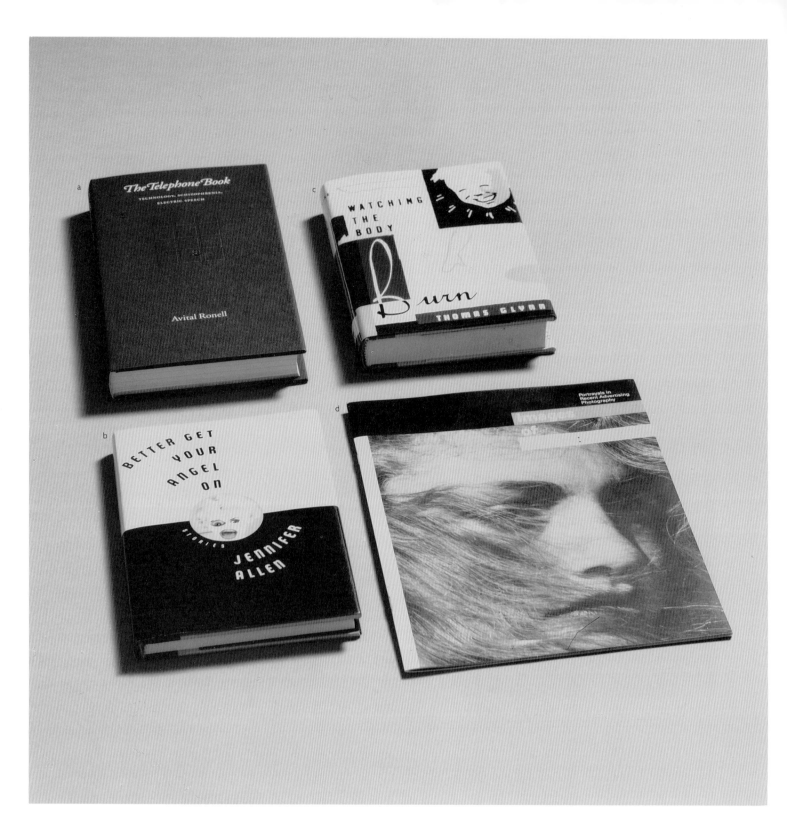

a **The Telephone Book**
b **Better Get Your Angel On**
c **Watching the Body Burn**
d **Images of Desire**

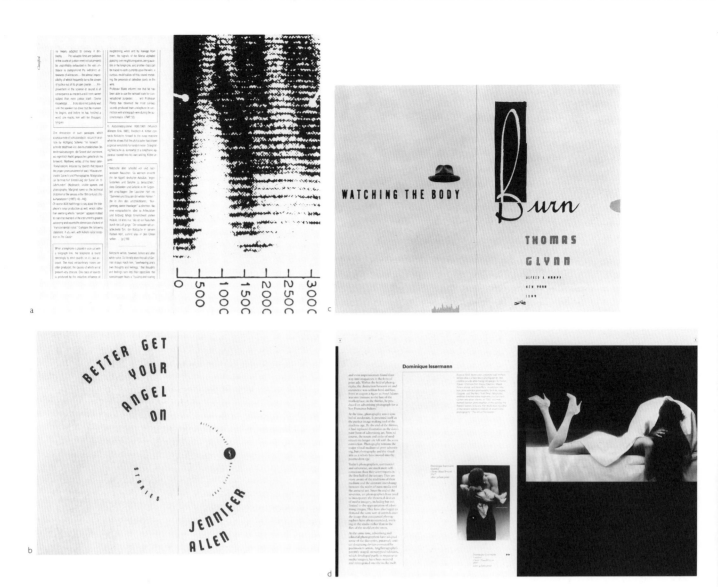

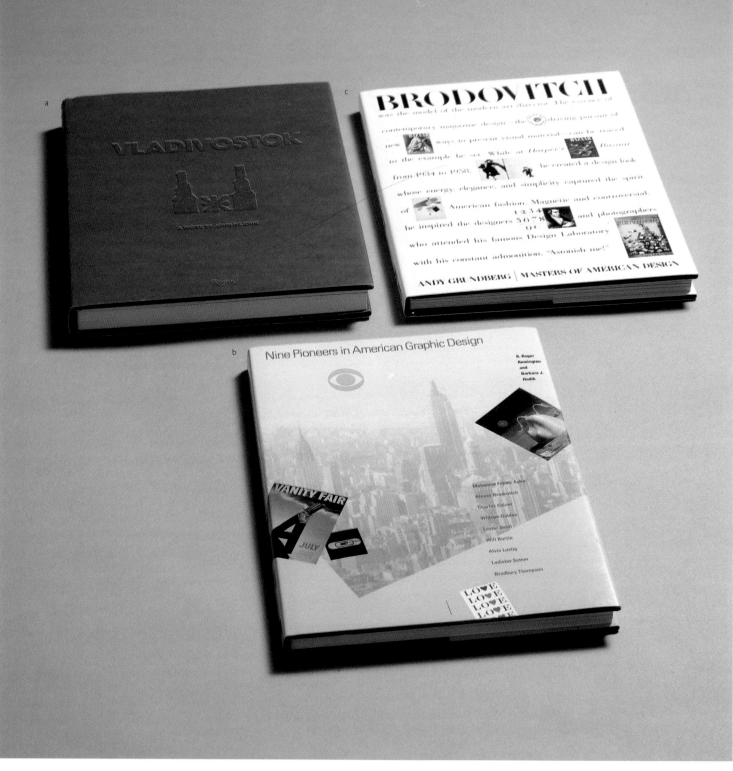

a **Vladivostock**
b **Nine Pioneers in American Graphic Design**
c **Brodovitch**

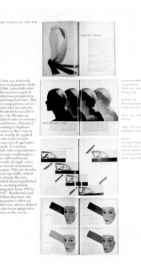

a **Vladivostok**
Kim Shkapich, Art Director
John Hejduk, Illustrator
Helene Binet, Photographer
Rizzoli International Editore, New York, NY, Publisher

b **Nine Pioneers in American Graphic Design**
Roger R. Remington and Barbara Hodik, Authors
Diane Jaroch, Art Director/Designer
Various, Illustrators and Photographers
The MIT Press, Cambridge, MA, Publisher
Craftsman Type, Typographer
Dai Nippon Printing Co. Ltd., Printer/Binder
Dick Wolflein, Production Manager
Royal Art Matt, Paper
Diane Jaroch, Jacket Designer
Various, Jacket Illustrators and Photographers

c **Brodovitch**
Andy Grundberg, Author
Will Hopkins, Project Manager
Ray Komai, Designer
Harry N. Abrams, Inc., New York, NY, Publisher
Axiom Design Systems, Typographer
Nissha Printing Co., Ltd., Printer/Binder
Shun Yamamoto, Production Director
Fukiage and Iro-Joshitsu, Papers
Samuel N. Antupit, Jacket Designer

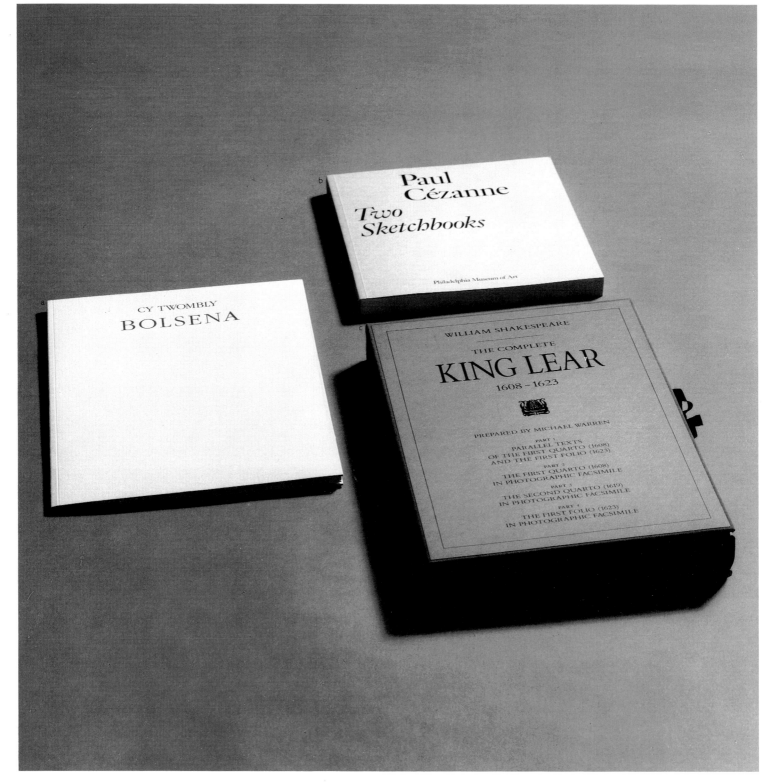

a **Cy Twombly/Bolsena Paintings**
b **Paul Cezanne: Two Sketchbooks**
c **The Complete King Lear 1608–1623**

a

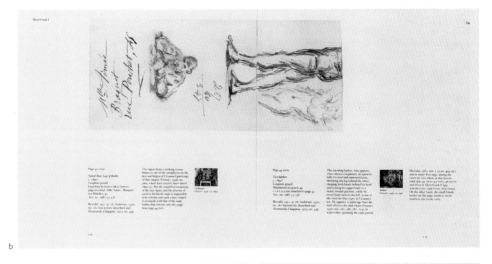

b

c

a **Cy Twombly/Bolsena Paintings**
Heiner Bastian, Author
Dan Miller, Art Director/Designer
Cy Twombly, Artist
Gagosian Gallery, New York, NY, Publisher
L. P. Thebault Company, Printer
Wayne Brown and Tom Grant, Production Managers
Sendor Bindery, Inc., Binder

b **Paul Cezanne: Two Sketchbooks**
Theodore Reff and Innis Howe Shoemaker, Authors
George H. Marcus, Art Director
Nathan Garland, Designer
Paul Cezanne, Artist
Graydon Wood, Photographer
Philadelphia Museum of Art, Philadelphia, PA, Publisher
Southern New England Typographic Service, Typographer
Stamperia Valdonega, Printer/Binder
Pordenone and Modigliani, Papers
Nathan Garland, Jacket Designer

c **The Complete King Lear 1608-1623**
Michael J. Warren, Editor
Chet Grycz, Art Director
Sandy Drooker, Designer
University of California Press, Berkeley, CA, Publisher
Ann Flanagan Typography, Typographer
Malloy Lithographing Inc., Printer
Ina Clausen, Production Coordinator
Anthony Crouch, Production Manager
Karma Matte, Paper
Special Editions Inc., Binder
Sandy Drooker, Designer (Portfolio Box)

a **The Photography of Invention**

b **Joel-Peter Witkin: Gods of Earth and Heaven**

Born: Bronx, New York, 1942
Resides: Los Angeles, California

American Gothic, 1985
Cibachrome prints, wood, aluminum
96 x 96 in.
Burnett Miller Gallery, Los Angeles

JEFF WEISS

200 • 201

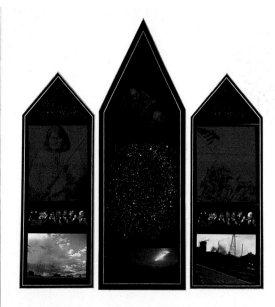

a

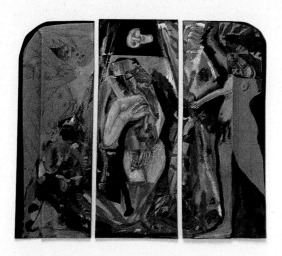

Gods of Earth and Heaven

b

JOEL-PETER WITKIN

GODS OF EARTH AND HEAVEN

a **The Photography of Invention**
Joshua Smith, Editor
Diane Jaroch, Art Director/Designer
Various, Photographers
The MIT Press, Cambridge, MA and,
The National Museum of Art (Smithsonian Institution), Washington,
D.C., Publishers
Macintosh-generated type, Typographer
Dai Nippon Printing Co. Ltd., Printer/Binder
Dick Wolflein, Production Manager
Royal Art Matt, Paper
Diane Jaroch, Jacket Designer
Sandy Skoglund, Jacket Photographer

b **Joel-Peter Witkin: Gods of Earth and Heaven**
John Yau and Gus Blaisdale, Authors
Jack Woody, Designer
Twelvetrees Press, Pasadena, CA, Publisher
Joel-Peter Witkin, Production Supervisor
Jack Woody, Jacket Designer

a **Modern Architecture**
b **Blueprints for Modern Living**
c **Louis Mueller**

a **Modern Architecture**
 Otto Wagner, Author
 Henry Francis Mallgrave, Translator
 Julia Bloomfield, Art Director
 Laurie Haycock, Designer
 Don Williamson and John Kiffe, Photographers
 The Getty Center for the History of Art and the Humanities,
 Santa Monica, CA, Publisher
 Continental Typographics, Inc., Typographer
 The Castle Press, Printer
 Julia Bloomfield and Hadley Soutter, Production Managers
 Mohawk Superfine 70 lb White and Soft White, Paper
 Roswell Bookbinding Co., Binder
 Laurie Haycock, Jacket Designer

b **Blueprints for Modern Living**
 Lorraine Wild, Designer
 Various, Photographers
 The MIT Press and Museum of Contemporary Art,
 Los Angeles, CA, Publishers
 Mondo Typo, Typographer
 Donahue Printing, Inc., Printer
 Roswell Bindery, Binder
 Lorraine Wild, Jacket Designer
 Esther McCoy, Jacket Photographer

c **Louis Mueller**
 Addison Parks, Author
 Michael Glass, Art Director/Designer
 Helen Drutt Gallery, New York, NY, Publisher
 Typographic Resource, Typographer
 Meridian Printing, Printer
 Gleneagle Dull Text, 100#, and Tuxedo Cover After Midnight, 115#,
 Papers

a **Fragments for a History of the Human Body**

b **Belles Lettres Series**

An Older Form of Manufacture, In Contrast (the Forge)

Factories did not spring up from nowhere; they developed from the need to coordinate actions, and from more or less explicit overall "automatization." This eighteenth-century factory has not yet reached its final form, but it's on the way there.

From Diderot and D'Alembert, L'Encyclopédie, 1765.

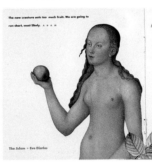

THE CONSTANT HEART

Shall I compare thee to a summer's day?
Thou art more lovely and more temperate.
Rough winds do shake the darling buds of May,
And summer's lease hath all too short a date.
Sometime too hot the eye of heaven shines,
And often is his gold complexion dimmed;
And every fair from fair sometime declines,
By chance or nature's changing course untrimmed.
But thy eternal summer shall not fade,
Nor lose possession of that fair thou ow'st,
Nor shall Death brag thou wand'rest in his shade,
When in eternal lines to time thou grow'st.
So long as men can breathe or eyes can see,
So long lives this, and this gives life to thee.

ZONE 4

a

Fragments for a History of the Human Body

Michel Feher, Editor

Ramona Naddaff and Nadia Tazi, Associate Editors

Bruce Mau, Art Director/Designer

Christine de Coninck and Anne Mensior, Image Research

Urzone Inc., New York, NY, Publisher

Bruce Mau, Typographer

Canadian Composition Inc., Typesetting

Provincial Graphics Inc., Printer

Zone Vellum Text, Paper

York Bookbinders, Binder

b

Belles Lettres Series

Christopher Ozubko, Seattle, WA, Art Director

Susan Ozubko, Jo Ann Sire, John Linse, Designers

Various, Photographers/Illustrators

Jana Stone, Series Editor

Jana Stone and Ozubko Design with STC, Publishers

Roy Finamore, Editor

Art-foto and Western Type, Typographers

Arnoldo Mondadori Editore S.p.A., Printer/Binder

Kathy Rosenbloom, Production Manager

Gardamatte, Paper

a **Two Rivers**
b **Oneg Shabbat**
c **Checklist: Stone House Press Books and Ephemera, 1978–1988**
d **Abberations**

TWO RIVERS

His father's voice awakened him. Stretching his back, arching against the mattress, he looked over at his parents' end of the sleeping porch. His mother was up too, though he could tell from the flatness of the light outside that it was still early. He lay on his back quietly, letting complete wakefulness come on, watching a spider that dangled on a golden, shining thread from the rolled canvas of the blinds. The spider came down in tiny jerks, his legs wriggling, then went up again in the beam of sun. From the other room the father's voice rose loud and cheerful.

Oh I'd give every man in the army a quarter
If they'd all take a shot at my mother-in-law.

The boy slid his legs out of bed and yanked the nightshirt over his head. He didn't want his father's face poking around the door, saying, "I plough deep while sluggards sleep!" He didn't want to be joked with. Yesterday was too sore a spot in his mind. He had been avoiding his father ever since the morning before, and he was not yet ready to accept any joking or attempts to make up. Nobody had a right hitting a person for nothing, and you bet they weren't going to be friends. Let him whistle and sing out there, pretending nothing was the matter. The whole business yesterday was the matter, the Ford that wouldn't start was the matter, the whole lost Fourth of July was the matter, the missed parade, the missed fireworks, the missed ballgame in Chinook were the matter.

JOHN DE POL
From Dark to Light

WITH AN ESSAY BY JOAN & JOHN DIGBY
AND AN INTRODUCTION,
CAPTIONS & NOTES BY M.A. GELFAND

Wood Engravings
for The Stone House Press

ROSLYN NEW YORK THE STONE HOUSE PRESS MCMLXXXVIII

Title page, 8¼x...

GOD, OPEN MY LIPS AND MY MOUTH SHALL DECLARE YOUR PRAISE.

You are blessed, our God and God of our ancestors, God of Abraham and Sarah, God of Isaac and Rebecca, and God of Jacob, Leah and Rachel, great, mighty, awesome, and exalted God. You bestow lovingkindness and possess all things. Mindful of our ancestors' love for You, You will lovingly bring redemption to their children's children. You are the Sovereign who helps, saves and protects. Blessed are You, Almighty, Shield of Abraham. You are mighty forever; You give immortality to the dead.

You cause the wind to blow and the rain to fall.

You sustain the living with lovingkindness, and in great mercy give immortality to the departed. You uphold the falling, heal the sick, set free those in bondage, and keep faith with those who sleep in the dust. Who is like You, Almighty God, who decrees death and life, and brings salvation? Blessed are You who gives immortality to the dead. You are holy and holy is Your name, and holy are those who praise You daily. Blessed are You, Almighty, our holy God.

Jury
Melissa Tardiff, Chairman, Art Director, *Town & Country*,
New York, NY
Chris Hill, Principal, Hill/A Marketing Design Group,
Houston, TX
Will Hopkins, Partner, Hopkins/Bauman, New York, NY
Jill M. Howry, Partner, Russell, Howry & Associates,
San Francisco, CA
John Jay, Senior Vice President and Creative Director for
Advertising and Design, Bloomingdale's, New York, NY

Call for Entries
Richard Turtletaub, New York, NY, Design
Unitron Graphics, Inc., Long Island City, NY, Typesetting
Gotham Graphics Inc., Lyndhurst, NJ, Color Separations
and Printing
Mohawk Paper Mills, Inc., Cohoes, NY, Paper
Sendor Bindery, New York, NY, Folding

insides

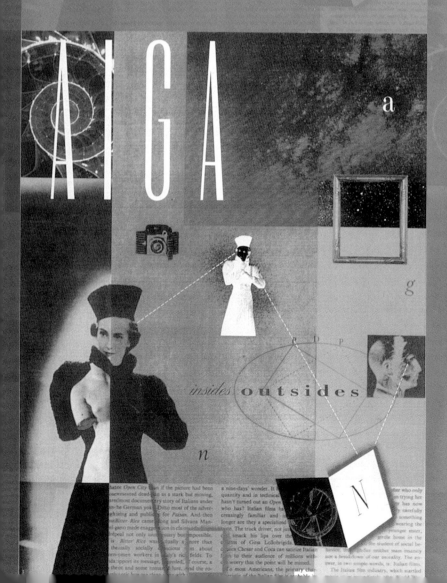

Insides/Outsides combined the Cover Show with a look at

the insides of publications. Its broad base resulted in a lively

mix of entries; from **LP** album covers (alas, too few of a

dying art), to promotional materials for everything from

o u t s i d e s

real estate to fashion, to mainstream magazines.

I had secretly hoped that some hypercard stacks would

be entered to challenge the notion of what a publication is;

however, none were. I was pleased to see small (under five

inches) pieces survive the rigors of judging to become a touch

of whimsy in the show.

The ephemeral nature of most of the entries struck me

during the judging—magazines are good until the next issue

hits the newsstand; real estate and fashion promos, until

the sale is made (perhaps not even that long), and invita-

tions, until the party begins.

Given the perishable nature of much of the work, the

purely documentary aspect of the **AIGA** shows is to be

lauded. It preserves for all of us a look at exceptional work.

—Melissa Tardiff, Chairman, Insides/Outsides

a

b

a **The Byblos Boutique at Marc Laurent,** Folder
Del Terrelonge, Toronto, CAN, Art Director
Ron Baxter Smith, Photographer
Terrelonge Design Inc., Design Firm
Marc Laurent, Publisher/Client
Lind Graphics, Typographer
Arthurs-Jones, Lithographers

b **Generra Men's Collection Spring 1990,** Brochure
Carol Davidson, David Edelstein and Lanny French, Seattle, WA, Art Directors
Carol Davidson, Designer
Mike Ross, Photographer
Edelstein Associates Advertising, Design Firm/Agency
Generra, Publisher/Client
Thomas & Kennedy, Typographer
United Graphics, Printer

c **Generra Fashion System,** Promotional Item
David Edelstein, Nancy Edelstein and Lanny French, Seattle, WA, Art Directors
Carol Davidson, David Edelstein, Nancy Edelstein and Lanny French, Designers
Peter Gravelle, Photographer
Edelstein Associates Advertising, Inc., Design Firm/Agency
Generra, Publisher/Client
Thomas & Kennedy, Typographer
Atomic and George Rice & Sons, Printers

a

b

a **Ghosts 1988: A Time Remembered,** Calendar Booklet
Jennifer Morla, San Francisco, CA, Art Director
Phil Makana, Photographer
Morla Design, Design Firm
Ghosts, Publisher/Client
On Line, Typographer
Dai Nippon Printing Co., Printer

b **The World is Our Campus,** Brochure
Linda Sullivan, Provo, UT, Art Director
Linda Sullivan and Lily McColough, Designers
John Snyder, Photographer
BYU Graphics, Design Firm
Brigham Young University Press, Publisher
Jonathan Skousen, Typographer
BYU Press, Printer

Nine-Layer Dip
Refried beans, cheddar cheese, guacamole, black olives, seasoned sour cream, green onions, tomatoes and cilantro, served with tortilla chips and fresh salsa.

customers." To maintain customer interest and keep the commercials fresh and new, the creative copy was changed frequently. However, the music and Muff's likeable character and attitude provided instant identification for Friday's regardless of the story line.

Friday's advertising program was complemented by several key promotions in 1988. In one of the most successful promotions in the company's history, the restaurants gave away nearly half a million pairs of red-and-white

striped Friday's sunglasses with selected beverage purchases during the summer. The distinctive sunglasses have appeared in a wide variety of media, multiplying the promotion's public relations value.

Other marketing efforts focused on improving store visibility. Friday's used directional billboard advertising in some markets and added eye-catching exterior features to many of its restaurants. The company installed red-and-blue neon outlining lights and T.G.I. Friday's name around restaurant roof lines to create an attractive identifying sign, which can be seen from any direction. The lights, along with new backlit

red-and-white striped awnings, dramatically improved store visibility.

In the restaurants themselves, Friday's concentrated on delivering a superior dining experience to customers. The company integrated the training and certification program, begun in 1987, into its ongoing operations and supplemented it with special training to introduce new service improvements and the new menu.

By October, new systems and procedures designed to improve customer service had been implemented throughout the T.G.I. Friday's

system. Service bottlenecks were eliminated and customer waiting time, both in ordering and settling the check, was reduced. In addition to improving responsiveness to customers, these changes also made a major contribution to the bottom line by significantly reducing labor costs.

c

Guilford upholstery fabrics maintain this tradition. The Guilford design team works with manufacturers to develop exclusive upholstery fabrics; and, its open line of solid and patterned seating fabrics are designed to complement its entire offering of panel, wall and ceiling textiles.

Guilford of Maine understands the American contract furniture industry. Its commitment to quality and on-time service has established Guilford as the leading supplier of fabrics to office systems manufacturers.

Guilford's strong working relationships with office furniture manufacturers ultimately benefit the design specifier and client with a tradition of superior service and reliability.

Seating fabrics from Guilford are unique in strength and retain their aesthetic integrity during years of daily use. Upholstery fabrics are available in a wide spectrum of colors and compositions, from smooth solids in 100% wool to rich textures of mixed yarns in wool/nylon blends.

UPHOLSTERY

d

c **T.G.I.Friday's Annual Report,** Operations Spread
Rick Gavos, Dallas, TX, Art Director
Mikie Baker and Lindy Grooms, Designers
Jim Olvera, Photographer
Harrison Simmons Design, Design Firm
T.G.I.Friday's, Publisher/Client
Southwest Typographics, Typographer
Williamson Printing Co., Printer

d **Guilford of Maine,** Brochure
Rick Biedel, New York, NY, Art Director
Bill Kontzias, Photographer
Bonnell Design Assoc., Design Firm
Guilford of Maine, Client/Publisher
Typogram, Typographer
The Hennegan Co., Printer

a **Instant Litter,** Book Cover
Art Chantry, Seattle, WA, Art Director/Designer
Art Chantry Design, Design Firm
Real Comet Press, Publisher

b **Love Triangles,** Magazine Cover
Judy Garlan, Boston, MA, Art Director
Theo Rudnak, Illustrator
Atlantic Monthly Co., Publisher
QUAD Graphics, Printer

c **The Viennese,** Book Jacket
Alex Gotfryd, New York, NY, Art Director
Carin Goldberg, Designer
Doubleday, Publisher

d **Alba,** Book Jacket
Jo Bonney, Designer
Robbin Schiff, New York, NY, Art Director
Geoff Spear, Photographer
Atlantic Monthly Press, Publisher
Coral Graphics, Printer

e

f

g

e **Heart/Bad Animals,** Album Cover
Norman Moore, Los Angeles, CA, Art Director/Designer
Norman Moore, Illustrator
Design/Art, Inc., Design Firm
Capitol Records, Publisher/Client
Norman Moore, Typographer
Ivy Hill, Printer

f **Green R.E.M.,** Record Album Cover
Jon McCafferty, Frank Olinsky and J. M. Stipe, New York, NY, Art
Directors
Frank Olinksy, Designer
Jon McCafferty, NASA and J. M. Stipe, Photographers
Manhattan Design, Design Firm
R.E.M., Client
SSY, Typographer

g **True Stories,** Album Cover
Bridget Desocio, New York, NY, Art Director
David Byrne, Publisher/Client
Concept Typographers, Typographer

a **Bowl-O-Rama,** Cover
H. Thomas Steele, New York, NY, Art Director
Abbeville Press, Publisher
New England Typographic Service, Typographer
Tien Wah Press, Printer

b **Where's Leo,** Booklet
Bruce Crocker, Boston, MA, Art Director
Susan Smith and Karen Watson, Illustrators
David Caras and Steve Marsel, Photographers
Crocker, Inc., Design Firm
Deborah Lipman, Artists Representative, Client
Innerer Klang, Typographer
Evsey Press, Printer

c **Miniature Golf,** Book Cover
Helene Silverman, New York, NY, Designer
Abbeville Press, Publisher
Tien Wah Press, Printer

d **Rainbow Kit,** Catalog Kit
Seth Jaben, New York, NY, Art Director/Designer
Seth Jaben, Illustrator
Seth Jaben Studio, Design Firm
e.g. smith, inc., Client
Boro Typographers, Typographer
Sterling Roman Press, Printer

a

Unknown, Ohio County

b

c

d

a **Sticks: Historical & Contemporary Kentucky Canes,** Booklet
Julius Friedman, Louisville, KY, Art Director
Albert Leggett, Photographer
Images, Design Firm
Kentucky Art & Craft Foundation, Publisher/Client
Queen City Type, Typographer
Pinaire Lithographing Corp., Printer

b **Broomshtick,** Self-Promotion Booklet
Woody Pirtle, New York, NY, Art Director/Illustrator
Pentagram Design, Design Firm
Woody Pirtle, Client
Hilton, Typographer
Heritage Press, Printer

c **US West Annual Report,** Annual Report
Sharon Werner, Minneapolis, MN, Art Director
Sharon Werner and Haley Johnson, Designers
Dan Weaks, Photographer
The Duffy Design Group, Design Firm
US West, Publisher/Client
Typeshooters, Typographers
Williamson Printing Co., Printer

d **French Quality,** Swatchbook
Charles Anderson, Minneapolis, MN, Art Director/Designer
Charles Anderson and Lynn Schulte, Illustrators
The Duffy Design Group, Design Firm
French Paper Co., Publisher/Client
Lino Typography, Typographer
Process Display, Printer

Rolling Stone

ISSUE 512 · NOV. 5TH – DEC. 10TH, 1987 · U.K. £2.25 · $4.95

INTERVIEWS with Bob Dylan, Bruce Springsteen, Paul McCartney, Mick Jagger, George Harrison, Keith Richards, Stevie Wonder, Pete Townshend, Bono, Sting, Tom Wolfe, Hunter Thompson, Edward Kennedy, Walter Cronkite, Jack Nicholson and more

XX

a

IN THE ISSUE

ISSUE 512: "ALL THE NEWS THAT FITS"

COVER: *Roman numerals designed by Jim Parkinson.*

TINA TURNER: *Photograph by Steven Meisel.*

b

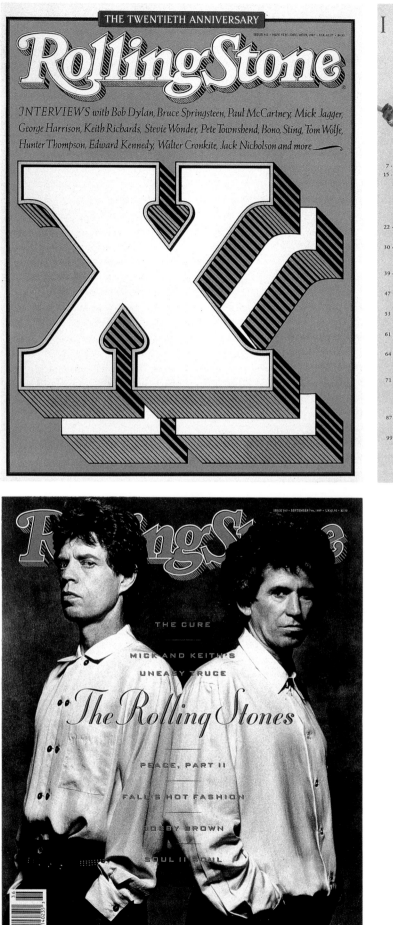

THE CURE

MICK AND KEITH'S UNEASY TRUCE

The Rolling Stones

PEACE, PART II

FALL'S HOT FASHION

BOBBY BROWN

SOUL II SOUL

a **Rolling Stone, XX Anniversary Issue Nov.5–Dec.10, 1987,** Magazine
 Fred Woodward, New York, NY, Art Director
 Rolling Stone, Design Firm
 Straight Arrow Publishers, Publisher

b **The Rolling Stones,** Magazine Cover
 Fred Woodward, New York, NY, Art Director
 Albert Watson, Photographer
 Rolling Stone, Design Firm
 Straight Arrow Publishers, Publisher

Whole Lot of *SHAKIN'* —Going On—

DENNIS QUAID HAS JUST WRITTEN A NEW SONG, and in a sound stage on the outskirts of Memphis, Tennessee, he's trying it out.

"Every Sunday morning/Well baby, I'm down on my knees," he sings, playing a basic blues progression on a black grand piano. "But Saturday night/Superman ain't got nothin' on me." He breaks into the crooked, beguiling smile that helped make him a star and gets to the song's chorus – and its punch line: "I'm a good man . . . and a *baaaaad* boy."

With roots-rocking wild man Mojo Nixon keeping time on a nearby set of drums, Quaid pounds on the piano and sings in his gravelly, lived-in voice: "I'll take a licking and keep on ticking" in one verse, "I dish out the licking that keeps your tickler ticking" in the next. It's a boasting, crowd-pleasing kind of song, but Quaid is playing it mostly to himself during this break in the filming of his new movie, *Great Balls of Fire*, the Jerry Lee Lewis story, which Orion planned to release on June 30th.

"Dennis finished that song last night," says Joe Mulherin, a veteran Memphis musician who's one of the film's music advisors. "He says he wrote it for Jerry Lee, but I think he kinda wrote it for *himself*, too."

But then, on this chilly Tennessee afternoon there's not a lot of difference between Dennis Quaid and Jerry Lee Lewis. After he finishes this film, Quaid is determined to take a hiatus from movies to play rock & roll with a band that he's formed. And when he finishes at the

Jerry Lee Lewis meets would-be Killer Dennis Quaid on the doubly star-struck set of 'Great Balls of Fire'

BY STEVE POND PHOTOGRAPHS BY TIMOTHY WHITE

118 · ROLLING STONE, JULY 13TH-JULY 27TH, 1989

ROLLING STONE, JULY 13TH-JULY 27TH, 1989 · 119

c **Rolling Stone, Special Issue July 13–27, 1989,** Magazine
Fred Woodward, New York, NY, Art Director
Rolling Stone, Design Firm
Straight Arrow Publishers, Publisher

a **Adweek Portfolio of Photography '87,** Directory Cover
Walter Bernard and Milton Glaser, New York, NY, Art Directors
Walter Bernard, Shelley Fisher and Milton Glaser, Designers
Sheila Metzner, Photographer
WBMG, Inc., Design Firm
A/S/M Publications, Client/Publisher
Seven Graphic Arts, Typographer
Dong-A Publishing & Printing, Printer

b **Visual Arts 1989 Journal,** School Journal
Silas Rhodes, New York, NY, Creative Director
Amy Cordell and Sheri G. Lee, Designers
Tom Sciacca, Cover Illustrator
School of Visual Arts Alumni Society, Publisher/Client
Veitch Printing, Printer

c **Adweek Portfolio of Illustration '88,** Directory Cover
Walter Bernard and Milton Glaser, New York, NY, Art Directors
Walter Bernard, Shelley Fisher and Milton Glaser, Designers
David Wilcox, Illustrator
WBMG, Inc., Design Firm
A/S/M Publications, Client/Publisher
Seven Graphic Arts, Typographer
Dong-A Publishing & Printing, Printer

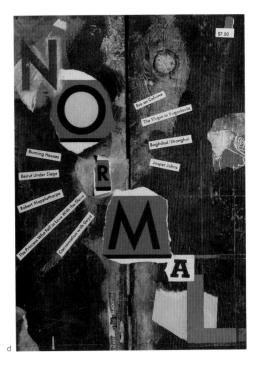

BURNING HOUSES
ANDREW HARVEY

BEAUTY OR THE BEAST

Isamu Noguchi

NOGUCHI REVISITED
BY KENNETH FRAMPTON

d **Normal #1, Summer 1989,** Magazine
Paul Davis, New York, NY, Art Director
Paul Davis Studio, Design Firm
Gini Alhadeff/Normal, Inc., Publisher
Dynagraphics, Typographer
Eastern Press, Printer

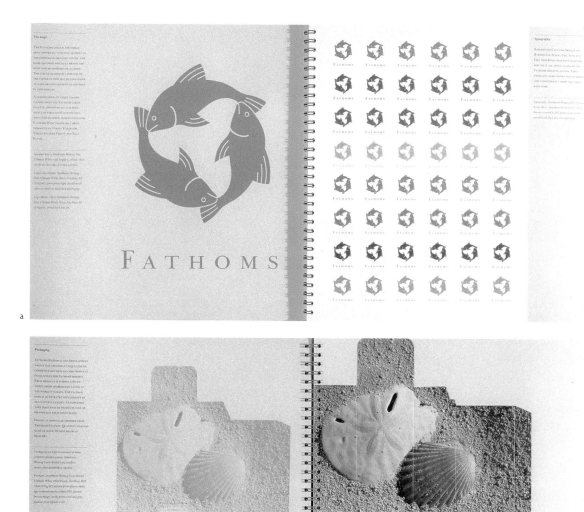

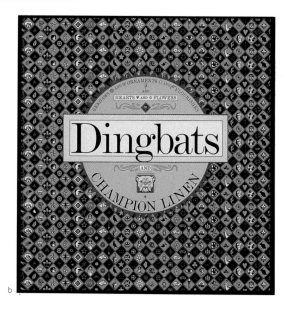

a **Fathoms,** Identity Brochure
Anthony Russell, Art Director
Susan Limoncelli, Designer
Michael Crumpton, Rob Day and Andrew Moore, Illustrators
Ben Russell and Bret Wills, Photographers
Anthony Russell & Associates, Inc., New York, NY, Design Firm
Strathmore Paper Co., Publisher/Client
Franklin Typographers, Typographer
Tanagraphics, Inc., Printer

b **Dingbats,** Promotional Booklet
Paula Scher, Art Director/Designer
Koppel & Scher, New York, NY, Design Firm
Champion International Co., Publisher/Client
JCH, Typographer

INSIDES, OUTSIDES

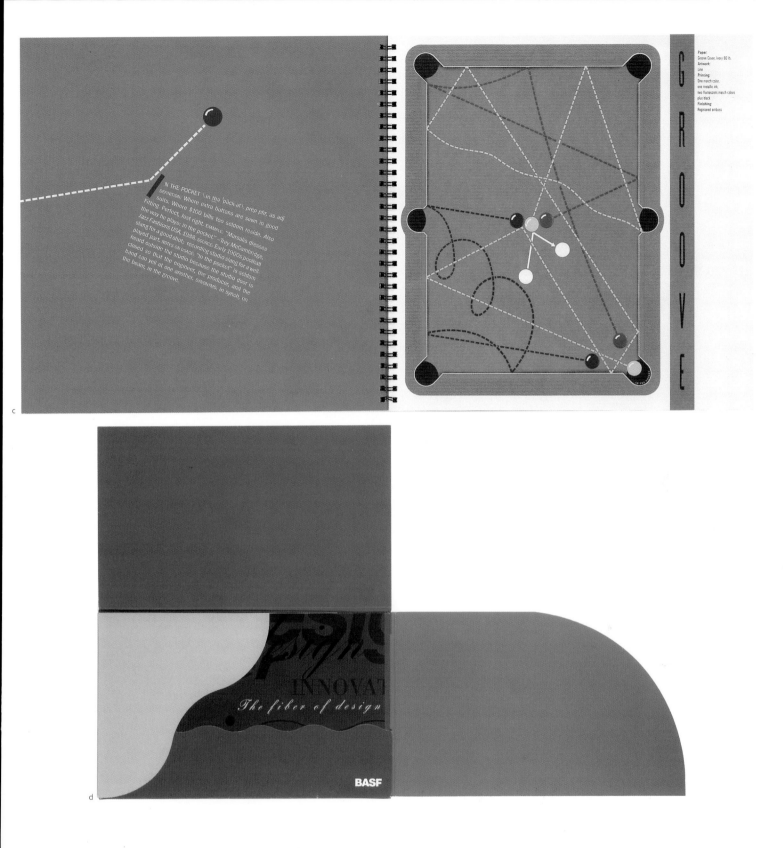

Paper:
Groove Cover, Ivory 80 lb.
Artwork:
Line
Printing:
One match color,
one metallic ink,
two fluorescent match colors
plus black
Finishing:
Registered emboss

N THE POCKET \ in tha 'pàck-at\ prep phr. as adj
DEFINITION: Where extra buttons are sewn in good
suits. Where $100 bills too seldom reside. Also
Fitting. Perfect. Just right. EXAMPLE: "Marsalis dresses
the way he plays: in the pocket." —Trey McCambridge,
Jazz Fashions USA, 1988. SOURCE: Early 1900s poolhall
slang for a good shot. NOTES ON USAGE: "In the pocket" is seldom
played part.
heard outside the studio because the studio door is
closed so that the engineer, the producer, and the
band can yell at one another. SYNONYMS: in synch, on
the beam, in the groove.

INNOVAT

The fiber of design

BASF

c **In the Groove,** Promotion Booklet
Larry Brooks Kosh, Los Angeles, CA, Art Director
Butler Kosh Brooks, Design Firm
Champion Paper, Publisher/Client
Heritage Press, Printer

d **Zeftron Nylon,** Brochure
Brad Copeland, Atlanta, GA, Art Director
Kevin Irby, Designer
Charles Purvis, Photographer
Copeland Design Inc., Design Firm
BASF, Inc. Fibers Division, Publisher/Client
Type Designs, Typographer
Service Litho, Printer

A Month of Days from Mead and Gilbert Papers

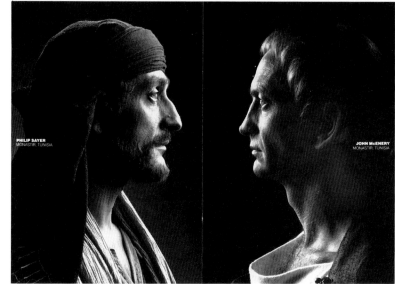

a **September,** Paper Promotion Booklet
 Peter Harrison and Susan Hochbaum, New York, NY, Art Directors
 Various, Illustrators
 Pentagram Design, Design Firm
 Mead/Gilbert Paper Co., Publisher/Client
 Typogram, Typographer
 Sterling Roman Press, Printer

b **Face to Face with Kromekote,** Booklet
 Butler Kosh Brooks, Art Director
 Craig Butler, Los Angeles, CA, Designer
 Tom Zimberoff, Photographer
 Butler Kosh Brooks, Design Firm
 Champion Paper, Publisher/Client
 Rembrandt, Printer

INSIDES, OUTSIDES

CUBA
libre

"AND WHAT'S IN
THE ALCOHOL?"

TEQUILA
SUNRISE

Nine Reasons to Wear Powder

3 SAFETY BUFFER.

Loose face powder creates a barrier that helps shield and protect skin, working to keep it safe from the soot, grime, dust and dirt that coat skin and can cause problems. When temperatures soar, powder helps to blot oil and perspiration so skin feels fresher, looks cleaner.

c **13 Cocktails and a Punch,** Booklet
Stephen Doyle and Tom Kluepfel, Art Directors
Various, Designers and Photographers
Drenttel Doyle Partners, Design Firm
Drenttel Doyle Partners, Publisher
Trufont, Typographer
Pollack Litho, Printer

d **9 Reasons to Wear Powder,** Booklet
Nancy Feldman, New York, NY, Art Director
Bob Hiemstra, Illustrator
Charles of the Ritz, Client
Sandy Alexander, Printer

a

b

a **A Collection of Endpapers,** Booklet
Andreé Cordella, Boston, MA, Art Director
Rob Howard and Andrew Berry, Illustrators
Geoff Stein, Photographer
Cordella Design, Design Firm
Gilbert Paper Co., Publisher/Client
Typographic House, Typographer
Chadis Printing Co., Printer

b **Interiors,** Self-Promotion Booklet
Margaret Marcy, New York, NY, Art Director
Jennifer Levy, Photographer
Margaret Marcy Design, Design Firm
Jennifer Levy Photography, Publisher/Client
Trufont, Typographer
Artanis Offset, Printer

c **Ziggy Marley and The Melody Makers/One Bright Day,** CD Package
Jeffrey Ayeroff, Beverly Hills, CA, Art Director
Mac James, Designer
Virgin Records America, Publisher
Westland Graphics, Printer

d **The Art of Writing,** Paper Promotion/Booklet
Jennifer Morla, San Francisco, CA, Art Director
Jeanette Aramburu and Jennifer Morla, Designers
Michael LaMotte and John Mattos, Illustrators
Morla Design, Design Firm
Simpson Paper Co., Publisher/Client
Andresen Typographics, Typographer
George Rice & Sons, Printer

e **E.U./Livin' Large,** CD Package
Melanie Nissen, Los Angeles, CA, Art Director
Tim Stedman, Los Angeles, CA, Designer/Illustrator
Jeffrey Scales, Photographer
Public Eye, Design Firm
Virgin Records America, Publisher/Client
Aldus Type Studio, Typographer

a

△ *Perro Cubano*

▷ *Haywire*

Dogs. Everybody loves them.
From the poorest to the
purest of breeds, they hunt our
game, lick our wounds,
share our solitude and steal
our hearts.

For centuries human beings
have depicted these
endearing companions in
every conceivable
style of art.

On the following pages I am
pleased to share with
you a selection of nine private
works as a personal tribute
to man's best friend.

Woody Pirtle

a **K-9,** Self-Promotion Booklet
Woody Pirtle, New York, NY, Art Director/Designer
Pentagram Design, Design Firm
Woody Pirtle, Client
Hilton, Typographer
Heritage Press, Printer

c **San Francisco International Airport Annual Report,** Annual Report
Spread
Jennifer Morla, San Francisco, CA, Art Director
Mariane Mitten, Designer
Paul Franz-Moore, Photographer
San Francisco International Airport, Publisher/Client
Mercury Typography, Typographer
Mastercraft Press, Printer

b **The Solid Waste Management Problem,** Booklet
Kathleen Wilmes Herring, Washington, DC, Art Director
Christopher Greiling, Designer
Stuart Armstrong, Illustrator
Yankee Doodles, Design Firm
The Council for Solid Waste Solutions, Publisher/Client
Harlowe Typography, Inc., Typographers
Peake Printers, Inc., Printer

d **The L.J. Skaggs & Mary C. Skaggs Annual Report,** Inside Spread
Michael Vanderbyl, San Francisco, CA, Art Director
The L.J. Skaggs & Mary C. Skaggs Foundation, Publisher/Client
Andresen Typographics, Typographer
George Rice & Sons, Printer

211

a

a **Auto Gallery, February 1987,** Magazine Cover
Michael Brock, Los Angeles, CA, Art Director/Designer
Cindy Lewis, Photographer
Michael Brock Design, Design Firm
Auto Gallery, Client/Publisher
Tom Nikosey, Calligrapher
John McCoy, Printer

b **Auto Gallery, May 1987,** Magazine Cover
 Michael Brock, Los Angeles, CA, Art Director/Designer
 Glen McCallister, Photographer
 Michael Brock Design, Design Firm
 Auto Gallery, Client/Publisher
 Tom Nikosey, Calligrapher
 John McCoy, Printer

c **Auto Gallery, September 1987,** Magazine Cover
 Michael Brock, Los Angeles, CA, Art Director/Designer
 Marvin Carlton, Photographer
 Michael Brock Design, Design Firm
 Auto Gallery, Client/Publisher
 Tom Nikosey, Calligrapher
 John McCoy, Printer

d **Auto Gallery, August 1987,** Magazine Cover
 Michael Brock, Los Angeles, CA, Art Director/Designer
 Cindy Lewis, Photographer
 Michael Brock Design, Design Firm
 Auto Gallery, Client/Publisher
 Tom Nikosey, Calligrapher
 John McCoy, Printer

e **ID/1987 Annual Design Review,** Contents Page
 Clive Jacobson, New York, NY, Art Director/Designer
 Various, Photographers
 Jacobson Design Inc., Design Firm
 Design Publications Inc., Publisher/Client
 Byrd, Printer

f **Auto Gallery, June 1987,** Contents Page
 Michael Brock, Los Angeles, CA, Art Director/Designer
 Various, Photographers
 Michael Brock Design, Design Firm
 Auto Gallery, Client/Publisher
 Character & Color, Typographer
 John McCoy, Printer

a

b

a **The Bike,** Brochure

　　Del Terrelonge, Toronto, CAN, Art Director

　　Ron Baxter Smith, Photographer

　　Terrelonge Design Inc., Design Firm

　　Ron Baxter Smith Photographer, Client/Publisher

　　Lind Graphics, Typographer

　　Arthurs-Jones, Lithographers

b **Dorsey & Whitney,** Brochure

　　Charles Anderson and Joe Duffy, Minneapolis, MN, Art Directors

　　Charles Anderson and Sara Ledgard, Designers

　　Gary McCoy, Photographer

　　The Duffy Design Group, Design Firm

　　Dorsey & Whitney, Client

　　Typeshooters, Typographer

　　Watt Peterson, Printer

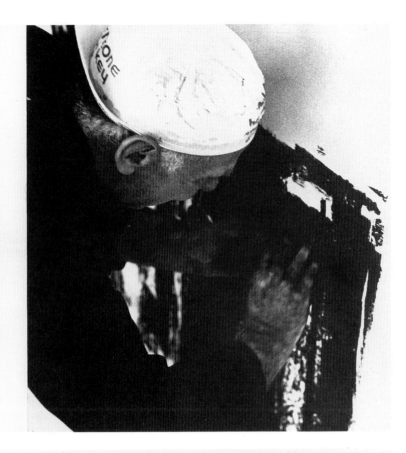

before a work was built. They enable me to understand different aspects of perception as well as the structural potential of a given sculpture. They are distillations of the experience of a sculptural structure. Drawing is another kind of language. Often, if you want to understand something, you have either to take it apart or to apply another kind of language to it. Since I started working, I have always thought, that if I could draw something I would have a structural comprehension of it. I do not draw to depict, illustrate or diagram existing works. The shapes originate in a glimpse of a volume, a detail, an edge, a weight. Drawing in that sense amounts to an index of structures I have built.

RICHARD SERRA, 1987

c

d

c **Richard Serra at Gemini,** Catalog
John Coy, Culver City, CA, Art Director
John Coy and Corinne Tuite, Designers
Charlie Crist, Sidney B. Felson and Douglas Parker, Photographers
COY, Los Angeles, Design Firm
Gemini, G.E.L., Publisher/Client
Allen Lithograph, Inc., Printer

d **Heritage Press Christmas Album,** Christmas Promotion Booklet
Kevin B. Kuester, Minneapolis, MN, Art Director
Kevin B. Kuester and Bob Goebel, Designers
Rex Peteet, Illustrator
Greg Booth + Associates, John Wong, Photographers
Madsen and Kuester, Design Firm
Heritage Press, Publisher/Client
TypeShooters, Inc., Typographer
Heritage Press, Printer

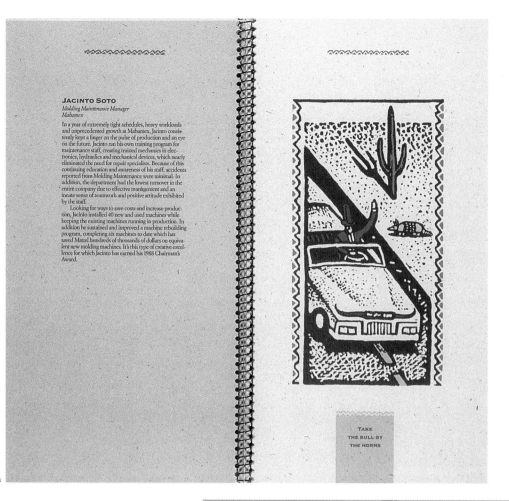

JACINTO SOTO
Molding Maintenance Manager
Mabamex

In a year of extremely tight schedules, heavy workloads and unprecedented growth at Mabamex, Jacinto consistently kept a finger on the pulse of production and an eye on the future. Jacinto ran his own training program for maintenance staff, creating trained mechanics in electronics, hydraulics and mechanical devices, which nearly eliminated the need for repair specialists. Because of this continuing education and awareness of his staff, accidents reported from Molding Maintenance were minimal. In addition, the department had the lowest turnover in the entire company due to effective management and an innate sense of teamwork and positive attitude exhibited by the staff.

Looking for ways to save costs and increase production, Jacinto installed 40 new and used machines while keeping the existing machines running in production. In addition he sustained and improved a machine rebuilding program, completing six machines to date which has saved Mattel hundreds of thousands of dollars on equivalent new molding machines. It's this type of creative excellence for which Jacinto has earned his 1988 Chairman's Award.

TAKE
THE BULL BY
THE HORNS

a

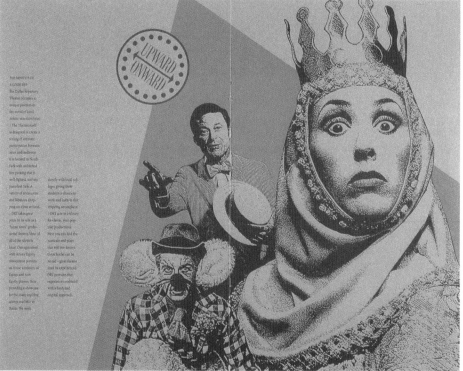

b

a **Mattel Toys Chairman's Award,** Booklet
 Linda Warren, Venice, CA, Art Director
 Tracy duCharme and Linda Warren, Designers
 Joe Crabtree, Illustrator
 The Warren Group, Design Firm
 Mattel Toys Corporate Communication, Publisher/Client
 JT & A, Typographer
 Westcott Press, Printer

b **Extra, Extra; Dallas Repertory Theater,** Brochure
 Scott Ray, Dallas, TX, Art Director
 Scott Ray, Designer/Illustrator
 Keith Nichols, Photographer
 Peterson & Company, Design Firm
 Dallas Repertory Theatre, Publisher/Client
 Characters, Typographers
 Proctor Press, Printer

HOUSECOAT?

TAILCOAT?

From the Take Five Series by Warren Graphics, Inc. Denver, Colorado.

"The sea was wet as wet could be,

the sands were dry as dry.

you could not see a cloud,

because no cloud was in the sky."

Lewis Carroll

c

d

c **Take Five,** Brochure
Monique Davis, Denver, CO, Art Director
Connie Lehman, Illustrator
Davis Design, Design Firm
Warren Graphics, Inc., Publisher/Client
EB Typecrafters, Typographer
Warren Graphics, Printer

d **When is Coated Overcoated?,** Booklet
Tjody Overson, Art Director
Todd Nesser and Tjody Overson, Designers
Various, Illustrators
Jean Rhode and Mike Gibbs, Writers
McCool & Co., Design Firm
Weyerhauser Paper Co., Publisher/Client
Mag Type, Typographer
Lebanon Valley Press, Printer

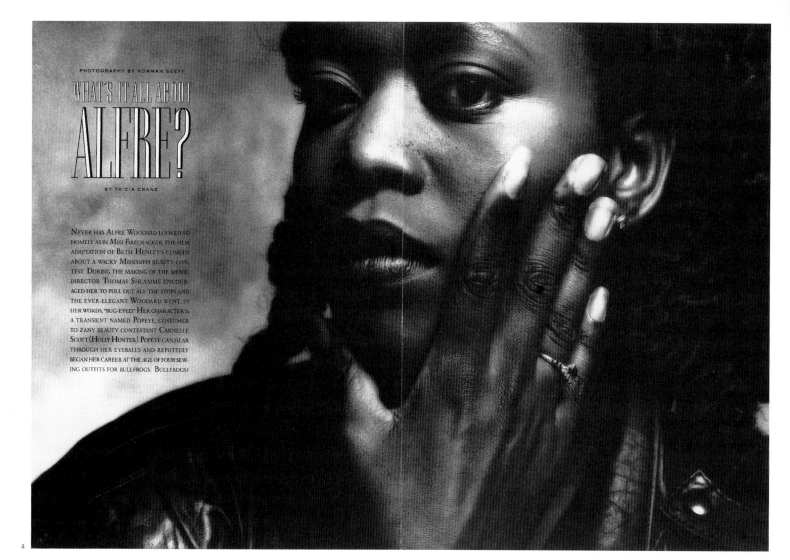

PHOTOGRAPHY BY NORMAN SEEFF

WHAT'S IT ALL ABOUT
ALFRE?

BY TRICIA CRANE

Never has Alfre Woodard looked so homely as in *Miss Firecracker*, the film adaptation of Beth Henley's comedy about a wacky Mississippi beauty contest. During the making of the movie, director Thomas Shlamme encouraged her to pull out all the stops and the ever-elegant Woodard went, in her words, "bug-eyed." Her character is a transient named Popeye, costumer to zany beauty contestant Carnelle Scott (Holly Hunter). Popeye can hear through her eyeballs and reputedly began her career at the age of four sewing outfits for bullfrogs. Bullfrogs?

a

a **What's It All About Alfre?,** Magazine Spread
Michael Brock, Los Angeles, CA, Design Director
Marilyn Babcock, Art Director/Design Director
Norman Seef, Photographer
L. A. Style, Client/Publisher
Photo Lettering, Typographer
Regnier America, Printer

PHOTOGRAPHY BY HERB RITTS PRODUCED BY KATE HARRINGTON

THINLY VEILED

AZZEDINE ALAIA'S SLEEK DRESS IN STRETCH KNIT.

ISSEY MIYAKE'S SHEER LAMÉ BLOUSE.

HAND-CROCHETED COTTON SWEATER BY MATSUDA.

b **Thinly Veiled,** Magazine Spread
Michael Brock, Los Angeles, CA, Design Director
Marilyn Babcock, Art Director/Designer
Herb Ritts, Photographer
L. A. Style, Client/Publisher
Photo Lettering, Typographer
Regnier America, Printer

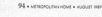

a **Metropolitan Home: Los Angeles/Where Trends Come From,** Magazine
Don Morris, Art Director
Richard Ferretti, Susan Foster and Don Morris, New York, NY,
Designers
Meredith Corporation, Publisher

b **ID, March/April 1987,** Magazine Cover
 Clive Jacobson, New York, NY, Art Director/Designer
 Clive Jacobson, Illustrator
 Design Publications Inc., Publisher/Client
 Clive Jacobson, Letterer
 Byrd, Printer

c **MADD 1987 Annual Report,** Cover
 Bryan L. Peterson, Dallas, TX, Art Director/Designer
 Paul Talley, Photographer
 Peterson & Company, Design Firm
 Mothers Against Drunk Driving, Publisher/Client
 Characters, Typographer
 Heritage Press, Printer

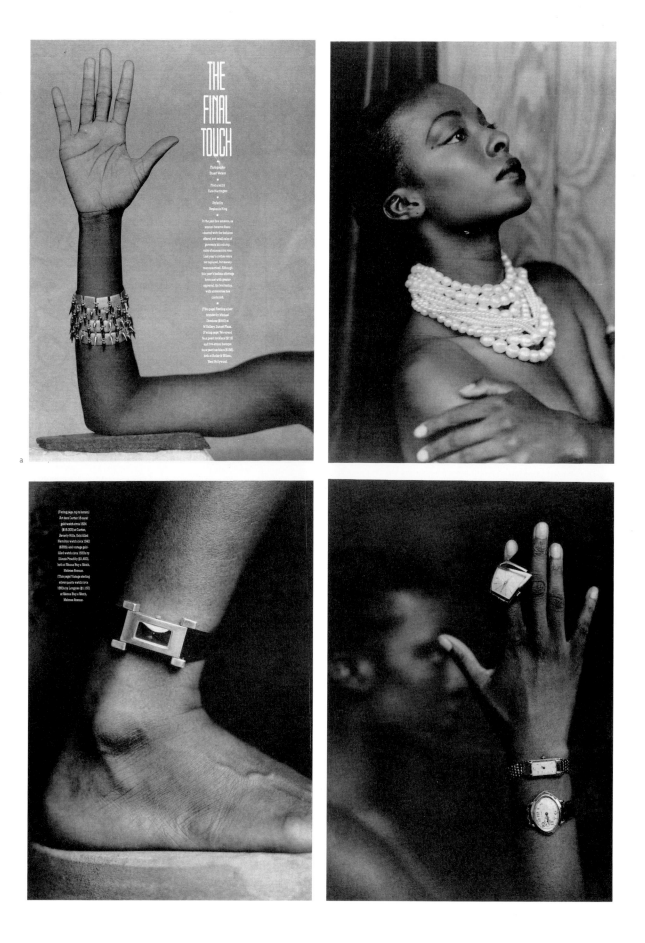

a **The Final Touch,** Magazine Spread

Michael Brock, Los Angeles, CA, Design Director

Stuart Watson, Photographer

Michael Brock Design, Design Firm

L. A. Style, Client/Publisher

Ad Print, Typographer

Regnier America, Printer

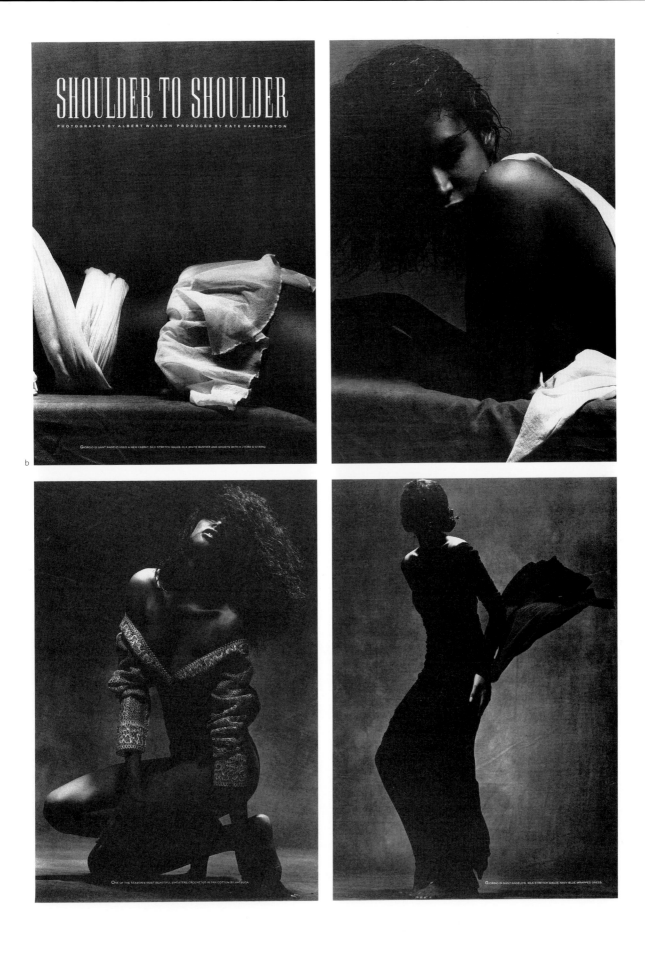

SHOULDER TO SHOULDER

PHOTOGRAPHY BY ALBERT WATSON PRODUCED BY KATE HARRINGTON

b

b **Shoulder to Shoulder,** Magazine Spread
Michael Brock, Los Angeles, CA, Design Director
Marilyn Babcock, Art Director/Designer
Albert Watson, Photographer
L. A. Style, Client/Publisher
Photo Lettering, Typographer
Regnier America, Printer

ESPRIT

THE COMPREHENSIVE DESIGN PRINCIPLE

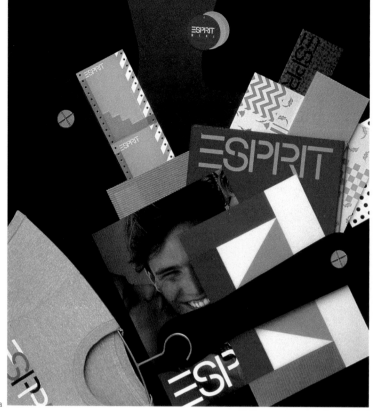

a

The traditional moving blanket has
been reinterpreted to serve a variety of
functions. Offered in four colors, the
Esprit Sport Quilt™ coordinates with the
rest of the Esprit Bath & Bed Collection,
either as an element for blending or
as a bed throw/accent. Its utilitarian
design also makes it suitable for the
beach, stadium, car, for exercise or as
a picnic blanket. The Sport Quilt is made
of a durable 50% combed cotton/50%
Dacron® polyester blend, so it's machine
washable and easy to care for.

b

a **The Comprehensive Design Principle,** Book Cover
 Tamotsu Yagi, San Francisco, CA, Art Director
 Roberto Carra, Sharon Risedorph and Oliviero Toscani, Photographers
 Esprit Graphic Design Studio, Design Firm
 Robundo Publishing, Publisher
 Display Lettering + Copy and Robundo, Typographers
 Nissha Printing, Printer

b **Esprit Bath & Bed,** Brochure
 Michael Vanderbyl, San Francisco, CA, Art Director
 Esprit International, Publisher/Client
 Hester Typography, Typographer
 George Rice & Sons, Printer

c

PHYSICAL RESOURCES

In addition to its function as a symbol of theatrical excellence throughout the country, The Guthrie Theater has been, for a quarter of a century, a Twin Cities landmark. Its stature as the flagship of a vibrant theatrical community makes it highly visible, both artistically and locationally.

Now, $5,100,000 is sought to improve the physical plant to accommodate better the needs of the public and to respond to the artistic imperative for enhanced space for rehearsals, for set and costume design and storage, and to house the Actors' Laboratory. The interior and the exterior of the Guthrie's twenty-five-year-old facility are due for modest renewal. The most critical need is that of reshaping the auditorium to improve the audience's access to the actors. Inherent in the design of the thrust stage is the immediate relationship of actors and audience. Currently acoustical as well as sightline problems in certain seating locations undermine that immediacy, detracting from the exercise of imagination. To correct this, extensive acoustical improvements will be accomplished, and seats with limited views will be removed. In this way, all audience members will be in a position to participate fully in the theatrical experience without distraction.

To bring the Guthrie into visual harmony with its artistic neighbor, the Walker Art Center, the Theater's facade and north terrace will be revamped. Over the years, changes in both the Walker and the Guthrie have diluted the original impact made by the complex, disrupting the aesthetic drama of the site. This will be addressed by significant renovation of the north lobby's facades and terrace. The glass curtain wall will be brought forward, and a new raised terrace will be created using granite and other materials found in the Walker facade. To complete the transformation, new paint and prominent signage will be added.

d

e

d **Cordage Paper Graphics,** Booklet
Julius Friedman, Louisville, KY, Art Director
Michael Brohm and Julius Friedman, Photographers
Images, Design Firm
Cincinnati Cordage & Paper Co., Publisher/Client
Queen City Type, Typographer
The Hennegan Co., Printer

c **Guthrie: A Campaign for Artistic Development,** Booklet
Eric Madsen, Minneapolis, MN, Art Director
Eric Madsen and Tim Sauer, Designers
Michal Daniel, Photographer
Madsen and Kuester, Design Firm
Guthrie Theater, Publisher/Client
Typeshooters, Inc., Typographer
Watt/Peterson, Printer

e **Warner Communications, Inc. 1987 Annual Report,** Cover
Harold Burch and Peter Harrison, New York, NY, Art Directors
Harold Burch and Peter Harrison, Designers
John Van Hammersveld, Illustrator
Pentagram Design, Design Firm
Warner Communications, Inc., Publisher/Client
Characters, Typographer
Case Hoyt Corporation, Printer

a

c

b

a **1989 L. A. Style Calendar,** Calendar
Michael Brock, Los Angeles, CA, Art Director
Michael Brock, Gaylen Braun, Designers
Various, Photographers
Michael Brock Design, Design Firm
L. A. Style, Client/Publisher
Ad Print, Typographer
Franklin Press, Printer

b **L.S. & Co. Ranch,** Sales Promotion Booklet
Neal Zimmermann, San Francisco, CA, Art Director
Mark Glasson and Neal Zimmermann, Designers
Kurt Markus, Photographer
Levi Strauss & Co., Publisher/Client

c **Levi's Silver Tab Collection,** Holiday Booklet
Jennifer Morla, San Francisco, CA, Art Director
Jeanette Aramburu, Designer
Jeffrey Newbury, Photographer
Morla Design, Design Firm
Levi Strauss & Co., Publisher/Client
Andresen Typographics, Typographer
James H. Barry, Printer

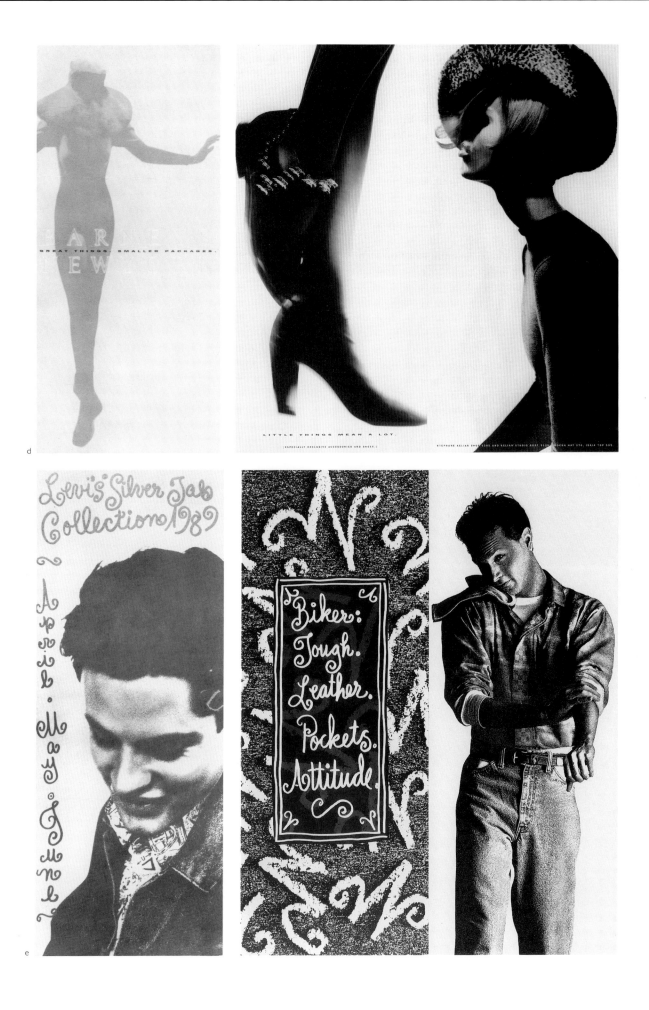

d **Barneys New York,** Brochure
Douglas Lloyd, New York, NY, Art Director
Nick Knight, Photographer
BNY Advertising, Agency
Barneys New York, Client
Macintosh Generated, Typographer
Graphic Arts Center, Printer

e **Levi's Silver Tab Collection, Spring,** Brochure
Jennifer Morla, San Francisco, CA, Art Director/Designer
Thomas Heisner, Photographer
Morla Design, Design Firm
Levi Strauss & Co., Publisher/Client
Jennifer Morla, Letterer
James H. Barry, Printer

a **Photo Metro, September 1987,** Magazine
 Henry Brimmer, San Francisco, CA, Art Director
 Henry Brimmer, Designer
 Various, Photographers
 Photo Metro, Publisher
 Peter Kesselman, Typographer
 Sierra Press, Printer

b **Photo Metro, October 1987,** Magazine
 Henry Brimmer, San Francisco, CA, Art Director
 Henry Brimmer, Mejia and Randall, Designers
 Various, Photographers
 Photo Metro, Publisher
 Peter Kesselman, Typographer
 Sierra Press, Printer

c **WH/The Way to Live,** Newspaper
 Dennis B. Freedman and Edward Leida, New York, NY, Art Directors
 Various, Photographers
 Fairchild Publications, Publisher
 R. R. Donnelley & Sons, Printer

d **WH/The Way to Live,** Newspaper
 Dennis B. Freedman and Edward Leida, New York, NY, Art Directors
 Various, Photographers
 Fairchild Publications, Publisher
 R. R. Donnelley & Sons, Printer

Will Manhattan sink under the weight
of all the buildings? It is hypothesized that
Manhattan is actually lighter in weight
today than when it was first settled because of
all the excavation for building foundations,
subway tunnels and conduits for electricity,
water, gas, telephones, etc. In fact, the
two World Trade Center towers weigh less than
the land excavated for the foundations.

a **Psst! Having Sex, Being Ready...,** Booklet
 Howard Belk, New York, NY, Art Director
 Carin Berger, Designer
 Arlin Schumur, Illustrator
 Belk Mignogna Assoc., Ltd., Design Firm
 Lexis Pharmaceuticals, Client/Publisher
 Trufont Typographers, Typographer
 Consolidated Press, Printer

b **Tape Critters,** Self-Promotion Booklet
 Craig Frazier, San Francisco, CA, Art Director
 Craig Frazier, Illustrator
 Frazier Design, Design Firm
 Frazier Design, Publisher
 Watermark Press, Printer

c **Guide to New York Design Scene,** Booklet
 Colin Forbes, New York, NY, Art Director
 Michael Gericke, Designer
 Mel Calman, Illustrator
 Pentagram Design, Design Firm
 Steelcase Co., Publisher/Client
 Typogram, Typographer
 L. P. Thebault, Printer

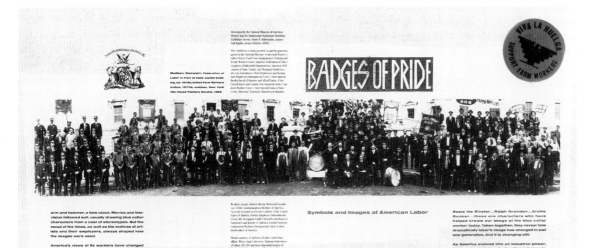

d **Badges of Pride,** Folder
Chris Noel, Washington, DC, Art Director
Chris Noel Design, Design Firm
SITES, Publisher/Client
Type Foundry, Typographer
Peake Printers, Printer

e **Return to Tradition,** Traveling Tours Brochure
Mike M. Y. Lam, New York, NY, Art Director/Designer
Journey to The East, Inc., Publisher/Client
Mike M. Y. Lam, Typographer
Jim Airs, Printer

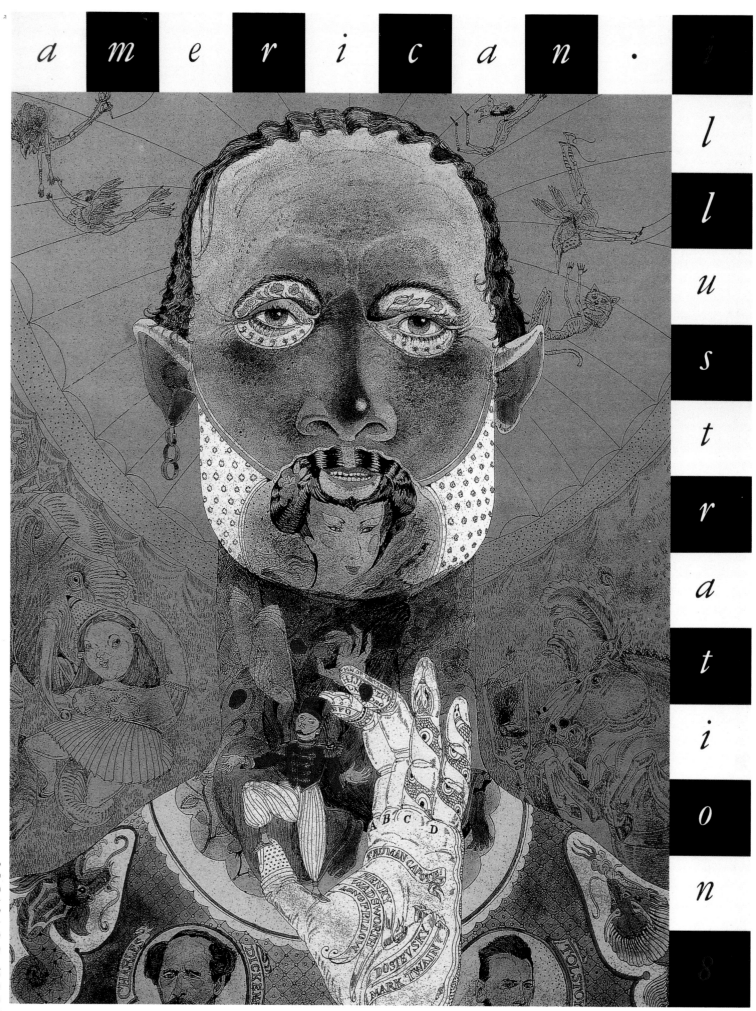

a **American Illustration 8,** Book Jacket
Woody Pirtle, New York, NY, Art Director
Jack Unruh, Illustrator
Pentagram Design, Design Firm
American Illustration, Publisher/Client
Seven Graphic Arts, Typographer
Toppan Printing Co., Printer

b **Graphic Artists Guild Directory of Illustration 5,** Book Jacket
Walter Bernard and Milton Glaser, New York, NY, Art Directors
Shelly Fisher/WBMG, Inc., Designer
Mirko Ilic, Illustrator
Nicky Lindeman, Photographer
WBMG, Inc., Design Firm
Madison Square Press, Client/Publisher
Typogram, Typographer
Dai Nippon Printing (America), Printer

c **American Illustration 4,** Book Cover
Paula Scher, New York, NY, Art Director/Designer
Gene Greif, Illustrator
Koppel & Scher, Design Firm

d **The Babe,** Book Jacket
Joe Duffy, Minneapolis, MN, Art Director/Designer
Joe Duffy and Lynn Schulte, Illustrators
The Duffy Design Group, Design Firm
Houghton Mifflin, Publisher/Client
Typeshooters, Typographer

a **Workspirit,** Design Journal
 April Greiman, Los Angeles, CA, Art Director/Designer
 April Greiman, Inc., Design Firm
 Vitra, International, Publisher/Client
 George Rice & Sons, Printer

b **Photo Metro, October 1989,** Magazine
 Henry Brimmer, San Francisco, CA, Art Director
 Henry Brimmer, Mejia and Randall, Designers
 Various, Photographers
 Photo Metro, Publisher
 Peter Kesselman, Typographer
 Sierra Press, Printer

Current approaches necessitate the removal of up to one quart of marrow under general anesthesia. But Marrow-Tech's system may require the extraction of as little as two teaspoons. This means that people could donate bone marrow in short, simple office procedures involving little discomfort and no hospitalization.

These small quantities of extracted marrow would then be replicated in our proprietary cell cultures to produce enough healthy bone marrow for transplantation.

Alternatively, these samples might be frozen for later use. This could allow individuals at high risk for certain cancers or for exposure to radiation or toxic chemicals to store their own healthy marrow in case of future need.

In addition to benefits to donors, Marrow-Tech's approach may provide a means of solving the serious compatibility problems which now plague bone marrow recipients.

One exciting research project now underway involves various manipulations of donor bone marrow in our cultures so as to reduce or eliminate Graft versus Host Disease. Success in this area alone could greatly increase the availability of bone marrow transplants and improve outcomes for recipients.

Marrow purging is another treatment modality which may be significantly enhanced by the Company's technology. Purging involves the removal of cancerous cells from a patient's extracted marrow. The remaining healthy portion of the marrow is then infused back into the patient. This allows even patients with cancer in their marrow to use their own marrow for a transplant, rather than depend on a donor. Because our system would require only small amounts of extracted marrow, bone marrow purging could become simpler, less costly and more effective than it is at present.

Marrow-Tech is developing these and other special application areas in collaboration with scientists at prominent medical research institutions across the country. In addition to Harvard, they include Duke University and the University of Florida, leading centers in bone marrow purging, and the University of Kentucky, a leader in the area of Graft versus Host Disease.

OUR LIVING ORGAN TISSUE CULTURES MAY

SERVE AS POWERFUL TOXICOLOGY TOOLS,

PROVIDING ALTERNATIVES TO MANY

ANIMAL AND NON-ANIMAL TESTS.

Nautilus pompilius

A SINGLE MULTIPLE-WELL PLATE,

A SECTION SHOWN LEFT, MAY CONTAIN UP TO 96

SEPARATE CULTURES FOR TESTING VARIOUS

DRUGS, CHEMICALS OR COSMETICS.

8

9

The Vital Need for Improved Bone Marrow Transplantation

According to the International Bone Marrow Registry, the number of transplantations has been increasing sharply in recent years. In 1977, fewer than 200 transplants were performed worldwide. In 1987, this number jumped to over 5,500 procedures. It has been estimated that over 20,000 patients per year in the U.S. alone could potentially benefit from bone marrow transplantation.

Marrow-Tech is working to increase the availability and safety of bone marrow transplants to meet these growing healthcare needs.

SKIN REPLACEMENT

"Marrow-Tech's cellular reconstruction of skin in three-dimensional matrices opens new avenues for providing functional skin equivalents which may be used in drug testing and potentially in wound healing."
DR. MAGDALENA EISINGER
MEMORIAL SLOAN-KETTERING

Each year over 70,000 victims of life-threatening second and third degree burns are admitted to special burn treatment centers in the U.S. Modern techniques have greatly improved chances for survival of these patients. But there is still no widely available ideal skin replacement. Patients must rely on grafts from intact areas of their own bodies, or on cadaver skin, animal skin or artificial wound dressings to cover their wounds until natural healing can occur. Such healing is usually accompanied by disfiguring wound contraction and scarring.

Marrow-Tech's scientists have adapted the Company's tissue-growth technology to produce a full-thickness skin, containing both epidermis and dermis. Epidermis is also grown naturally in other systems. What is unique to our skin is the natural growth of the critical support layer of dermis, consisting of dividing, collagen-producing and metabolically active dermal cells. In our preclinical studies, grafts of our cultured dermis have promoted healing with minimal contraction and scarring. Equally important, there has been no evidence of rejection.

Pending successful completion of these studies, we plan to file with the Food and Drug Administration in order to commence human clinical trials.

a

a **Our Living Organ Tissue...,** Annual Report Operations Spread
Diana De Lucia, New York, NY, Art Director
Patricia Kovic, Designer
Bard Martin, Photographer
Diana De Lucia Design, Design Firm
Noonan/Russo Communications, Client
Marrow-Tech Corp., Publisher
Trufont, Typographer
Rapaport Printing Co., Printer

+ LIKE AN EXCITING NEW COLOR TREND, THE FIBER-ADDED LOOK HAS CAUGHT ON. FRONT LINE DESIGNERS EVERYWHERE

HAVE DISCOVERED THE TEXTURAL RICHNESS AND VISUAL DEPTH OF FIBER-ADDED FINISHES. NEENAH PAPER HAS

Titanium White – Wove Finish	24W
Titanium White – Laid Finish	24W
Terrazzo – Wove Finish	24W
Terrazzo – Laid Finish	24W
Solar White	80T
Millstone	24W
Whitestone	80T
Solar White	24W
Ivorystone	80T
Whitestone	100C
Graystone	80C
Silverstone	24W
Solar White	24W
Millstone	75T
Silverstone	65C
Ivorystone	80C
White	70T
Cinnamon	80T
Bluestone	80C

COLOR WT.

+ NEENAH'S NEW COLLECTION OFFERS YOU A GREATER CHOICE OF FIBER-ADDED COLORS AND FINISHES THAN YOU'VE EVER HAD BEFORE. ALTOGETHER, THERE ARE 12 BOLD COLORS, PLUS THREE BRIGHT WHITES IN A SELECTION OF LAID, LINEN, WOVE, CREST AND FELT FINISHES. EACH PROVIDES YOU WITH AN EXCITING NEW DESIGN OPTION, EXECUTED WITH THE HIGH-QUALITY CRAFTSMANSHIP FOR WHICH NEENAH PAPER IS KNOWN. EACH PROVIDES EXCEPTIONAL CRISPNESS AND SURFACE FORMATION FOR FINE PRINTING. SO DISCOVER THE WAYS IN WHICH NEENAH PAPER'S FIBER-ADDED COLLECTION CAN ADD WARMTH AND STYLE TO YOUR DESIGNS.

OF ADDING FIBER TO DESIGN USE NEENAH PAPERS

b

c

d

b **Fiber Added,** Swatchbook
Brad Copeland, Atlanta, GA, Art Director
Kevin Irby, Designer
Copeland Design, Inc., Design Firm
Neenah Papers, Publisher/Client
Graphic Center, Typographer

c **River Heritage,** Folder
William Homan, Minnetonka, MN, Art Director/Designer
William Homan Design, Design Firm
River Heritage, Publisher/Client
Diversified Graphics, Inc., Printer

d **This Boy's Life,** Book Jacket
Robbin Schiff, New York, NY, Art Director
Jose Ortega, Illustrator
Atlantic Monthly Press, Publisher
Longacre Press, Printer

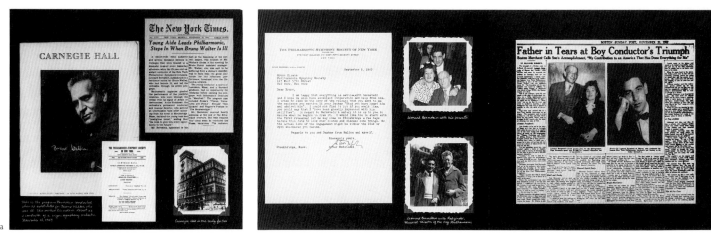

a **Leonard Bernstein's 45th Anniversary Program,** Booklet
 Oliver Johnston, New York, NY, Art Director
 Susan Parr, Designer
 US Design, Design Firm
 New York Philharmonic, Publisher/Client
 The Typecrafters, Typographer

b **D'Amico Cucina,** Booklet
 Sharon Werner, Minneapolis, MN, Art Director
 Haley Johnson and Sharon Werner, Designers
 Sharon Werner, Illustrator
 Jim Williams, Photographer
 The Duffy Design Group, Design Firm
 D'Amico & Partners, Publisher/Client
 Typeshooters, Typographer
 Print Craft, Printer

c

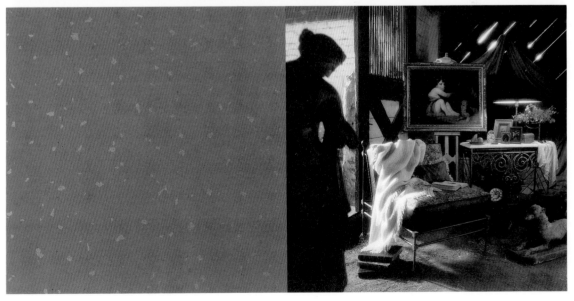

c **Blackhorse,** Booklet
Cecelia Conover, Solana Beach, CA, Art Director
David Diaz, Illustrator
Joan Vandeschnit, Photographer
Conover, Design Firm
Davidson Communities, Publisher/Client
Central Graphics, Typographer
Rush Press, Printer

a

a **Design & Style #5/De Stijl,** Paper Promotion Brochure
Seymour Chwast, New York, NY, Art Director
Roxanne Slimak, Designer
Roxanne Slimak, Illustrators
Seymour Chwast, Illustrator
The Pushpin Group, Design Firm
Mohawk Paper Mills, Publisher/Client

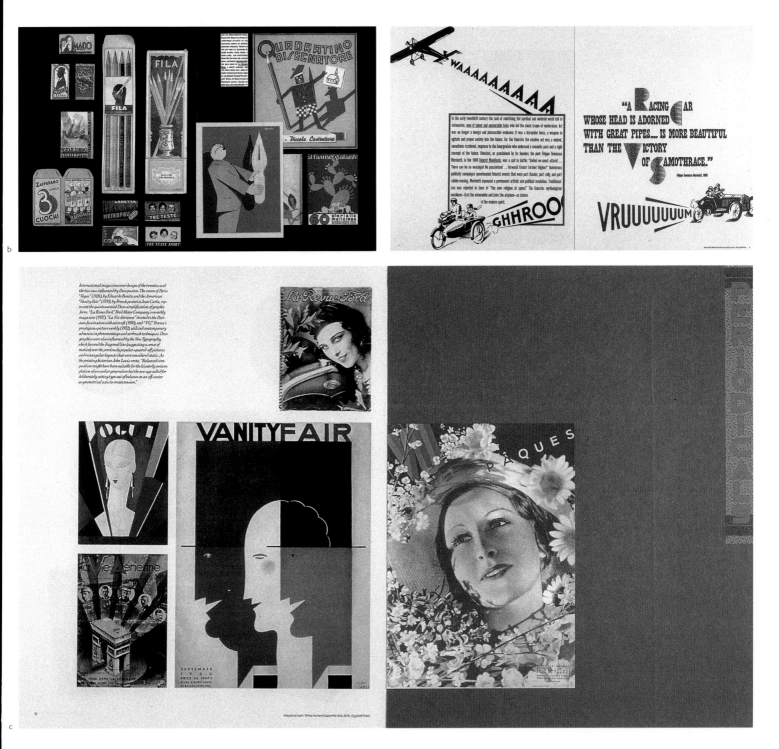

b **Design & Style #4/Futurism,** Paper Promotion Brochure
Seymour Chwast, New York, NY, Art Director
Roxanne Slimak, Designer
Roxanne Slimak, Illustrator
The Pushpin Group, Design Firm
Mohawk Paper Mills, Inc., Publisher/Client

c **Design & Style #3/Paris Deco,** Paper Promotion Brochure
Seymour Chwast, New York, NY, Art Director
Seymour Chwast, The Pushpin Group, Designers
Seymour Chwast, Illustrator
The Pushpin Group, Design Firm
Mohawk Paper Mills, Publisher/Client

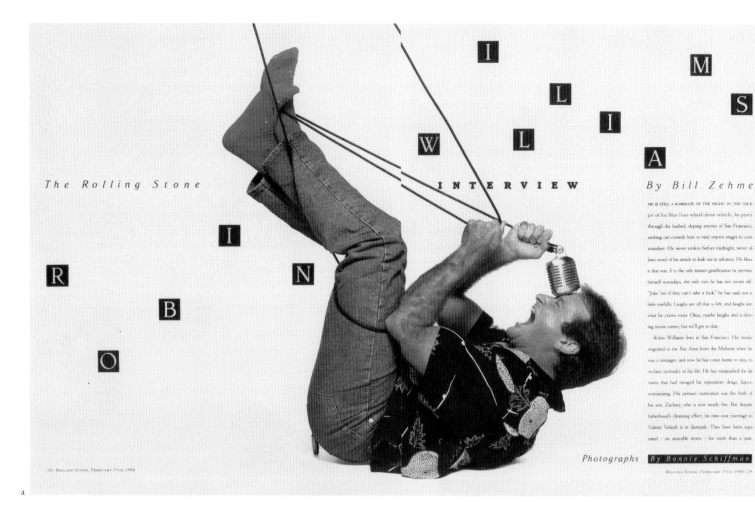

WILLIAMS
ROBIN

The Rolling Stone **INTERVIEW** *By Bill Zehme*

HE IS STILL A KAMIKAZE OF THE NIGHT. IN THE COCK-pit of his blue four-wheel-drive vehicle, he purrs through the hushed, sloping arteries of San Francisco, seeking out comedy huts to raid, improv stages to commandeer. He never strikes before midnight, never allows word of his attack to leak out in advance. He likes it that way. It is the only instant gratification he permits himself nowadays, the only vice he has not sworn off. "Joke 'em if they can't take a fuck," he has said, not a little ruefully. Laughs are all that is left, and laughs are what he craves most. Okay, maybe laughs and a thriving movie career, but we'll get to that.

Robin Williams lives in San Francisco. His family migrated to the Bay Area from the Midwest when he was a teenager, and now he has come home to stay, to reclaim normalcy in his life. He has vanquished the demons that had ravaged his reputation: drugs, liquor, womanizing. His primary motivation was the birth of his son, Zachary, who is now nearly five. But despite fatherhood's cleansing effect, his nine-year marriage to Valerie Velardi is in disrepair. They have been separated — on amicable terms — for more than a year,

Photographs **By Bonnie Schiffman**

28 · ROLLING STONE, FEBRUARY 25TH, 1988

ROLLING STONE, FEBRUARY 25TH, 1988 · 29

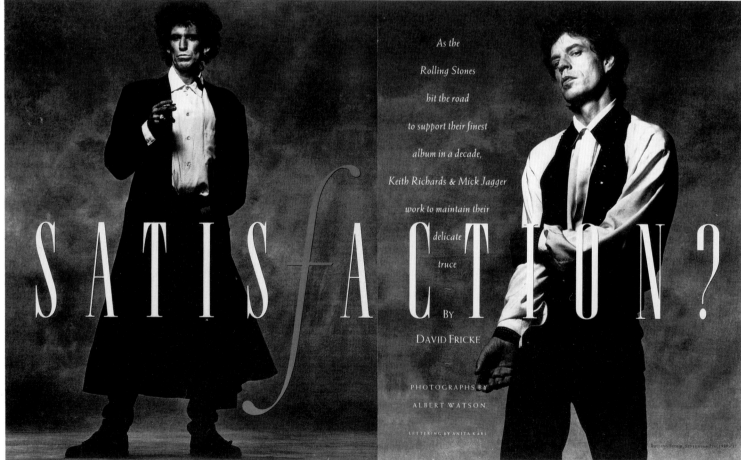

As the
Rolling Stones
hit the road
to support their finest
album in a decade,
Keith Richards & Mick Jagger
work to maintain their
delicate
truce
BY
DAVID FRICKE

SATISFACTION?

PHOTOGRAPHS BY
ALBERT WATSON

LETTERING BY ANITA KARL

ROLLING STONE, SEPTEMBER 7TH, 1989 · 53

a **The R.S. Interview: Robin Williams,** Magazine Spread
Fred Woodward, New York, NY, Art Director
Jolene Cuyler, Designer
Bonnie Schiffman, Photographer
Rolling Stone, Design Firm
Straight Arrow Publishers, Publisher

b **Satisfaction?,** Magazine Spread
Fred Woodward, New York, NY, Art Director
Catherine Gilmore-Barnes, Designer
Albert Watson, Photographer
Rolling Stone, Design Firm
Straight Arrow Publishers, Publisher

PART ONE: THE SHIFT Most of us have lived our entire lives with the threat of the cold war, the terror of nuclear annihilation. But now, for the first time in memory, peace–not war–is breaking out around the world. From Moscow to Washington, the old assumptions are falling away, and a new and vastly different era is coming into being. After all the darkness and carnage of the twentieth century, is man finally ready to give up his most catastrophic habit– the urge to make war? BY LAWRENCE WRIGHT

PEACE

With a new movie, another hit record and a world tour she's bigger than ever. But does anybody really know the person behind the celebrity?

The Madonna Mystique

IT IS A SEVERE, WIND-SWEPT SATURDAY NIGHT IN THE teeming city of Tokyo, and Madonna – the most notorious living blonde in the modern world – sits tucked into the corner of a crowded limousine, glaring at the rain that is lashing steadily against the windows. "We never had to cancel a show before," she says in a low, doleful voice. "Never, never, never." With her upswept hairdo, her cardinal-red lips and her pearly skin, she looks picture perfect lovely – and also utterly glum.

Madonna has come to Japan to launch the biggest pop shebang of the summer, the worldwide Who's That Girl Tour, and since arriving at Narita Airport several days ago, she's been causing an enormous commotion. By all accounts, the twenty-eight-year-old singer, dancer, film star and lollapalooza has been fawned over, feted, followed and photographed more than any visiting pop sensation since the Beatles way back in 1966. All this hubbub is nothing new. In America, Madonna has attracted intense scrutiny throughout her career: from fans, inspired by her alluring manner; from critics, incensed by what they perceive as her vapid tawdriness; and from snoopers of all sorts, curious about the state of her marriage to the gifted and often combative actor Sean Penn. But in Japan – where she enjoys a popularity that has lately eclipsed even that of Michael Jackson and Bruce Springsteen – Madonna is something a bit better than another hot or controversial celebrity: she is an icon of Western fixations. Tonight, though, Madonna's popularity in the Far

BY MIKAL GILMORE

c **Peace, Part One,** Magazine Spread
 Fred Woodward, New York, NY, Art Director
 Brian Cronin, Illustrator
 Rolling Stone, Design Firm
 Straight Arrow Publishers, Publisher

d **The Madonna Mystique,** Magazine Spread
 Fred Woodward, New York, NY, Art Director
 Herb Ritts, Photographer
 Rolling Stone, Design Firm
 Straight Arrow Publishers, Publisher

a **Chili's Inc. Annual Report 1989,** Operations Spread
 Brian Boyd, Dallas, TX, Art Director/Designer
 John Craig, Illustrator
 Richards Brock Miller, Mitchell & Assoc., Design Firm
 Chili's Inc., Publisher/Client
 Chiles & Chiles, Typographer
 Heritage Press, Printer

b **Chili's Inc. Annual Report 1988,** Operations Spread
 Brian Boyd, Dallas, TX, Art Director
 Regan Dunnick, Illustrator
 Richards Brock Miller Mitchell & Assoc., Design Firm
 Chili's Inc., Publisher/Client
 Chiles & Chiles, Typographer
 Heritage Press, Printer

c **Chili's Inc. Annual Report 1987,** Financial Pages
Brian Boyd, Dallas, TX, Art Director
Various, Illustrators
Richards Brock Miller Mitchell & Assoc., Design Firm
Chili's Inc., Publisher/Client
Chiles & Chiles, Typographer
Heritage Press, Printer

a **The Annual Report: Make It A Winner,** Brochure
Kevin B. Kuester and Eric Madsen, Minneapolis, MN, Art Directors
Bob Goebel, Kevin B. Kuester and Eric Madsen, Designers
Craig Anderson, Photographer
Mike Lizama, Ribbon Designer
Madsen and Kuester, Design Firm
Potlatch Corporation, Publisher/Client
TypeShooters, Inc., Typographer
Bradley Printing Co., Printer

b **Reeves Communications Corp. 1988 Annual Report,** Shareholders Spread
David Suh, New York, NY, Designer
Michael Melford and Paul Stevens, Photographers
Frankfurt Gips Balkind, Design Firm
Reeves Communications Corp., Publisher/Client
Frankfurt Gips Balkind, Typographer
Lebanon Valley Offset, Printer

c **Morgan Core Equity,** Brochure Cover
Kathleen Schenck Row, New York, NY, Art Director
Steve Orant and Kathleen Schenck Row, Designers
J.P. Morgan Investment, Publisher/Client
Typogram, Typographer
Crafton/Milocraft, Printer

d **Chili's Inc. Annual Report 1989,** Operations Spread
Brian Boyd, Dallas, TX, Art Director/Designer
John Craig, Illustrator
Richards Brock Miller Mitchell & Assoc., Design Firm
Chili's Inc., Publisher/Client
Chiles & Chiles, Typographer
Heritage Press, Printer

a **CMA Americana Clothing,** Brochure
 Jennifer Morla, San Francisco, CA, Art Director
 Elaine Keenan, Photographer
 Morla Design, Design Firm
 C.M.A., Publisher/Client
 Solotype, Typographer
 Mastercraft Press, Printer

b **Greens Restaurant,** Menus
 David Poe, Designer
 David Poe, San Francisco, CA, Illustrator
 Design Office of Emery/Poe, Design Firm
 Greens, Publisher/Client
 Andresen Typographics, Typographer
 First California Press, Printer

Whatever else they may have been, the Fifties were the last great days of the classic American household: Mom, Dad, and the Kids. It was a time when the words "house" and "home" and "family" still meant the same thing, when *I Love Lucy*, *Leave It to Beaver*, *Ozzie and Harriet*, and *Father Knows Best* represented the house, the home, and the family next door. And if it happened that the house next door looked very much like all the other houses up and down the block, that was because standardized mass production was the most efficient means of satisfying the post-war demand for homes. ¶ Well-populated communities suddenly appeared where there had once been pastures and farmland. They had names like Oak Meadows, Park Forest, and Fairless Hills, and they contained as many as 15,000 homes and 60,000 people. This was suburbia, and in 1950, one-third of the nearly two million homes built in America were built there. The houses, most of them, were scaled-down versions of Cape Cod Colonial or California ranch style. The old front porch was gone, and the living room had been moved from the front of the house to the side or the rear where it had a view of the patio and the barbeque. Instead of two floors there was now one and a half, or a split level. *Architectural Forum* cast a critical eye on these acres of look-alike houses, calling them "pathetic little white boxes with dressed up street fronts." The American Public Health Association worried that they were too small, observing in an official report that "As one drives through the suburban areas, it is often difficult to determine which is the house and which is the garage." ¶ Nonetheless, the homes were affordable for most, and despite their modest simplicity, they provided effective shelter and pride of ownership. They also helped to relieve a desperate post-war shortage in which 5.6 million people were without homes of their own. Above all, the homes were a solid first step in achieving the nation's primary housing goal, which was enunciated with ringing clarity in the Declaration of Purpose attached to the Housing Act of 1949: namely, to provide every American family with "a decent home and a suitable living environment."

A $100-BILLION HIGHWAY BUILDING PROGRAM ENABLED SUBURBANITES TO DRIVE TO WORK ON 41,000 MILES OF NEW ROADWAY. IN ADDITION, THE 40-HOUR WORK WEEK, MANDATED IN 1938, GAVE WORKERS MORE TIME TO THEMSELVES BUT MUCH OF IT WAS SPENT COMMUTING.

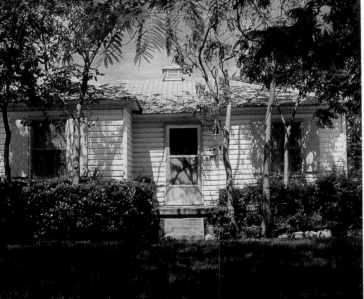

MOBILE, ALABAMA

1958
1968

IF AMERICANS LIVING IN HOMES BUILT IN THE 1960s WERE MORE COMFORTABLE THAN EVER BEFORE, THEY WERE ALSO FEELING A TWINGE OF CONSCIENCE AS THE HOUSING PLIGHT OF MINORITIES BECAME A PUBLIC ISSUE.

THE NATION RECONSIDERED ITS VALUES AND PRIORITIES IN THE SIXTIES; EVEN THE CLASSIC NUCLEAR FAMILY CAME IN FOR SCRUTINY AND CHANGE.

c **Home/Fannie Mae,** Booklet
Peter Harrison and Susan Hochbaum, New York, NY, Art Directors
Various, Illustrators
Pentagram Design, Design Firm
Fannie Mae, Publisher/Client
Typogram, Typographer
Sterling Roman Press, Printer
International Color Service, Color Separations

a **Photos,** Magazine Spread
 Scott Minister, Columbus, OH, Art Director
 Eric Albrecht and Barth Falkenberg, Photographers
 The Columbus Dispatch, Design Firm
 Capitol Magazine, Publisher/Client

b **Art Ohio,** Newspaper Spread
 Scott Minister, Columbus, OH, Art Director
 Cincinnati Museum of Art, Photograph
 The Columbus Dispatch, Design Firm
 Capitol Magazine, Client

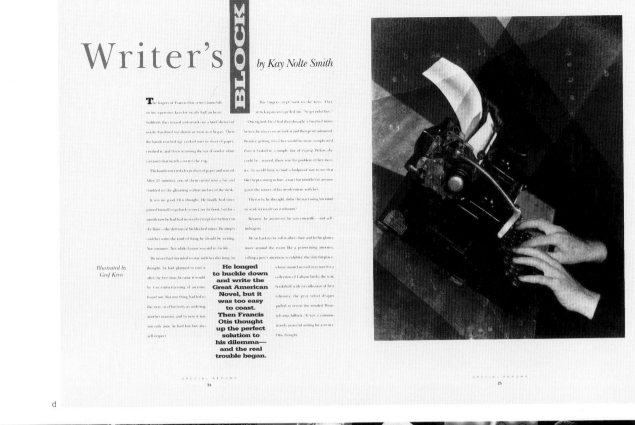

Writer's BLOCK

by Kay Nolte Smith

Illustrated by Geof Kern

The fingers of Francis Otis rested immobile on his typewriter keys for nearly half an hour. Suddenly they tensed and struck out a brief skein of words that dried up almost as soon as it began. Then the hands reached up, yanked out the sheet of paper, crushed it, and threw it among the sea of tender white carcasses that nearly covered the rug.

The hands inserted a fresh sheet of paper and waited. After 25 minutes, one of them curled into a fist and thudded on the gleaming walnut surface of the desk.

It was no good, Otis thought. He finally had disciplined himself to go back to work on the book, but for a month now he had had no result except for the litter on the floor—the detritus of his blocked mind. He simply couldn't write the kind of thing he should be writing. Not anymore. Not while Louise was still in his life.

He never had intended to stay with her this long, he thought; he had planned to end it, after the first time, because it would be too embarrassing if anyone found out. But one thing had led to the next, as effortlessly as ordering another martini, and by now it was not only time he had lost but also self-respect.

He longed to buckle down and write the Great American Novel, but it was too easy to coast. Then Francis Otis thought up the perfect solution to his dilemma— and the real trouble began.

His fingers crept back to the keys. They struck again and spelled out, "So get rid of her."

Otis sighed. He'd had that thought a hundred times before; he always wanted to and then procrastinated. Besides, getting rid of her would be more complicated than it looked in a simple line of typing. Before she could be... retired, there was the problem of her stories; he would have to find a foolproof way to see that they kept coming to him, or was that wouldn't let anyone guess the nature of his involvement with her.

This is why, he thought, didn't I set using his mind to work seriously on a solution?

Because, he answered, he was cowardly—and self-indulgent.

He sat back in the soft leather chair and let his glance move around the room like a prosecuting attorney, calling a jury's attention to exhibits: the slate fireplace, whose mantel served as a rowel for a collection of Lalique birds; the teak bookshelf with its collection of first editions; the gray velvet drapes pulled to reveal the wooded Pennsylvania hillside. It was a consummately peaceful setting for a writer, Otis thought.

d

How our customers use their Connection Machines: Quantum mechanics, fundamental physics, data base text retrieval, medical imaging, seismic processing, fourier analysis, protein sequencing analysis, stress analysis, linear algebra, animation, fluid flow, image processing, two-phase flow behavior,

molecular dynamics, helicopter wake analysis, ray tracing, signal processing, evolutionary biology, materials science, medical imaging, optimization, aircraft design, statistical analysis, matrix processing, non-linear dynamics, neural networks, thermal distribution analysis, process simulation analysis, etc.

e

c **Unconventional Perspectives,** Magazine Spread
Michael Brock, Los Angeles, CA, Design Director
Rod Baer, Artist
Michael Brock Design, Design Firm
L. A. Style, Client/Publisher
CTS, Typographer
Regnier America, Printer

d **Writers Block,** Corporate Magazine Spread
Alan Avery and Jim Darilek, Knoxville, TN, Art Directors
Alan Avery, Designer
Geof Kern, Illustrator
Whittle Communications, Design Firm

e **How Our Customers . . .,** Brochure Spread
Robert Cipriani, Boston, MA, Art Director
John Goodman and Al Fisher, Photographers
Cipriani Kremer Design Group, Design Firm
Thinking Machines, Publisher/Client
Typographic House, Typographer
Acme Printing Co., Printer

251

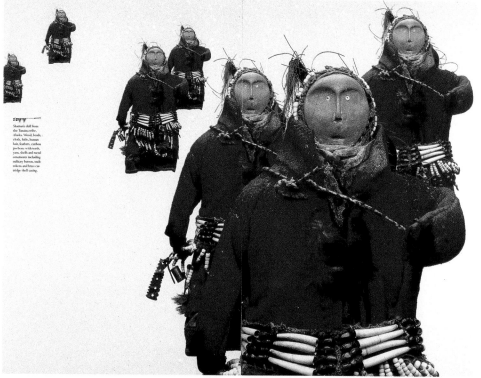

Shaman's doll from the Tanaina tribe, Alaska. Wood, beads, cloth, hide, human hair, feathers, caribou jawbone with teeth, yarn, shells and metal ornaments including military button, trade tokens and brass cartridge shell casing.

a **Enduring Designs,** Promotional Booklet
Jak Katalan and Alyssia Lazin, New York, NY, Art Directors
Andrew Unangst, Photographer
Lazin & Katalan, Design Firm
Tanagraphics, Publisher/Client
Tanagraphics, Printer

a **Awareness,** Hospital Journal

Lakshmi Narayan Burns and Mark Feldman, Art Directors

Mark Feldman, Oak Brook, IL, Designer

Mary Ellen Sullivan and Nancy Tait, Editors

Creative Services Group, Design Firm

Christ Hospital and Medical Center, Client

Publishers Typesetters, Typographer

E&D Web, Printer

b **Designers Saturday/IDCNY,** Catalog

Rick Biedel, New York, NY, Art Director

John Klotnia, Designer

Various, Photographers

Bonnell Design Assoc., Design Firm

IDCNY/Interior Design Center, New York, Client/Publisher

Mac Pagemaker, Typographer

W. E. Andrews, Printer

a **Generra Autumn/Winter 1988,** Booklet
David Edelstein, Nancy Edelstein and Lanny French, Seattle, WA, Art
Directors
David Edelstein, Nancy Edelstein, Lanny French and Sonny Shender,
Designers
William Doke, Photographer
Edelstein Associates Advertising, Design Firm/Agency
Generra, Publisher/Client
Thomas & Kennedy, Typographer
Atomic and George Rice & Sons, Printers

b **Porsche,** Brochure

Joe Duffy, Minneapolis, MN, Art Director

Charles Anderson, Joe Duffy and Haley Johnson, Designers

Jan Evans and Lynn Schulte, Illustrators

Jeff Zwart, Photographer

The Duffy Design Group, Design Firm

Porsche Cars North America, Publisher/Client

Typeshooters, Typographer

Williamson Printing, Printer

a **Young Audiences of Greater Dallas,** Brochure
Scott Ray, Dallas, TX, Art Director/Designer
Bryan Peterson and Scott Ray, Illustrators
Stewart Cohen, Photographer
Peterson & Company, Design Firm
Young Audiences of Dallas, Publisher/Client
Robert J. Hilton Co., Typographer
Hicks Printing, Printer

b **Cordage Paper Graphics,** Booklet
Julius Friedman and Walter McCord, Louisville, KY, Art Directors
Various/University of Louisville Archives, Photographers
Images, Design Firm
Cincinnati Cordage & Paper Co., Publisher/Client
Queen City Type, Typographer
The Hennegan Co., Printer

c **Black Face,** Journal
Rodney Stringfellow, Brooklyn, NY, Art Director
Berta Martinez and Rodney Stringfellow, Designers
Yvonne Buchanan, Berta Martinez and Michael Stevenson, Illustrators
Courtney Brown, Cooper Cunningham, Darien Davis and Chuck McWhorter, Photographers
Black Filmmaker Foundation, Publisher/Client
ARG Graphics, Printer

d **An Open Conversation,** Brochure
**Jamie Alexander, Shelley Evenson, Austin Henderson and John
Rheinfrank, Worthington, OH,** Art Directors
Kwok C. (Peter) Chan, Designer
Steven Trank, Photographer
Fitch Richardson Smith, Design Firm
Steelcase, Publisher/Client
Shirley Rogers, Typographer
West-Camp Press, Printer

Anyone who's ever judged a show like this knows it can be a real pain. Sometimes the submissions put you to sleep, the judges can't even agree on who gets what sandwich at lunch, and the people running the event work you like sharecroppers.

Thankfully, this show was not like that at all.

To begin with, there was a lot of excellent work for us to look at—an unusually high number of entries, equally split between photography and illustration, sent in from all over the map. The exhibition was called "People, Places, and Things," and yet most entries were from the first category—skinheads, Sinatras, even a near-sighted cyclops.

The jury was made up of people from diverse backgrounds, including a great illustrator who didn't know that much about photography and a great photographer who knew even less about illustration. Nevertheless, there was surprisingly strong harmony in the selection process. No great trends here that I could spot, other than that good people are doing good work.

—Fred Woodward, Chairman, People, Places, and Things

PEOPLE PLACES THINGS

AIGA · *The Best in Photography & Illustration, 1984–1989*

Fred Woodward, Chairman, Art Director, *Rolling Stone*, New York, NY
Henrik Drescher, Illustrator, Durham, NY
Rip Georges, Art Director, *Esquire*, New York, NY
Susan Hochbaum, Associate, Pentagram Design, New York, NY
Kurt Markus, Photographer, Kalispell, MO

Call for Entries
Fred Woodward, Gail Anderson, New York, NY, Design
Geof Kern, New York, NY, Photography
Hansford Ray, Williamson Printing Corp., Dallas, TX, Printing
Mohawk Paper Mills, Inc., Cohoes, NY, Paper
Kin Aquino, Jan Borowicz, Susan Cole, Jim Kaltwasser, Eric
Marquard, Chris Raymond, Dan Sullivan, New York, NY,
Typesetting and Production
Dennis Ortiz-Lopez, New York, NY, Lettering

a **Still Life with Phone,** Self-Promotional Illustration
 Hans Neleman, New York, NY, Photographer
 Hans Neleman, Publisher

b **Still Life with Bats,** Self-Promotional Illustration
 Hans Neleman, New York, NY, Photographer
 Hans Neleman, Publisher

c **Still Life with Seahorses,** Self-Promotional Illustration
Hans Neleman, New York, NY, Photographer
Hans Neleman, Publisher

a **Confessions of a Head Case,** Magazine Illustration
Rip Georges, Art Director
Cathleen Munisteri, Designer
Lane Smith, New York, NY, Illustrator
Esquire Magazine, Publisher

b **The Congress of Wonders,** Magazine Illustration
Rip Georges, Art Director
Pamela Barry, Designer
Blair Drawson, West Vancouver, CAN, Illustrator
Esquire Magazine, Publisher

c **Tupelo Nights,** Magazine Illustration
Rip Georges, Art Director
Pamela Berry, Designer
Blair Drawson, West Vancouver, CAN, Illustrator
Esquire Magazine, Publisher

d **David Pike—Pikes Peak,** Album Cover
Stacy Drummond, Art Director
Hendrik Drescher, Durham, NY, Illustrator
CBS Records, Publisher

a

b

a **1989 CADC Call for Entries,** Poster
 Mike Scricco, Art Director
 Brad Holland, New York, NY, Illustrator
 Connecticut Art Directors Club, Publisher

b **One Ninety One Peachtree,** Poster
 Tom McNeff, Art Director
 Tom McNeff, Houston, TX, Illustrator
 Herring Design, Design Firm
 Gerald D. Hines Interests, Publisher

c **Conscience,** Poster
Brad Holland, Art Director
Jim McCune, Designer
Brad Holland, New York, NY, Illustrator
Lorraine Press, Publisher

d **Canadian Opera Company, 1986-1987,** Poster
Scott Taylor and Paul Browning, Art Directors/Designers
Anita Kunz, Toronto, CAN, Illustrator
Taylor/Browning, Design Firm
The Canadian Opera Company, Client

race music...R&B...soul music...black music...AFRICAN-AMERICAN music.

Recording the changing FACE of music. Epic and The CBS Associated Labels.

b

c

a **Recording the Changing Face of Music,** Magazine Advertisement
Stacy Drummond, Art Director
Alan David-Tu, Photographer
CBS Records, New York, NY, Publisher

b **Suede Shoes,** Magazine Illustration
Rip Georges, Art Director
Raymond Meir, New York, NY, Illustrator
Esquire Magazine, Publisher

c **Goodness Gracious,** Magazine Illustration
Rip Georges, Art Director
Cathleen Munisteri and Rip Georges, Designers
Lee Crum, New Orleans, LA, Photographer
Esquire Magazine, Publisher

a

b

c

a **Jerry Harrison–Casual Gods,** Album Cover
 Tibor Kalman, Art Director
 Emily Oberman, Designer
 Sebastiao Salgado, Photographer
 M&Co, Design Firm
 Warner Bros Records, Publisher

b **A-Ha—Hunting High & Low,** Album Cover
 Jeffrey Kent Ayeroff and Jeri Heiden, Art Directors
 Jeri Heiden, Designer
 Just Loomis, Photographer
 Warner Bros Records, Burbank, CA, Publisher

c **Robbie Robertson,** Album Cover
 Jeri Heiden, Art Director
 Chris Callis, Photographer
 Warner Bros Records, Burbank, CA, Design Firm
 Warner Bros Records, Publisher

d **Phoebe Snow—Something Real,** Album Cover
Carol Bobolts, New York, NY, Art Director
Michele Clement, Photographer
Elektra/Asylum Records, Publisher

e **Isaac Hayes–Showdown,** Album Cover
Allen Weinberg, Art Director
William Coupon, New York, Photographer
CBS Records, Publisher

f **Steve Winwood—Back in the High Life,** Album Cover
Jeri Heiden, Art Director
Arthur Elgort, Photographer
Warner Bros Records, Burbank, CA, Publisher

a

b

a **How to Shoot a Love Scene,** Magazine Illustration
Robert Best and David Walters, Art Directors
Blair Drawson, West Vancouver, CAN, Illustrator
Premiere Magazine, Publisher

b **Managing Credit Risk–The Individual Banker,** Brochure Illustration
Keith McDavid, Art Director
Tana Kamine, Designer
Gene Grief, New York, NY, Illustrator
Tana & Co., Design Firm
Chase Manhattan Bank, Publisher/Client

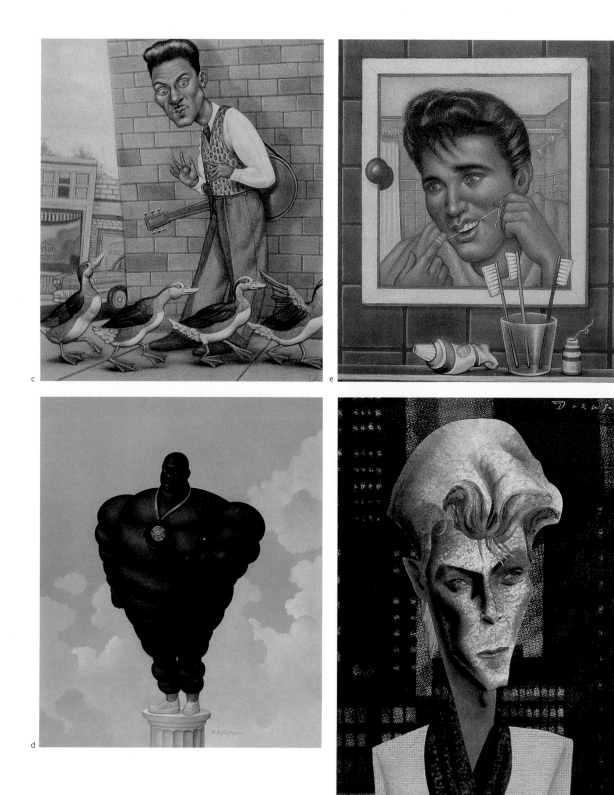

c **Chuck Berry Gets a Great Idea,** Magazine Illustration
Fred Woodward, Art Director
Anita Kunz, Toronto, CAN, Illustrator
Rolling Stone/Straight Arrow Publishers, Inc., Publisher

d **Career Opportunity,** Magazine Illustration
Fred Woodward, Art Director
Robert Goldstorm, Brooklyn, NY, Illustrator
Rolling Stone/Straight Arrow Publishers, Inc., Publisher

e **The Birth of the Sneer—Elvis,** Magazine Illustration
Fred Woodward, Art Director
Anita Kunz, Toronto, CAN, Illustrator
Rolling Stone/Straight Arrow Publishers, Inc., Publisher

f **Recordings—The Dark Soul of a New Machine,** Magazine Illustration
Fred Woodward, Art Director
Blair Drawson, West Vancouver, CAN, Illustrator
Rolling Stone/Straight Arrow Publishers, Inc., Publisher

a **4 Reasons Unknown,** Album Cover
 Stacy Drummond, Art Director
 Ray Hand, Photographer
 CBS Records, New York, NY, Publisher

b **Miles Davis—Tutu,** Album Cover
 Eiko Ishioka, Art Director
 Susan Welt, Designer
 Irving Penn, New York, NY, Photographer
 CBS Records, New York, NY, Publisher

c **Mick Jagger—Primitive Cool,** Album Cover
 Christopher Austopchuk, Art Director
 Francesco Clemente, New York, NY, Illustrator
 CBS Records, New York, NY, Publisher

d **Kitaro-Tenku,** Album Cover
 Jeffrey Kent Ayeroff, Art Director
 Jeri Heiden, Designer
 Matt Mahurin, New York, NY, Photographer
 Warner Bros Records/Geffen Records, Publisher

e **Queen of the Damned,** Magazine Illustration
 Fred Woodward, Art Director
 Matt Mahurin, New York, NY, Photographer
 Rolling Stone/Straight Arrow Publishers, Inc., Publisher

graphis

235

American Illustration |6

EDITED BY EDWARD BOOTH-CLIBBORN

THE BERKELEY MONTHLY

**Encounter with
a Nobel Laureate**

Bad Times on the Border • Thyme Travel • Yankee Writers, Go Home!

The Boston Globe Magazine

JUNE 18, 1989

THE
COLOR
LINE
Blacks
and
whites
in a
divided
America

BY JONATHAN
KAUFMAN

a **Graphis 235/Cyclopedia,** Cover Illustration
Brad Holland, New York, NY, Illustrator
Walter Herdeg/Graphis, Publisher

b **American Illustration 6,** Book Jacket Illustration
Walter Bernard and Milton Glaser, Art Directors/Designers
Barbara Nessim, New York, NY, Illustrator
WBMG, Inc., Design Firm
American Illustration, Publisher

c **Czeslaw Milocsz,** Magazine Illustration
Laura Hamburg-Cirolia, Art Director
Ward Schumaker, San Francisco, CA, Illustrator
The Berkeley Monthly, Publisher

d **The Color Line,** Newspaper Magazine Illustration
Lucy Bartholomay, Art Director
Brad Holland, New York, NY, Illustrator
The Boston Globe Magazine, Publisher

Retrospective
Exhibition
The Cooper Union
7th St. & Third Ave.
New York City
Sept. 10-26, 1987

Edward Sorel

a

WILLIE McCOVEY

b

a **Edward Sorel Retrospective . . . ,** Poster (Sinatra)
 George Lois, Art Director
 Seymour Chwast, Designer
 Edward Sorel, New York, NY, Illustrator
 The Cooper Union, Publisher/Client

b **Willie McCovey,** Poster
 Ward Schumaker, Art Director
 Ward Schumaker, San Francisco, CA, Illustrator
 Ward Schumaker, Design Firm
 Ward Schumaker, Publisher

c **Mentors,** Poster
 Michael Vanderbyl, Art Director/Designer
 Michael Vanderbyl, San Francisco, CA, Illustrator
 Vanderbyl Design, Design Firm
 AIA-San Francisco Chapter, Publisher

PEOPLE, PLACES & THINGS

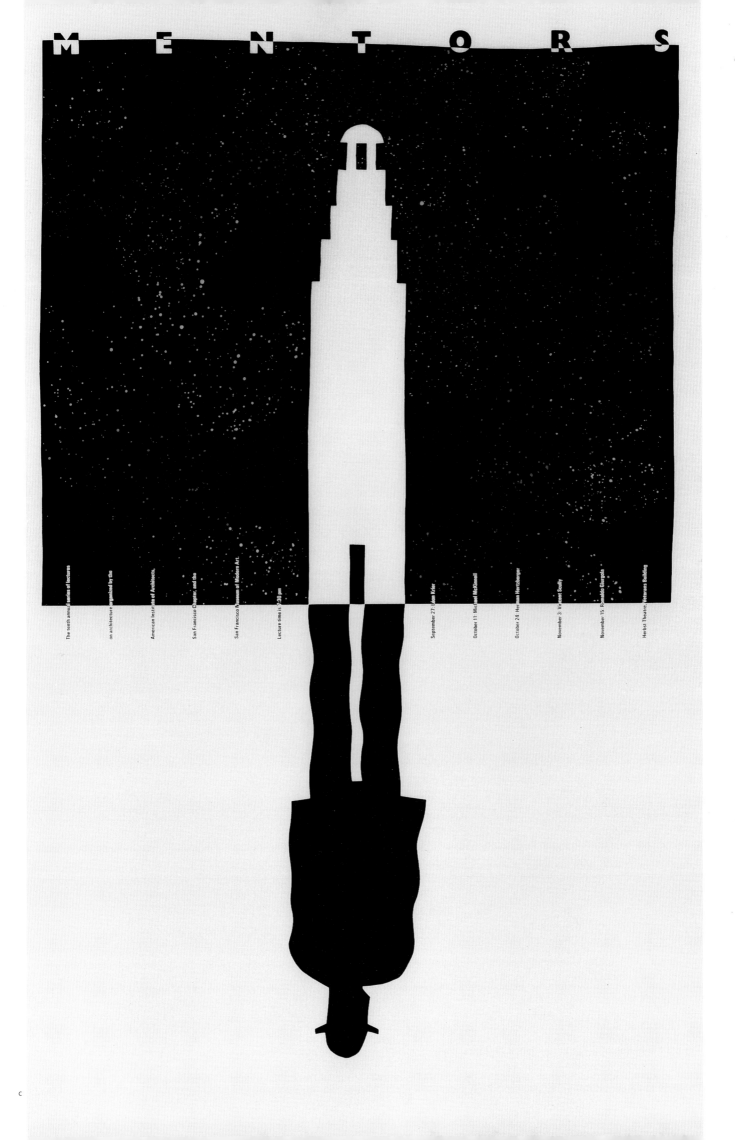

The tenth annual series of lectures

on architecture organized by the

American Institute of Architects,

San Francisco Chapter, and the

San Francisco Museum of Modern Art.

Lecture time is 7:30 pm

September 27: Leon Krier

October 11: Michael MacKinnell

October 24: Herman Hertzberger

November 3: Vincent Scully

November 15: Romaldo Giurgola

Herbst Theatre, Veterans Building

a **Phil Woods—Warm Woods,** Album Cover
Christopher Austopchuk, New York, NY, Art Director
John Gosfeld, New York, NY, Illustrator
Hal Bach, Photographer
CBS Records, Publisher

a **Washington Monuments—Washington Monument,** Magazine Illustration
Fred Woodward, Art Director
Matt Mahurin, New York, NY, Photographer
Regardie's Inc., Publisher

b **Yen at Work,** Magazine Illustration
John Korpics, Art Director
Frank W. Ockenfels III, Photographer
Regardie's Inc., Publisher

c **Washington Monuments—John F. Kennedy Eternal Light,** Magazine
Illustration
Fred Woodward, Art Director
Matt Mahurin, New York, NY, Photographer

d **Hollywood's Golden Boy/Robert Downey, Jr.,** Magazine Illustration
Robert Best and David Walters, Art Directors
Mark Hanauer, Los Angeles, CA, Photographer
Premiere Magazine, Publisher

e **Privatizing Public Service,** Brochure Illustration
Peter Deutsch, Art Director/Designer
Steve Hill, New York, NY, Photographer
Deutsch Design, Inc., Design Firm
Ernst & Whitney International, Publisher

a

The first ever British / American design and advertising conference DESIGN

Featuring Live in New York City via Satellite from London AND

Design Awards: April 11 / Advertising Awards: April 12 INTO

For conference and awards information, telephone 212 995 7298. THE 90'S

The 27th D&AD Gold and Silver Awards Presentations ADVERTISING

Sponsored by ADWEEK and the Designers and Art Directors Association of London.

SHEILA METZNER

G. RAY HAWKINS GALLERY · LOS ANGELES

b

SHEILA METZNER

G. RAY HAWKINS GALLERY · LOS ANGELES

c

b **Sheila Metzner–Uma, Patou Dress and Hat,** Poster
Dallas Saunders, Designer
Sheila Metzner for British Vogue, Conde Nast Int'l, New York, NY,
Client
Devon Editions, Publisher

c **Sheila Metzner,** Poster
Dallas Saunders, Designer
Sheila Metzner, New York, NY, Photographer
Devon Editions, Publisher

a **D & AD '90,** Poster
Woody Pirtle, Art Director/Designer
Libby Carton and Jared Schneidman, New York, NY, Illustrator
Pentagram Design, Design Firm
Design & Art Directors Association of London, Publisher

285

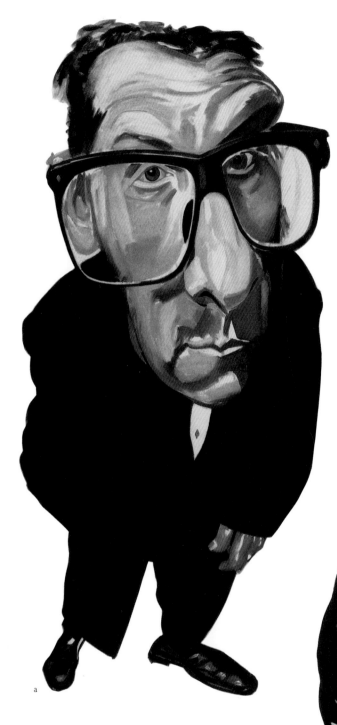

a **Elvis Costello,** Magazine Illustration
 Fred Woodward, Art Director
 Philip Burke, New York, NY, Illustrator
 Rolling Stone/Straight Arrow Publishers, Inc., Publisher

b **Lou Reed,** Magazine Illustration
 Fred Woodward, Art Director
 Philip Burke, New York, NY, Illustrator
 Rolling Stone/Straight Arrow Publishers, Inc., Publisher

c **Reflections,** Brochure Illustration
Steve Liska, Art Director
Bob Cosgrove, Designer
Lane Smith, New York, NY, Illustrator
Liska & Associates, Inc., Design Firm
Consolidated Paper Co., Publisher/Client

d **Immunex Annual Report,** Annual Report Cover
Kit Hinrichs, Art Director
**Wilson McClean, Jack Unruh, Ed Linlof, Douglas Fraser, John Craig
and Dave Stevenson,** Illustrators
Pentagram, San Francisco, CA, Design Firm
Immunex Corp., Publisher

e **The Point,** Magazine Illustration
Rip Georges, Art Director
James McMullan, New York, NY, Illustrator
Esquire Magazine, Publisher

a **Nicholas Cricket,** Book Jacket Illustration
Harriett Barton, Art Director
William Joyce, Illustrator
Harper & Row, Publisher

b **The Man Who Stole The Mona Lisa,** Book Jacket
Louise Fili, Art Director
Dave Calver, Rochester, NY, Illustrator
Pantheon Books, Publisher

c **AKE, The Years of Childhood,** Paperback Cover Illustration
Judy Loeser, Art Director
Keith Sheridan, Designer
Wendy Hoile, London, England, Illustrator
Vintage/Aventura, Publisher

d **Brothers in Arms,** Jacket Illustration
Louise Fili, Art Director
Blair Drawson, West Vancouver, CAN, Illustrator
Pantheon Books, Publisher

e **The Fifth Child,** Book Jacket
Susan Mitchell, Art Director
Marc J. Cohen, Designer
Andrzej Dudzinski, New York, NY, Illustrator
Vintage International, Publisher

f **Better Get Your Angel On,** Book Jacket Illustration
Carol Carson, Art Director
Chip Kidd and Barbara De Wilde, Designers
Chip Kidd, New York, NY, Illustrator
Kidd & De Wilde, Design Firm
Alfred A. Knopf, Inc., Publisher

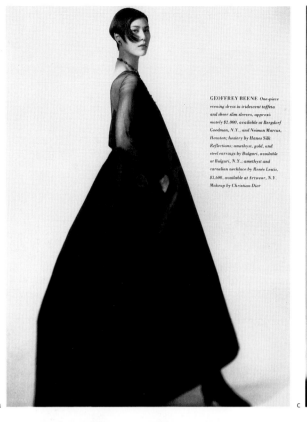

a

GEOFFREY BEENE *One-piece
evening dress in iridescent taffeta
and sheer slim sleeves, approxi-
mately $2,000, available at Bergdorf
Goodman, N.Y., and Neiman Marcus,
Houston; hosiery by Hanes Silk
Reflections; amethyst, gold, and
steel earrings by Bulgari, available
at Bulgari, N.Y.; amethyst and
carnelian necklace by Renée Lewis,
$3,600, available at Artwear, N.Y.
Makeup by Christian Dior*

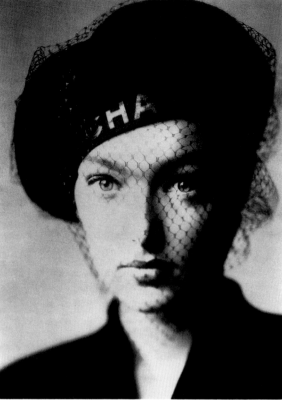

c

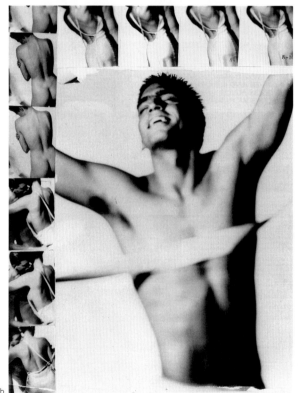

b

d

OPPOSITE PAGE: Nylon two-
piece bathing suit with short
stretch skirt ($78) by Calvin
Klein at Barneys, NY; Holt
Renfrew, CA; Nan Duskin.
Nickel coin purse on a belt ($150)
by Accessories in Metal by
Wendy Stevens at Clodagh Ross
and Williams, NY; Dianne B, NY;
Max Field, L.A. White-gold
water-repellent watch ($1,695)
by Omega Art, at Neiman-
Marcus and other fine stores. To
protect your skin from the sun,
Beverly Hills Tan regime, from
Giorgio.
THIS PAGE: Drop-waist tiered
dress ($400) by Escada, at Escada,
Great Neck, NY; Frost Bros., TX;
J.W. Robinson, CA.
ON OPENING PAGE: "Masque
de Femme" ($3,700) by Cristal
Lalique, at Cristal Lalique, 680
Madison Ave., NY.

a **Geoffrey Beene One Piece Evening Dress ,** Magazine Illustration
March Balet, Art Director
Guzman, New York, NY, Photographer
Fame Magazine, Publisher

b **The Physiology of Sex,** Magazine Illustration
Rip Georges, Art Director
Cathleen Munisteri, Designer
Guzman, New York, NY, Photographer
Esquire Magazine, Publisher

c **...CHA...,** Fashion Illustration
Guzman, New York, NY, Photographer
R.H. Macy, Inc., Publisher/Client

d **Escada Tiered Dress,** Magazine Illustration
China Machado, Art Director
Art Kane, New York, NY, Photographer
Lear's Publishing, Publisher

1990

e **1990,** Booklet
Steven Meisel, New York, NY, Photographer
Bloomingdale's, Publisher
John C. Jay, Publisher

a **The 200th Anniversary of George Washington's Inauguration,** Poster
 Milton Glaser, Art Director/Designer
 Milton Glaser, New York, NY, Illustrator
 NYC Commission on the Bicentennial of the Constitution, Publisher

b **Confessions of a Short Order Artist,** Poster
 Brad Holland, Art Director/Designer
 Brad Holland, New York, NY, Illustrator
 Tulsa Litho Co., Publisher

c **James Beard,** Poster
 Milton Glaser, Art Director/Designer/Artist
 Milton Glaser, New York, NY, Illustrator
 The James Beard Foundation/American Express, Publisher

Celebrate James Beard!

on his
83rd Birthday
May 5th!

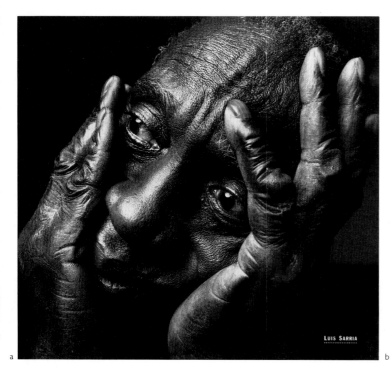

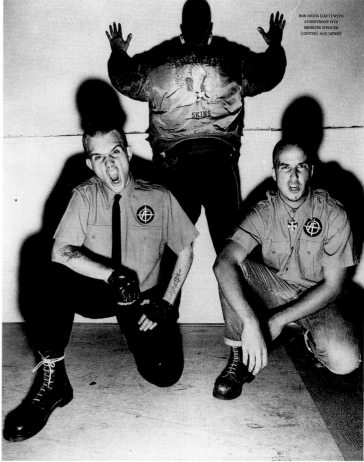

BOB HEICK (LEFT) WITH STORMTROOP FIVE MEMBERS SPENCER (CENTER) AND DEWEY

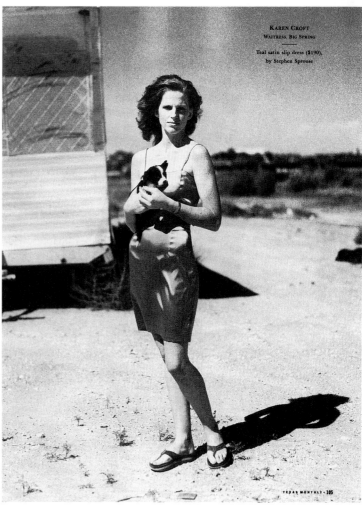

KAREN CROFT
WAITRESS, BIG SPRING

Teal satin slip dress ($190),
by Stephen Sprouse

a **Luis Sarria,** Magazine Illustration
 Steven Hoffman, Art Director/Designer
 Gregory Heisler, New York, NY, Photographer
 Sports Illustrated/Time Inc., Publisher

b **Skinhead Nation,** Magazine Illustration
 Fred Woodward, Art Director
 Gail Anderson, Designer
 Brian Smale, Toronto, CAN, Photographer
 Rolling Stone/Straight Arrow Publishers, Inc., Publisher

c **True Stories,** Magazine Illustration
 D.J. Stout, Art Director
 Geof Kern, Dallas, TX, Photographer
 Texas Monthly Magazine, Publisher

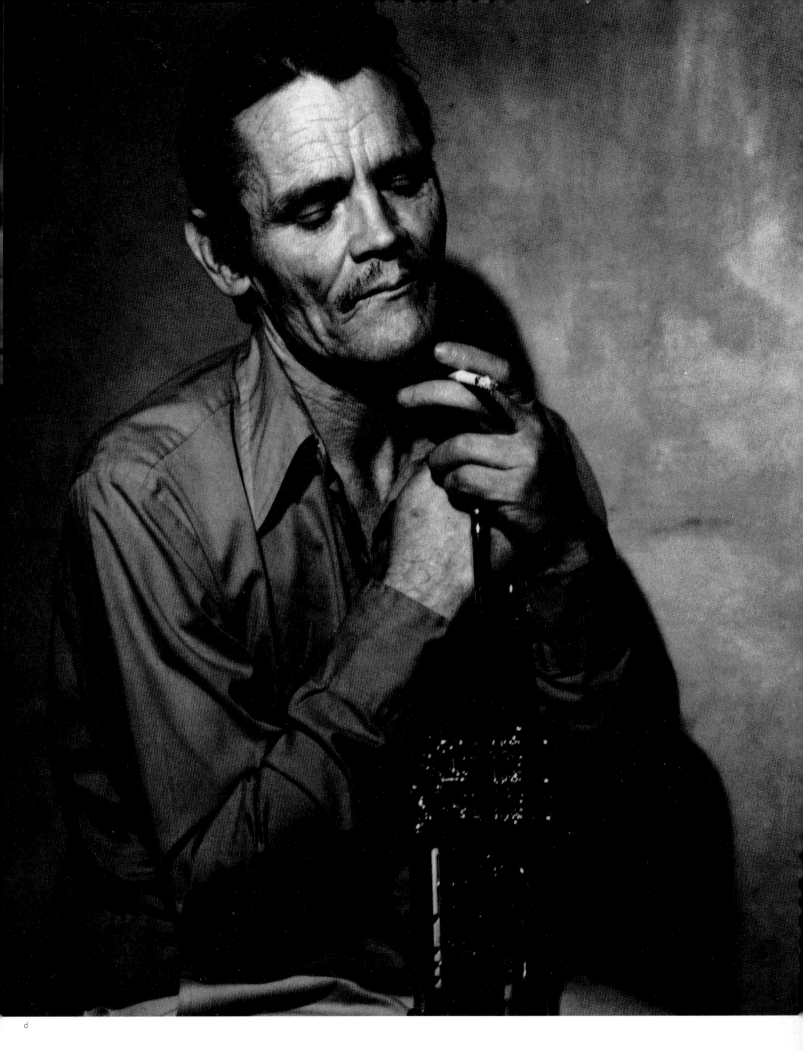

d

d **At long last, Jazz,** Magazine Illustration
Donna Agajanian, Art Director
Bruce Weber, New York, Photographer
American Film Magazine, Publisher

a

b

a **P.C.P.,** Magazine Illustration
 Fred Woodward, Art Director
 Karen Simpson, Designer
 Henrik Drescher, Durham, NY, Illustrator
 Rolling Stone/Straight Arrow Publishers, Inc., Publisher

b **Guess What's Coming to Dinner,** Magazine Illustration
 Jane Palecek, Art Director
 Tom Curry, Austin, TX, Illustrator
 Hippocrates Magazine, Publisher

c **Audibility of Distortion,** Magazine Illustration
Sue Llewellyn, Art Director
Lane Smith, New York, NY, Illustrator
Stereo Review, Design Firm
Diamandis Communications, Inc., Publisher

d **Brain Storm,** Magazine Illustration
Jane Palecek, Art Director/Designer
Andrezej Dudzinski, New York, NY, Illustrator
Hippocrates Magazine, Publisher

e **The Narc has Nightmares,** Magazine Illustration
John Korpics, Art Director
Henrik Drescher, Durham, NY, Illustrator
Regardie's Inc., Publisher

a **Who Does That Dame Think She Is?,** Magazine Illustration
B.W. Honeycutt, Art Director
Philip Burke, New York, NY, Illustrator
Spy Magazine, Publisher

b **Anatomical New York,** Magazine Illustration
B.W. Honeycutt, Art Director
Lilla Rogers, New York, NY, Illustrator
Spy Magazine, Publisher

c **Downstream,** Magazine Illustration
Rip Georges, Art Director
Cathleen Munisteri, Designer
Anthony Russo, Providence, RI, Illustrator
Esquire Magazine, Publisher

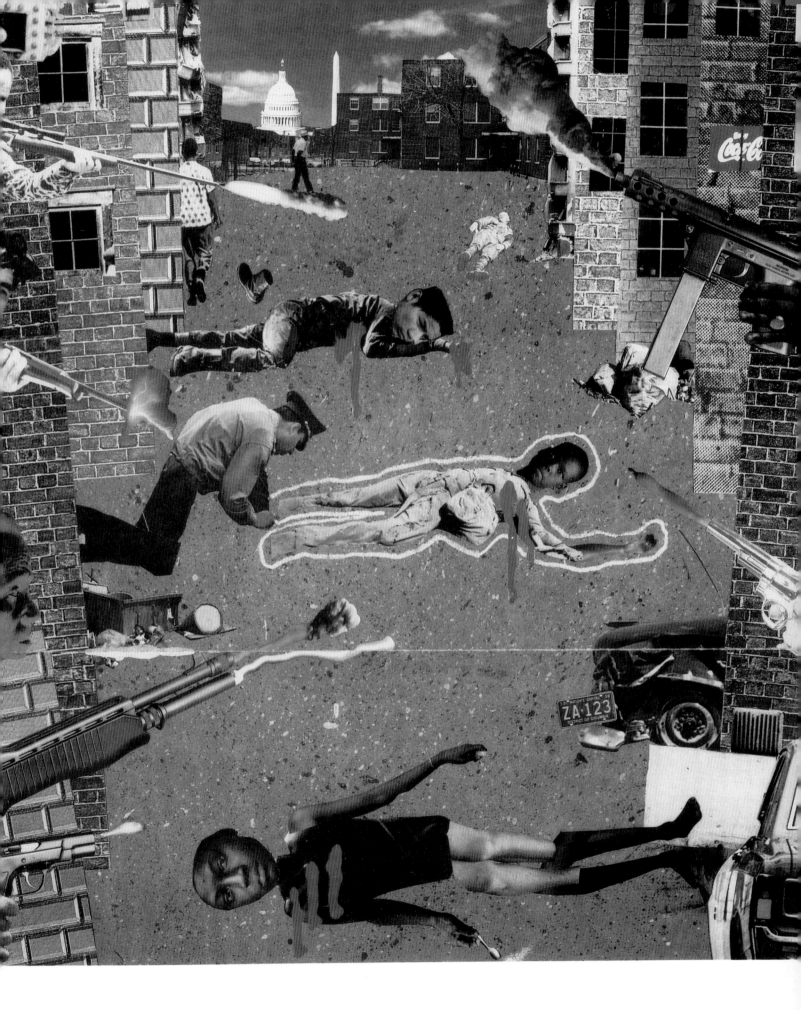

d **Murdertown, U.S.A.,** Magazine Illustration
John Korpics, Art Director
Melissa Grimes, Illustrator
Regardie's Inc., Publisher

a

b

a **1989,** Shopping Bag
 Robert Valentine, Art Director
 Robert Shadbolt, London, England, Illustrator
 Bloomingdale's, Publisher

b **Summer 1989,** Shopping Bag
 Robert Valentine, Art Director
 Phillipe Weisbecker, New York, NY, Illustrator
 Bloomingdale's, Publisher

c **CHICAGO,** Promotional Invitation
Robert Valentine, Art Director
Kelly Stribling, Illustrator
Bloomingdale's, Design Firm
Bloomingdales's, Publisher

世界ヘビー級タイトルマッチ

a

b

c

a **Tyson/Tubbs–Tokyo Dome,** Poster
John C. Jay, Art Director
Anthony Russo, New York, NY, Illustrator
John Jay Design, New York, NY, Design Firm
D.C.A. Special Projects, Publisher
Neville Brody, Type Designer
Mr. Haruo Koriyama, Client

b **The Front Page,** Poster
Jim Russek, Art Director
James McMullan, New York, NY, Illustrator
Russek Advertising Agency, Lincoln Center Theater at the Vivian Beaumont, Publisher

c **Death and The King's Horseman,** Poster
Jim Russek, Art Director
James McMullan, New York, NY, Illustrator
Russek Advertising Agency, Lincoln Center Theater at the Vivian Beaumont, Publisher

d **Party Safe,** Poster
Craig Frazier, Art Director
Craig Frazier, San Francisco, CA, Illustrator
Frazier Design, Design Firm
Friday Night Live/Marin, Public Schools, Client

a

b

September 1988: William Tell **5** Festival, New Glarus, Wisconsin

c

a **Invitation For a Gallery Opening,** Exhibition Invitation
Jeff Jackson, Art Director
Paul Sych, Designer
Jeff Jackson, Toronto, CAN, Illustrator
Reactor Art & Design, Design Firm
Reactor Art & Design, Publisher

b **The Rain Maker,** Magazine Illustration
John Korpics, Art Director
Blair Drawson, West Vancouver, CAN, Illustrator
Regardie's Inc., Publisher

c **William Tell Festival,** Promotional Booklet Illustration
Susan Hochbaum, Art Director/Designer
Henrik Drescher, Durham, NY, Illustrator
Pentagram Design, Design Firm
Mead/Gilbert Paper Companies, Publisher

d **Miles Davis—Aura,** Album Cover
Stacy Drummond, Art Director
Gilles Larrain, Photographer
CBS Records, New York, NY, Publisher

e **Cyndi Lauper—What's Going On,** Album Cover
Stacy Drummond, Art Director
Ann Leibovitz, Photographer
CBS Records, New York, NY, Publisher

f **Ornette Coleman & Prime Time—Virgin Beauty,** Album Cover
Christopher Austopchuk, Art Director
Angela Fisher, Photographer
CBS Records, New York, NY, Publisher

g **The Outfield Bangin',** Album Cover
Christopher Austopchuk, New York, NY, Art Director
Chip Simmons, Photographer
CBS Records, Publisher

a **Matchimanito,** Magazine Illustration
Judy Garlan, Art Director
Brad Holland, New York, NY, Illustrator
The Atlantic Monthly, Publisher

b **Liars,** Magazine Illustration
Michael Walsh, Art Director
Anita Kunz, Toronto, CAN, Illustrator
The Washington Post Magazine, Publisher

c **Brad Holland/Kansas City Art Directors Club,** Poster
Brad Holland, Art Director/Designer
Brad Holland, New York, NY, Illustrator
Kansas City Art Directors Club, Publisher

d **Oscar's Luck,** Newspaper Magazine Illustration
Donna Crivello, Art Director
Becky Heavner, Illustrator
The Baltimore Sun, Publisher

a **Simplicity/Citicorp 1988 Stock Purchase Plan,** Brochure Illustration
 Bob Warkulwiz, Michael Rogalski and William F. Smith, Jr., Art Directors
 Peter Olson, Photographer
 Warkulwiz Design Associates, Design Firm
 Citicorp, Publisher

b **Uniform appearance . . . 70# Miragloss,** Promotional Booklet Illustration
 Steve Liska, Art Director
 Susan Bennett, Designer
 Laurie Rubin, Chicago, IL, Photographer
 Liska and Associates, Design Firm
 International Paper Company, Publisher

c **Adweek Portfolio/Photography,** Cover Illustration
 Walter Bernard and Milton Glaser, Art Directors
 Walter Bernard, Milton Glaser and Shelley Fisher, Designers
 Joyce Ravid, New York, NY, Photographer
 WBMG, Inc., Design Firm
 A/S/M Publications, Publisher

d **Hot Shots/Dexter Manley,** Magazine Illustration
 John Korpics, Art Director
 Brian Smale, Toronto, CAN, Photographer
 Regardie's Inc., Publisher

e INCORPORATING ART DIRECTORS' INDEX

e **Adweek Portfolio/Illustration,** Cover Illustration
Walter Bernard and Milton Glaser, Art Directors
Walter Bernard, Milton Glaser and Shelley Fisher, Designers
David Wilcox, Califon, NJ, Illustrator
WBMG, Inc., Design Firm
A/S/M Publications, Publisher

a

b

a **Bottles,** Corporate Brochure Illustration
 Michael Lamotte, Photographer
 Halleck Design Group, Design Firm
 Tragon Co., Publisher

b **Huang Zhi Jian Painting,** Annual Report Illustration
 Bennett Robinson, Art Director
 Bennett Robinson and Baruch Gorkin, Designers
 Eddie Adams, Photographer
 Corporate Graphics Inc., New York, NY, Design Firm
 H.J. Heinz Company, Publisher

c **Portrait of Harlan Carter,** Magazine Illustration
 Fred Woodward, Art Director
 Brian Smale, Toronto, CAN, Illustrator
 Regardie's Inc., Publisher

d **Homer Henderson, Randy Erwin,** Magazine Illustration
 D.J. Stout, Art Director
 Brian Smale, Toronto, CAN, Illustrator
 Texas Monthly Magazine, Publisher

a

c

b

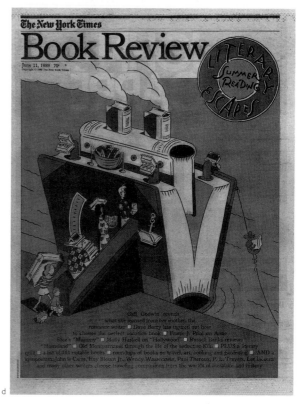

d

a **Campaignus Interruptus,** Magazine Illustration
Fred Woodward, Art Director
Howard Klein, Designer
Alan E. Cober, Ossining, NY, Illustrator
Rolling Stone/Straight Arrow Publishers, Inc., Publisher

b **Here's Looking at You,** Magazine Illustration
Kerig Pope, Art Director
Steven Guarnaccia, New York, NY, Illustrator
Playboy Magazine, Publisher

c **Fighting Drugs with Video,** Magazine Illustration
Terry Koppel, Art Director/Designer
Alexa Grace, New York, NY, Illustrator
Koppel & Scher, Design Firm
V-Magazine, Publisher

d **Literary Escapes—Summer Reading,** Book Review Cover
Steven Heller, Art Director
Steven Guarnaccia, New York, NY, Illustrator
The New York Times, Publisher

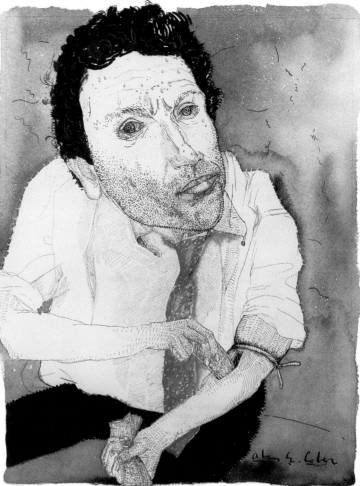

e **Junkie,** Magazine Illustration
John Korpics, Art Director
Alan E. Cober, Ossining, NY, Illustrator
Regardie's Inc., Publisher

a **"Never Before in the History,"** Annual Report Spread
 Peter Harrison and Harold Burch, Art Directors
 Harold Burch and Peter Harrison, Designers
 Gene Greif, New York, NY, Illustrator
 Pentagram Design, Design Firm
 Warner Communications, Inc., Publisher/Client

b **Heaven Departed,** Book Illustration c **Peron,** Book Jacket Illustration
 Marshall Arisman, Art Director **Louise Fili,** Art Director
 Marshall Arisman, New York, NY, Illustrator **Julian Allen, New York, NY,** Illustrator
 Vision Publication, Publisher **Random House,** Publisher

316

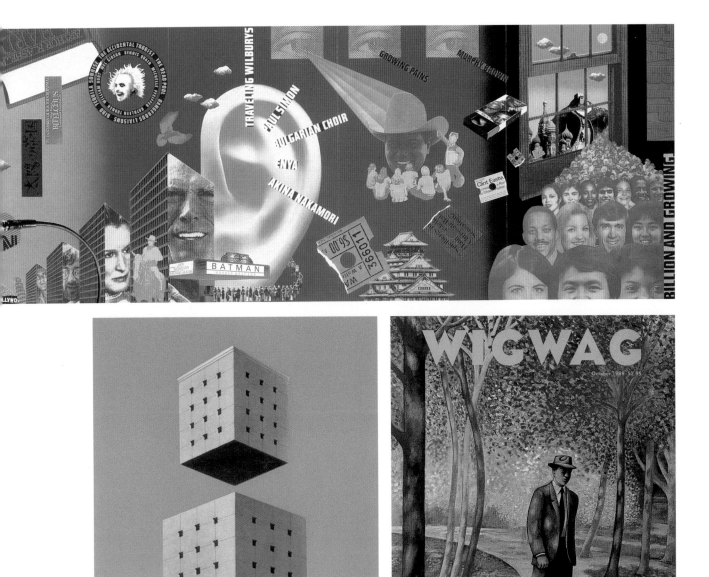

d **3 Com,** Brochure Cover
Marty Neumeier, Art Director
Marty Neumeier and Kathleen Joynes, Designers
David Wilcox, Califon, NJ, Illustrator
Neumeier Design Team, Design Firm
3Com Corporation, Publisher

e **Wigwag, October 89,** Magazine Cover
Paul Davis, Art Director
Paul Davis, New York, NY, Illustrator
Wigwag Magazine Co., Inc., Publisher

a

c

b

a **HBO-Making News,** Magazine Illustration
 Bryan L. Peterson, Art Director/Designer
 Geof Kern, Dallas, TX, Photographer
 Peterson & Company, Design Firm
 Northern Telecom, Publisher

b **Abortion Street,** Magazine Illustration
 D.J. Stout, Art Director
 Matt Mahurin, New York, NY, Photographer
 Texas Monthly Magazine, Publisher

c **The Game Teachers Play,** Magazine Illustration
 Fred Woodward, Art Director
 Kathi Rota, Designer
 Geof Kern, Dallas, TX, Photographer
 Rolling Stone/Straight Arrow Publishers, Inc., Publisher

d **Separated at Birth,** Magazine Illustration
 Alexander Isley, Art Director
 Alexander Whitney Knowlton, Designer
 Various, Photographers
 Spy Magazine, Publisher

Soon-to-be-post-presidential-candidate Bruce Babbitt

&

Washington Post chairman **Katharine Graham?**

Erstwhile Rolling Stone Mick Jagger

&

Don Knotts as the Incredible Mr. Limpet?

Gorgeous lalapalooza Tammy Faye Bakker

&

an Ewok?

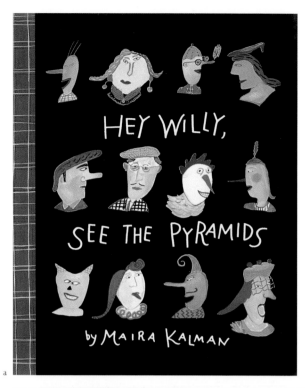

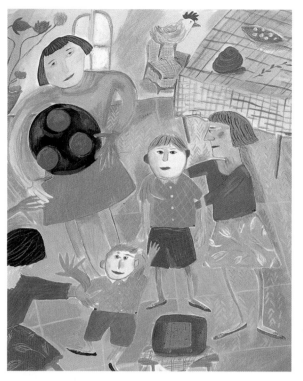

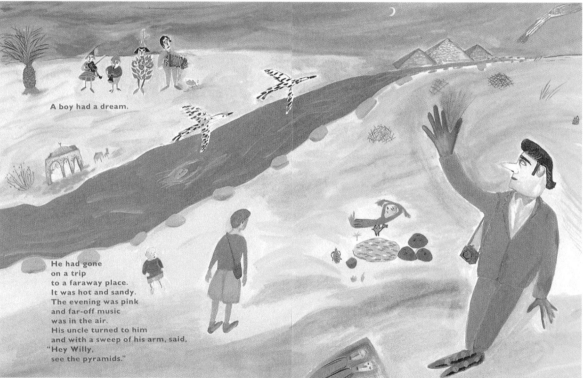

A boy had a dream.

He had gone
on a trip
to a faraway place.
It was hot and sandy.
The evening was pink
and far-off music
was in the air.
His uncle turned to him
and with a sweep of his arm, said,
"Hey Willy,
see the pyramids."

a **Hey Willy, See the Pyramids,** Book Illustrations
 Tibor Kalman, Art Director
 Douglas Riccardi, Designer
 Maira Kalman, New York, NY, Illustrator
 M&Co., Design Firm
 Viking Kestrel, Publisher

b **Slaves of the Lawn,** Magazine Cover
Michael Walsh, Art Director
Steven Guarnaccia, New York, NY, Illustrator
Washington Post, Publisher

c **The Adweek Portfolio of Illustration,** Cover Illustration
Walter Bernard and Milton Glaser, Art Directors
Walter Bernard, Milton Glaser and Shelley Fisher, Designers
Elwood Smith, Rhinebeck, NY, Illustrator
WBMG, Inc., New York, NY, Design Firm
A/S/M Publications, Publisher

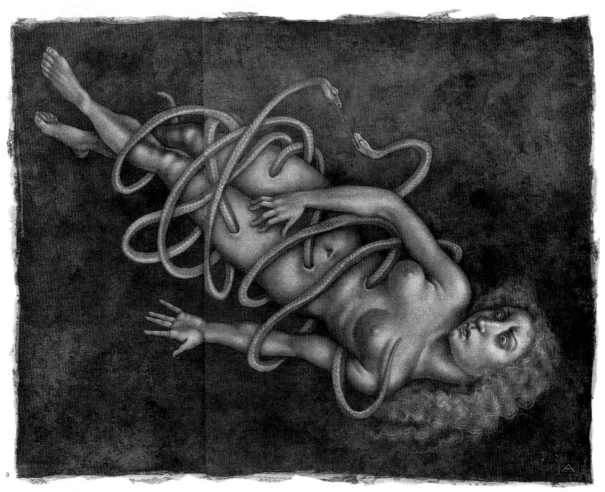

a **Journey into Fear,** Magazine Illustration
 Fred Woodward, Art Director/Designer
 Anita Kunz, Toronto, CAN, Illustrator
 Rolling Stone/Straight Arrow Publishers, Inc., Publisher

b **The Boys Who Would Be Buckley,** Magazine Spread
 B.W. Honeycutt, Art Director
 Christiaan Kuypers, Designer
 C.F. Payne, Cincinnati, OH, Illustrator
 Spy Magazine, Publisher

c **The Dirty Secrets of George Bush,** Magazine Illustration
 Fred Woodward, Art Director
 Jolene Cuyler, Designer
 Janet Wooley, England, Illustrator
 Rolling Stone/Straight Arrow Publishers, Inc., Publisher

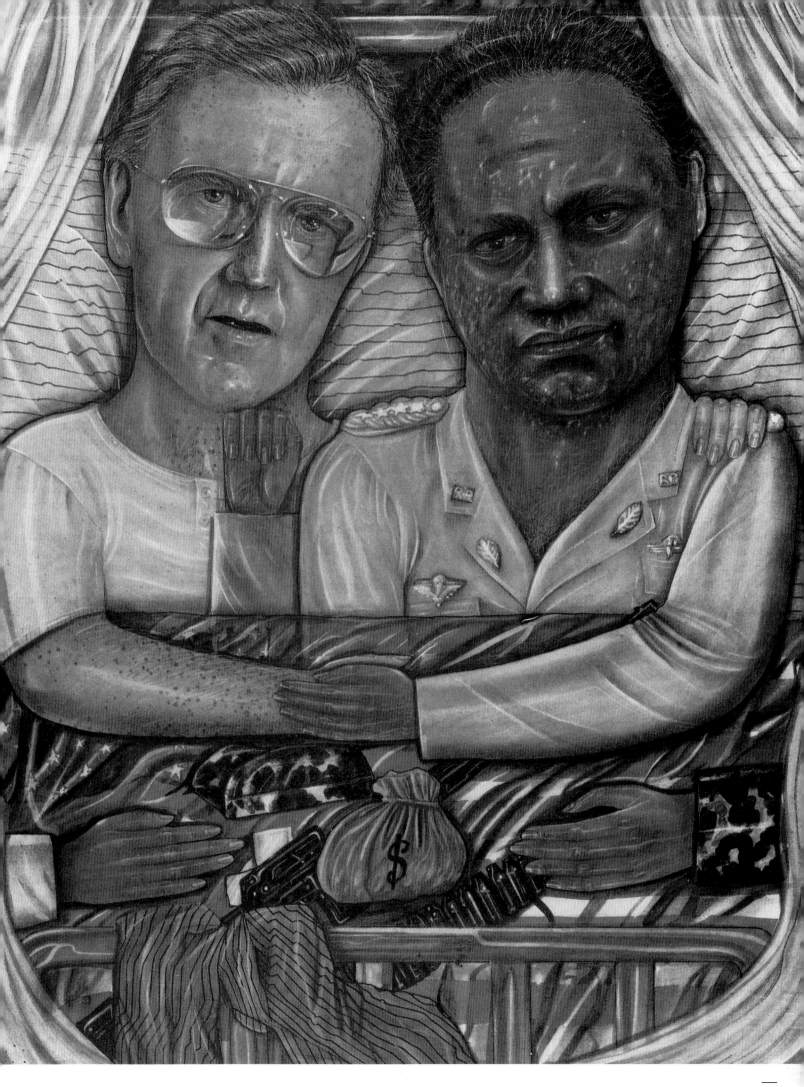

b

c

d

a **Noel Coward–Star Quality,** Poster
 Seymour Chwast, Art Director
 Seymour Chwast–The Pushpin Group, Designers
 Seymour Chwast–The Pushpin Group, New York, NY, Illustrator
 The Pushpin Group, Design Firm
 Mobil Oil Corporation, Publisher

b **The Joys of Entertaining,** Book Illustration
 James Wageman, Art Director
 Philippe Weisbecker, New York, NY, Illustrator
 Abbeville Press, Publisher

c **Pantheon–Fall 1987,** Cover Illustration
 Louise Fili, Art Director
 Elwood Smith, Rhinebeck, NY, Illustrator
 Random House–Pantheon Books, Publisher

d **Market Mascots,** Promotional Illustration
 Michael Mabry, Art Director
 Steven Guarnaccia, New York, NY, Illustrator
 Michael Mabry Design, Design Firm Client
 Strathmore Paper Company, Publisher

a **Ivanarama,** Magazine Cover
B.W. Honeycutt, Art Director
Adam Scull, New York, NY, Photographer
Spy Magazine, Publisher

b **Deflate Nasal Congestion,** Advertisement Illustration
Ernie Smith, Art Director
Kenneth and Carl Fischer, New York, NY, Photographers
Creative Medical Communications, Agency
Parke-Davis, Client

c **Old Route 66 T-Shirt,** Magazine Illustration
China Machado, Art Director
Art Kane, New York, NY, Photographer
Lear's Publishing, Publisher

d **A Day in the Life of the Soviet Union,** Magazine Cover
Rudy Hogland, Art Director
Dilip Mehta, New York, NY, Photographer
Time Magazine, Publisher

SPECIAL SECTION
A Day in the Life of the
SOVIET UNION
Rout on Wall St. ■ Explosions in the Gulf

OCTOBER 26, 1987

TIME

A 38-Page Portrait of the Changing Superpower

a **Peace–Part II,** Magazine Illustration
Brian Cronin, Ireland, Illustrator
Rolling Stone/Straight Arrow Publishers, Inc., Publisher

b **The Witches of Eastwick,** Magazine Illustration
 Kerig Pope, Art Director/Designer
 Anita Kunz, Toronto, CAN, Illustrator
 Playboy Magazine, Publisher

c **Draw the Cowboy,** Magazine Illustrations
 Fred Woodward, Art Director
 Various, Illustrators
 Texas Monthly Magazine, Publisher

d **Rescuing a Hard Disk,** Magazine Illustration
 Christopher Burg, Art Director
 Tom Morgan, Designer
 John Hersey, San Francisco, CA, Illustrator
 PCW Communications, Publisher

e **A Garden of Visual Delights,** Magazine Illustration
 Terry Koppel, Art Director/Designer
 Alexa Grace, New York, NY, Illustrator
 Koppel & Scher, Design Firm
 V-Magazine, Publisher

NOT KNOW □ TO KNOW IS NOTHING AT ALL; TO IMAGINE IS EVERYTHING □ I AM ONLY A PUBLIC ENTERTAINER WHO HAS

a

Karsh: The Art of the Portrait

c

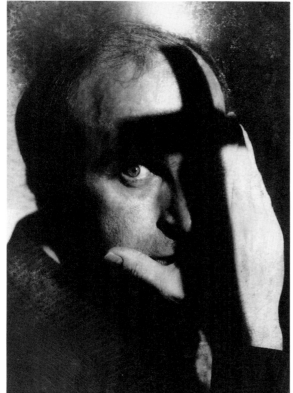

b

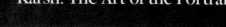

d

a **Jerry della Femina,** Annual Report Illustration
 Bennett Robinson, Art Director
 Bennett Robinson and Erika Siegel, Designers
 Seymour Chwast, New York, NY, Illustrator
 Corporate Graphics, Inc., Design Firm
 WCRS Group, Publisher

c **Karsh: The Art of the Portrait,** Book Jacket Illustration
 Yousuf Karsh, Ottawa, CAN, Illustrator
 Eiko Emori Inc., Design Firm
 National Gallery of Canada, Publisher

b **Sins of Walker Railey,** Magazine Illustration
 D. J. Stout, Art Director
 Geoff Kern, Dallas, TX, Photographer
 Texas Monthly Magazine, Publisher

d **After the Bite,** Magazine Illustration
 Jane Palecek, Art Director
 Jeffrey Newbury, San Francisco, CA, Photographer
 Hippocrates Magazine, Publisher

PEOPLE, PLACES & THINGS

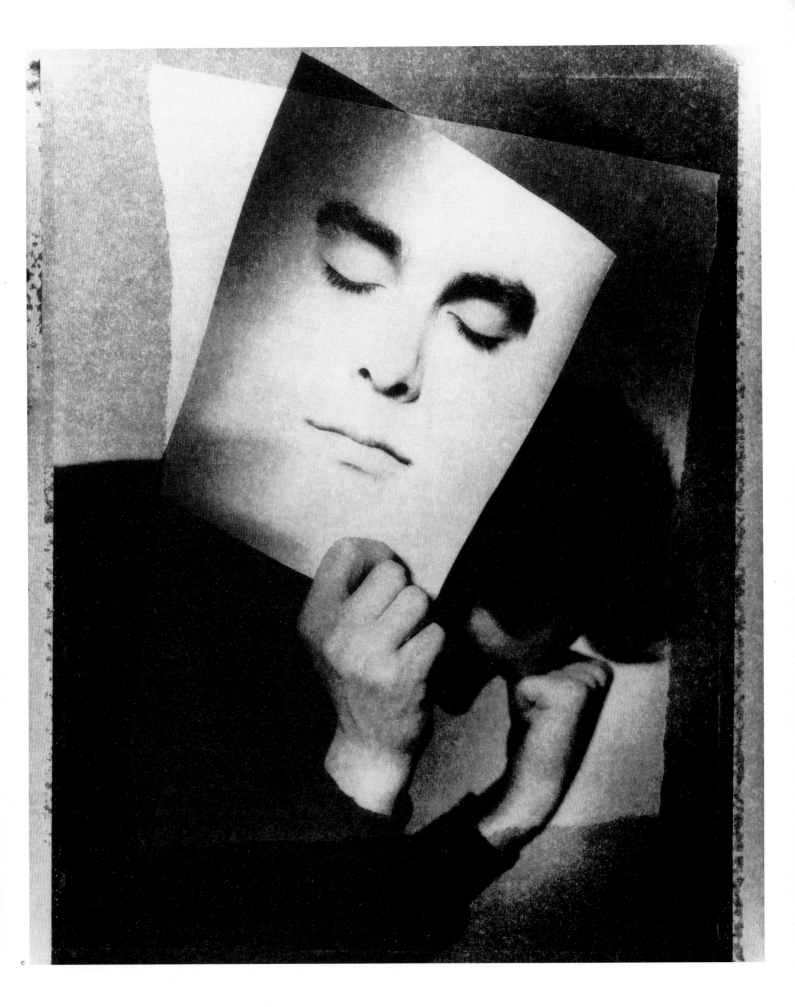

e **The No Decade,** Magazine Illustration
D.J. Stout, Art Director
Geof Kern, Dallas, TX, Photographer
Texas Monthly Magazine, Publisher

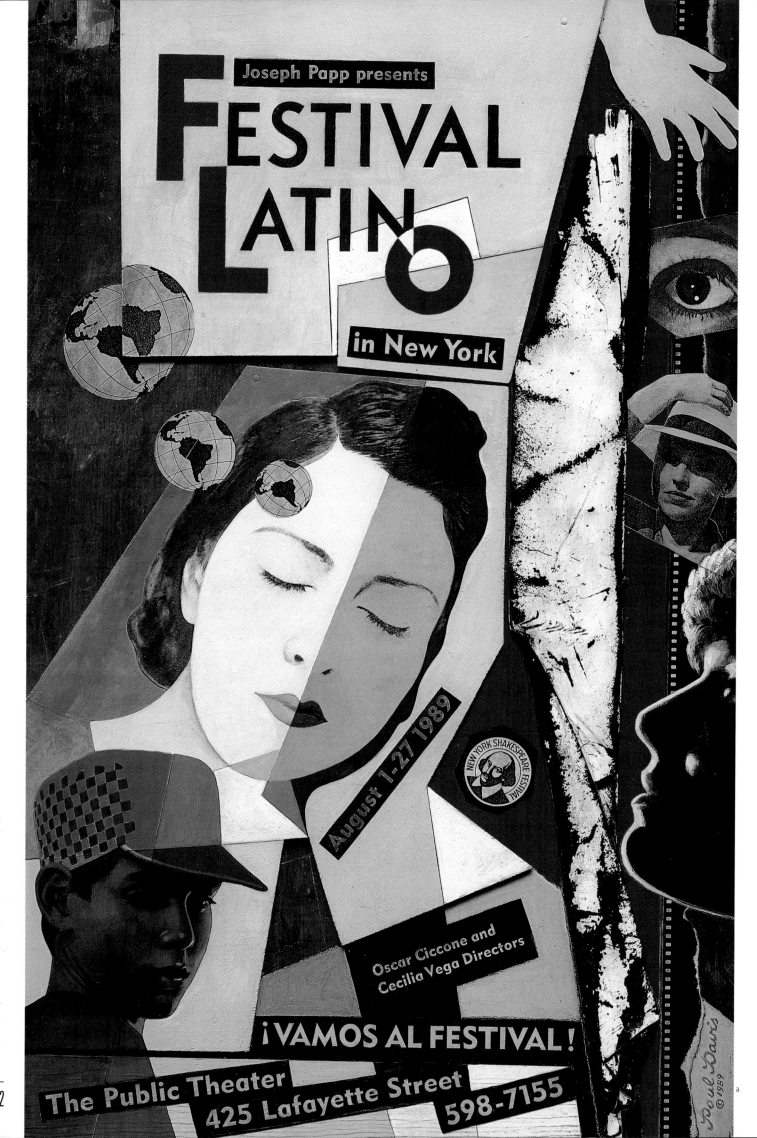

a **Festival Latino 1989,** Poster
Paul Davis, Art Director
Paul Davis, New York, NY, Illustrator
Paul Davis Studio, Design Firm
New York Shakespeare Festival, Publisher

b **Broomshtick,** Promotional Booklet
Woody Pirtle, Art Director/Designer
Woody Pirtle, New York, NY, Illustrator
Jim Olvera, Photographer
Pentagram Design, Design Firm
Woody Pirtle, Publisher

c **Surrealist Watch Collection,** Illustrated Box
Seth Jaben, Art Director
Seth Jaben, New York, NY, Illustrator
Seth Jaben Studio, Design Firm
Seth Jaben Watch Collection™, Publisher

a **Joe Louis,** Magazine Illustration
Wendy Thomas, Art Director
Dugald Stermer, San Francisco, CA, Illustrator
Monthly Detroit, Publisher

b **It Looks Like We're Expanding Again,** Announcement Illustration
Scott Paramski, Art Director/Designer
Gerry Kano, Dallas, TX, Photographer
Peterson & Company, Design Firm
Peterson & Company, Publisher

c **The Adventures of Money,** Magazine Illustration
John Korpics, Art Director
Lane Smith, New York, NY, Illustrator
Regardie's Inc., Publisher

d **Nothing Works,** Newspaper Magazine Illustration
Nancy Duckworth, Art Director
Lane Smith, New York, NY, Illustrator
Los Angeles Times Magazine, Publisher

a **The Art of Martex,** Brochure Illustration
James Sebastian, Art Director
Bruce Wolf, New York, NY, Photographer
Designframe, Inc., Design Firm
West Point Pepperell/Martex, Publisher

b **Zimbabwe,** Annual Report Illustration
Bennett Robinson, Art Director
James McMullan, New York, NY, Illustrator
Corporate Graphics, Inc., Design Firm
H.J. Heinz Company, Publisher/Client

c **Venezuela,** Annual Report Illustration
Bennett Robinson, Art Director
Julian Allen, New York, Illustrator
Corporate Graphics, Inc., Design Firm
H.J. Heinz Company, Client

a **Greg Louganis in Briefs,** Magazine Illustrations
Rip Georges, Art Director
Kurt Marcus, Kalispell, MT, Photographer
Esquire Magazine, Publisher

b **Texas Prisons,** Magazine Illustration
Fred Woodward, Art Director
Matt Mahurin, New York, NY, Photographer
Texas Monthly Magazine, Publisher

c **Springhill 60# Miragloss and Miraweb,** Promotional Booklet Illustration
Steve Liska, Art Director
Susan Bennett, Designer
Geoff Kern, Dallas, TX, Photographer
Liska and Associates, Design Firm
International Paper Company, Publisher

d **The War Zone,** Magazine Illustration
D.J. Stout, Art Director
Mary Ellen Mark, Photographer
Texas Monthly Magazine, Publisher

e **Texas Sheriffs/Rufe Jordan,** Magazine Illustration
Fred Woodward, Art Director
Kent Barker, Dallas, TX, Photographer
Texas Monthly Magazine, Publisher

Leslee Avchen, Principal, Avchen & Jacobi
Capabilities brochure, Leonard, Street & Deinard, Lawyers
Communication Graphics

GRAPHIC
DESIGN USA
10 The Annual of
the American Institute
of Graphic Arts

Jeff Barnes, Principal, Barnes Design Office
Print ad, Novastone Tables,
Johnson Industries, Inc.
Communication Graphics

Robert Appleton, Principal, Appleton Design
Cover design, *Graphic Design USA: 10*
Communication Graphics

Michael Manwaring, Principal,
Office of Michael Manwaring
Logo, The Mary Edwards Collection
Communication Graphics

Valerie Richardson, Principal, Creative Director,
Richardson or Richardson
Package design, Howard's Book of Simple Wooden Toys
Communication Graphics

Ray Honda, Designer, Primo Angeli, Inc.,
Oakland A's All-Star Games, 1987
Communication Graphics

Woody Pirtle, Partner, Pentagram Design
Swatchbook symbol, Fox River Paper Co.
Communication Graphics

Pat Samata, Chair, Partner, Samata Associates
Editorial spread, YMCA of Metropolitan
Chicago Annual Report, 1989
Communication Graphics

Nancy Skolos, President, Skolos, Wendell and Raynor
Poster, Berkeley Typographers, Boston
Communication Graphics

Tyler Smith, Art Director,
Graphic Designer
Print ad, Louis, Boston
Communication Graphics

Ron Sullivan, Partner, Sullivan Perkins
Original illustration
Communication Graphics

John Van Dyke, Director, Van Dyke Company
Weyerhaeuser Paper Co., Annual Report, 1988
Communication Graphics

Lucille Tenazas, Principal, Tenazas Design
Poster, Dutch Design Exhibition, 1987

Steven Heller, Senior Art Director,
The New York Times, Art Director,
The New York Times Book Review
Cover design, *Designing With Illustration*,
by Steven Heller and Karen Pomeroy,
Van Nostrand Reinhold, Publisher
The Book Show

Douglas Wadden, Professor, University of Washington
Exhibition poster, "Artists and Process"
The Book Show

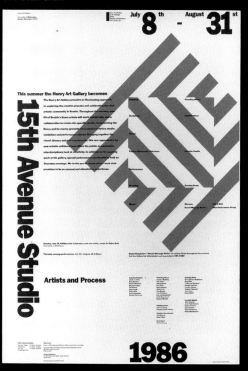

Michael Beirut, Chair,
Partner, Vignelli Associates
Cover design, *We The Homeless*,
Photographs by Stephanie Hollyman,
Text by Victoria Irwin,
The Philosophical Library, Inc., Publisher
The Book Show

Andrew Stewart, President,
Stewart, Tabori & Chang
Cover design, *Paintings In the Louvre*,
by Sir Lawrence Gowing,
Stewart, Tabori & Chang, Publisher
The Book Show

Maira Kalman, Writer, Illustrator, M&Co.
Original Illustration
The Book Show

Susan Hochbaum, Associate, Pentagram Design
'21' Cigars
People, Places & Things

Henrik Drescher, Illustrator
Self-promotional illustration
People, Places & Things

Rip Georges, Art Director, *Allure*
Editorial spread, *Esquire*
People, Places & Things

THE AIDS PRINCIPLE

**Chris Hill, Principal, Hill/ A Marketing Design Group
The AIDS Principle
Insides/Outsides Show**

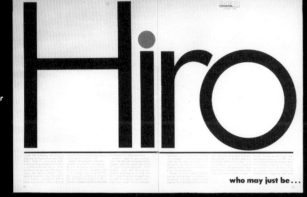

**Will Hopkins, Partner,
Hopkins/Bauman
Editorial spread,
American Photographer
Insides/Outsides**

Hiro

who may just be . . .

**Jill M. Howry, Partner, Russell, Howry & Associates
Advertising brochure, MSLI
Insides/Outsides Show**

**John Jay, Senior Vice-President and
Creative Director for Advertising and Design,
Bloomingdale's, New York
Poster, Tyson vs. Tubbs Championship Fight,
The Tokyo Dome
Insides/Outsides**

TOWN & COUNTRY

DECEMBER 1989/$3.00

Season's Best!

**Melissa Tardiff, Chair, Art Director,
Town & Country
Cover design, *Town & Country*
Insides/Outsides**

**Kurt Markus, Photographer
Fashion editorial, *Allure*
People, Places & Things**

**Fred Woodward, Chair, Art director, *Rolling Stone*
Editorial spread, *Rolling Stone*
People, Places & Things**

PART TWO: LIVING WITHOUT ENEMIES
Gorbachev wasn't just revolutionizing his own society; he was transforming ours as well. Since Stalin's day, the Soviets had played the perfect enemy. The evil Russian bear defined our national purpose and gave us a global mission. But here was Gorbachev declaring peace. Could we look at him and still see the face of the enemy? And what posed the greater threat, having an enemy or not having one? BY LAWRENCE WRIGHT

PEACE

Publishers, Publications and Clients

Typographers, Letterers and Calligraphers

Printers, Binders, Engravers, Fabricators and Separators